The Best Seasonal Promotions

Poppy Evans

NORTH LIGHT BOOKS
Cincinnati, Ohio

METRIC CONVERSION CHART

TO CONVERT	TO	MULTIPLY BY
Inches	Centimeters	2.54
Centimeters	Inches	0.4
Feet	Centimeters	30.5
Centimeters	Feet	0.03
Yards	Meters	0.9
Meters	Yards	1.1
Sq. Inches	Sq. Centimeters	6.45
Sq. Centimeters	Sq. Inches	0.16
Sq. Feet	Sq. Meters	0.09
Sq. Meters	Sq. Feet	10.8
Sq. Yards	Sq. Meters	0.8
Sq. Meters	Sq. Yards	1.2
Pounds	Kilograms	0.45
Kilograms	Pounds	2.2
Ounces	Grams	28.4
Grams	Ounces	0.04

This hardcover edition of **The Best Seasonal Promotions** features a "self-jacket" that eliminates the need for a separate dust jacket. It provides sturdy protection for your book while it saves paper, trees and energy.

01 00 99 98 97 5 4 3 2 1

Library of Congress Cataloging-in-Publication Data
Evans, Poppy,
Best Seasonal Promotions/Poppy Evans.
 p. cm.
 Includes index.
 ISBN 0-89134-775-5 (alk. paper)
 1. Graphic Arts—United States—Marketing. 2. Commercial Art—United States—Marketing.
 I. Title
 NC 1001.6.B83 1997
 741.6'068'8—dc20 97-45514
 CIP

Edited by Terri Boemker
Designed by Angela Lennert Wilcox

The permissions beginning on page 142 constitute an extension of this copyright page.

North Light Books are available for sales promotions, premiums and fundraising use. Special editions or book excerpts can also be created to specification. For details, contact: Special Sales Manager, F&W Publications, 1507 Dana Avenue, Cincinnati, Ohio 45207.

This book is dedicated to my dear friends Eric and Sally Soderlund.

✳

Acknowledgments

Producing a book of this enormity is never easy. Many individuals and firms are contacted and oblige by forwarding their projects, and answering countless questions. I would first, and foremost, like to thank the design firms, illustrators and freelancers who contributed their work to this project and were so generous with their time and expertise in providing information on their pieces.

I would also like to thank Lynn Haller at North Light Books for selecting me to author this book and for her input during its developmental stages.

Finally, I would like to thank Terri Boemker for all of her help in getting this book into production. Her vision and eye for organization was one of the crucial steps in making this book a reality.

About the Author

After graduating from the University of Cincinnati with a degree in fine arts, Poppy Evans got her first taste of publishing by functioning as a one-person production staff—writing, editing and laying out a company newsletter. She has worked as a graphic designer and as a magazine art director for Screen Printing and the American Music Teacher, a national association magazine that won many awards under her direction for its redesign and artfully conceived covers.

She returned to writing and editing in 1989, as managing editor of HOW magazine. Since leaving HOW, she has written many articles that have appeared in graphic arts-related magazines, including Print, HOW, Step-By-Step, Publish, Single Image and Confetti. She is the author of many books on graphic design, a freelance publication designer, and teaches graphic design and computer publishing at the Art Academy of Cincinnati.

✳

Contents

✳

Introduction
6

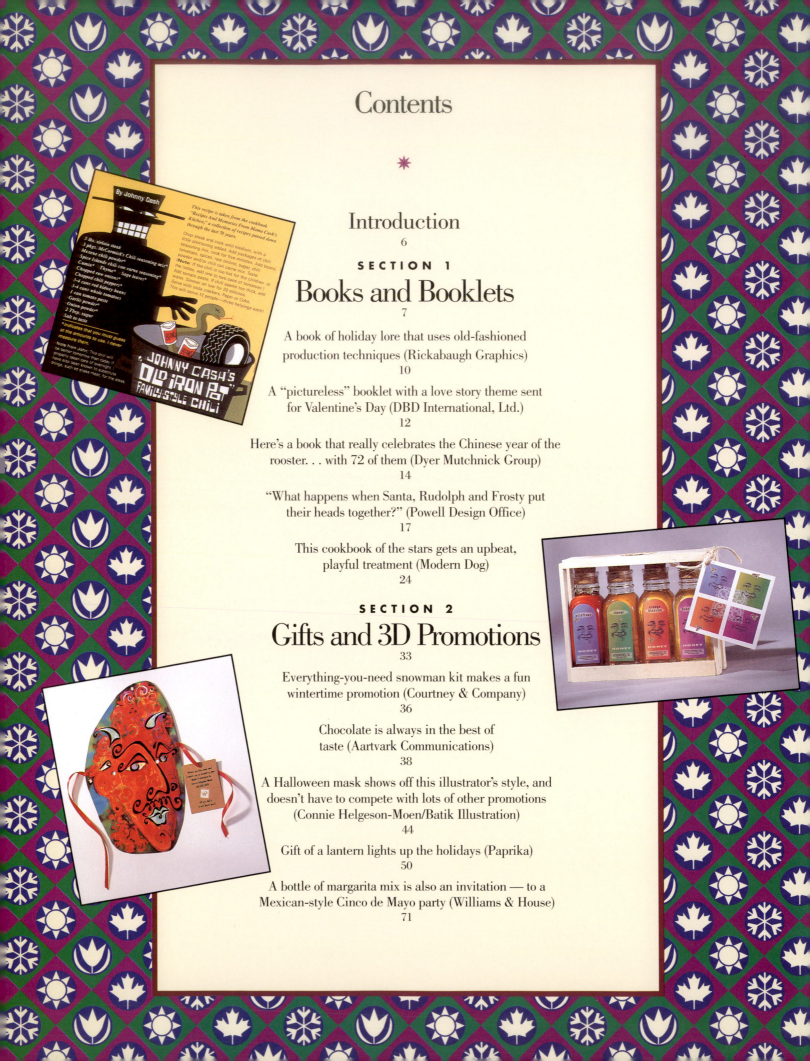

During the holiday season, businesses have traditionally sent a card or even a small gift to clients, vendors and associates thanking them for their business and wishing them well. Nobody expected any more than this, until graphic designers and illustrators got into the act. In recent years, creative professionals have jumped on the Christmas/Hanukkah/New Year's season, as well as other holidays at other times of the year, as an opportunity to do a promotional mailing that will dazzle and impress current and prospective clients with their creativity and wit.

This book's extraordinary collection of seasonal and holiday greetings proves that the obligatory holiday greeting has become something far more elaborate and sophisticated than the traditional card and gift. Browse these pages and you'll find that holiday cards have grown into paper ornaments, booklets, or even a packet of prayer cards. The humble gift has grown into a designer T-shirt, a custom-faced watch, a recipe book, or custom-packaged foods or spirits. Some design firms specializing in multimedia have even created animated greetings, sent to clients and colleagues on a floppy disk.

And what of the calendar that's often sent as a combined gift and greeting? The calendars in this collection go far beyond the conventional flip format with the company name on top. Unconventional die-cuts, unusual materials and arresting visuals have turned calendars into three-dimensional masterpieces of clever engineering as well as outstanding design.

Unrestricted by client-imposed bounds or preconceived notions of what a holiday promotion should be, the pieces in this book run the gamut of possibilities. They truly push the envelope in their exploration of design venues, range of techniques and humor. It shouldn't be overlooked, however, that in addition to providing an inspiring array of seasonally-themed promotional pieces, this book will no doubt intrigue and entertain designers and illustrators. These pieces also express the sentiments and design sensibilities of their creators. Each one is as personal as a peek at a colleague's studio and, in some instances, a glimpse into their soul. ✳

—Poppy Evans

Books and Booklets

*

Elaborate Holiday Brochure Is Sent in Custom Mailer

Holiday customs and folk tales from around the world were compiled in this brochure, designed by Dallas-based David Carter Design Associates.

The brochure contains twenty pages, including a die-cut gatefolded page at the center that shows stars from around the world. Other pages include colorful illustrations of angels, bells, candles and a description of the role they play in other cultures' holiday celebrations. Calligraphy headlines add to the brochure's warm, yet elegant appeal.

The brochure was printed on recycled paper on a waterless press—an eco-friendly alternative to conventional offset printing. Four-color process plus three match colors were used on the brochure. Its cover is die cut to reveal an angel-shaped charm, purchased from a wholesale charm manufacturer and attached to the opening page of the brochure with ribbon looped through two slits.

The brochure's international theme is appropriate to the design firm's international client base. It was sent in its own custom mailer, printed in copper and purple, to over fifteen hundred of the studio's clients and vendors throughout the world.

Design firm: David Carter Design Associates

Client: David Carter Design Associates

Art directors: David Carter, Lori B. Wilson

Designer: Tracy Huck

Illustrator: Donna Ingemanson

Materials: Simpson Quest (cover, mailer), Simpson Starwhite Vicksburg (interior pages)

Printing method: Waterless printing

Quantity: 1,500

Scrap Paper and Do-it-Yourself Thermography Yield Elegant Results

"The Textures of Our Lives, the Patterns of Our Traditions," is the title of this elegantly packaged collection of cards that tells the story behind time-honored holiday traditions. Designed by Bloomington, Illinois-based Osborn & DeLong, the set of cards is contained in a wallet-sized, custom-designed pocket folder.

The folder's cover sets the theme by depicting holiday icons thermographed onto a printer's trim—a dark blue piece of Fox River Confetti. The icons were imprinted onto the paper by art director Al Fleener and other staff members using a do-it-yourself thermography kit purchased at a craft store. Fleener describes the process as "grueling," but the kit yielded dramatic results even more effective than commercial thermography. The icons —a hearth flame, Christmas tree, candle, mistletoe and stocking—are carried into the design of the folder's interior, where they comprise a multicolored pattern, and are also carried through on the individual cards within.

Each icon symbolizes a holiday tradition. The story behind each symbol is told on each of the five cards tucked within the folder pocket. Textural interest was created by printing the cards on a variety of stocks—all wasted trim from other jobs, which the printer offered to Osborn & DeLong at a discount. A translucent flyleaf printed with a subtle version of the icon pattern was also tucked into the pocket along with the cards.

Osborn & DeLong staff members stuffed the folders with the cards and glued the hand-torn piece of paper bearing the thermography icons to each cover before sending them off to clients, vendors and friends.

Design firm: Osborn & DeLong
Client: Osborn & DeLong
Art director: Al Fleener
Designer/Illustrator: Al Fleener
Copywriter: Doug DeLong
Materials: Various papers (printer's trim)
Printing methods: Sheetfed offset, foil stamping, thermography
Quantity: 250

Book of Holiday Lore Uses Antique Production Techniques

This book of holiday lore, titled "The Rites of Christmas Past," uses vintage techniques to support its nostalgic theme. Designed by Rickabaugh Graphics, the book contains interesting accounts of holiday traditions that were practiced prior to this century.

Much of the book's charm comes from its hand-crafted production techniques. For an image in step with the pre-computer era, all story copy was set on a typewriter. Simple woodcut illustrations by Michael Tennyson Smith support the piece's antiquated look.

The book was printed on a letterpress, a method of printing which was used before the advent of offset lithography. The printing technique leaves a faint impression on soft paper, such as the book's uncoated ivory stock. Although interior pages were machine trimmed, the book's cover was torn by hand for a rustic effect. All other work on the book's assembly was also done by hand, including the stitched binding. Rickabaugh staffers even hand-glued "The Rites of Christmas Past" title plate onto the book's cover. Before each book was mailed, a cardboard ornament of St. Nick, purchased at a gift and novelty shop, was tied to its bound edge.

Clients, suppliers and friends of Rickabaugh Graphics were impressed with the book's textural richness and creative use of hand-crafted techniques.

Design firm: Rickabaugh Graphics
Client: Rickabaugh Graphics
Art director: Eric Rickabaugh
Designer/Illustrator: Michael Tennyson Smith
Materials: Simpson Evergreen, purchased ornament
Printing method: Letterpress
Quantity: 150

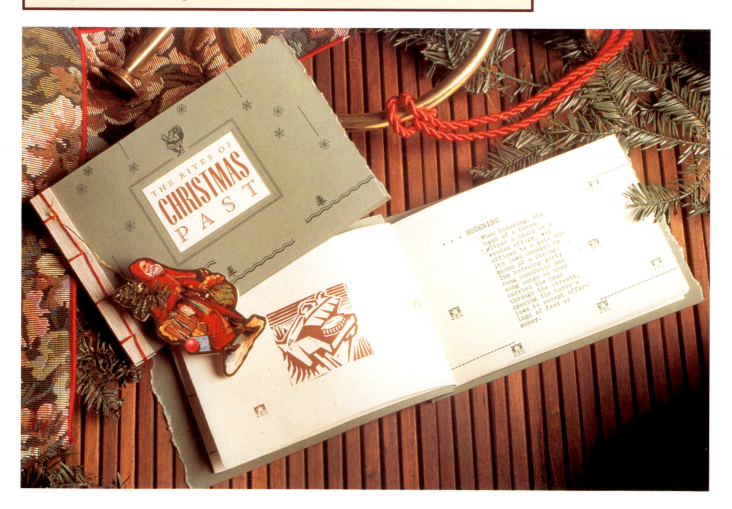

Rock 'n' Roll Cookbook With a Retro Look

Warner Bros. Records' *Holiday Favorites* is not a collection of Christmas music. Instead, it's the title of a mini cookbook that the record company sent to clients and associates in the recording industry as a holiday greeting.

Designed by Seattle-based Modern Dog, the cookbook contains favorite recipes from Warner Bros.' recording artists. It includes a variety of specialties, ranging from Madonna's Krispy Marshmallow Treats to a recipe for enchiladas from Los Lobos.

Modern Dog chose a retro image for the cookbook's graphic theme—a look in step with our perception of the fifties as an era when all moms were stay-at-home moms who cooked from a collection of wholesome recipes. To capture this nostalgic look, designer Robynne Raye created illustrations reminiscent of the style used by Saul Bass in that era. Liberal use of Coronet, a typeface typical of the commercial script commonly used in the fifties, reinforces the cookbook's look. The cookbook's three match colors—pink, yellow and lime green—are also in keeping with popular colors of the time.

Modern Dog, along with Warner Bros. art director Jeri Heiden, conceived the cookbook as a holiday greeting that would also be a keepsake—not something that would end up as more trash in our already cluttered landfills. They succeeded in this mission, "People loved it," says Raye. "Fans wanted to hang on to these mini cookbooks because stars like Madonna contributed their secret recipes to it."

WARNER BROS. RECORDS
proudly presents

Holiday Favorites

Recipes from the Family of Warner Bros. Records Recording Artists

Design firm: Modern Dog
Client: Warner Bros. Records
Art director: Jeri Heiden, Warner Bros. Records
Designer: Robynne Raye
Illustrator: Robynne Raye
Materials: Simpson Starwhite Vicksburg
Printing method: Sheetfed offset
Quantity: 10,000

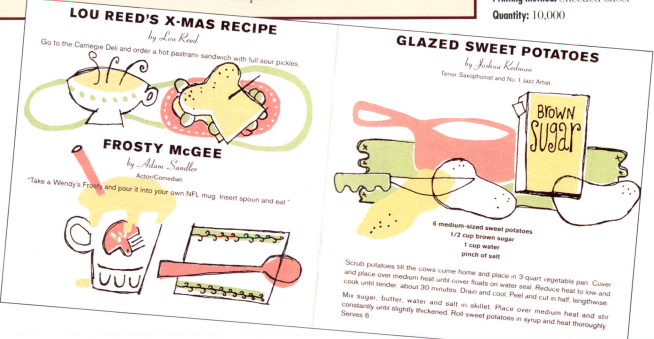

LOU REED'S X-MAS RECIPE
by Lou Reed

Go to the Carnegie Deli and order a hot pastrami sandwich with full sour pickles.

FROSTY McGEE
by Adam Sandler
Actor/Comedian

"Take a Wendy's Frosty and pour it into your own NFL mug. Insert spoon and eat."

GLAZED SWEET POTATOES
by Joshua Redman
Tenor Saxophonist and No. 1 Jazz Artist

BROWN SUGAR

6 medium-sized sweet potatoes
1/2 cup brown sugar
1 cup water
pinch of salt

Scrub potatoes till the cows come home and place in 3-quart vegetable pan. Cover and place over medium heat until cover floats on water seal. Reduce heat to low and cook until tender, about 30 minutes. Drain and cool. Peel and cut in half, lengthwise. Mix sugar, butter, water and salt in skillet. Place over medium heat and stir constantly until slightly thickened. Roll sweet potatoes in syrup and heat thoroughly
Serves 6

A Pictureless Valentine's Day Promotion

DBD International, Ltd., created this conversation starter—a "pictureless" booklet with a love story theme—as a Valentine's Day promotion.

Sent to current and prospective clients, the booklet's two-color cover sets the mood with its use of vintage stock images and traditional colors. The twelve pages within are filled with titled frames—picture boxes with no images, so that the reader can fill in the blanks. The "punch line," printed on the back cover of the booklet, is that DBD International can create "something out of nothing." Vintage typefaces, such as Bank Gothic and Trade Gothic, tie in with the booklet's nostalgic theme.

Rather than print on both sides of a text-weight paper, designer and firm principal David Brier chose to use Neenah UV Ultra, a paper with the feel of parchment, typically used for flysheets. To prevent show-through, the paper is printed on one side and is French-folded so that each page is a double thickness of the stock. The paper's rich, antique look adds textural interest to the primarily blank pages.

The booklet's 4" x 9" size fits neatly into a business-size envelope for mailing. Because the pictureless booklet is the antithesis of most designer's image-driven promotions, it prompted many comments from delighted recipients.

Design firm: DBD International, Ltd.
Client: DBD International, Ltd.
Art director: David Brier
Designer: David Brier
Materials: Neenah Columns Duplex Cover, Neenah UV Ultra
Printing method: Sheetfed offset
Quantity: 350

A Holiday Brochure That's Also a Holiday Decoration

At first glance, "The Circle Widens" appears to be a brochure. The element of surprise in this holiday promotion comes when the recipient starts to read it—each page is perforated into three strips, each of which is slotted so that the strips can be assembled into a ring. When linked together, the rings form a decorative magenta and green chain.

The holiday promotion starts with Mark Oldach Design's greeting, followed with a story about decorating a Christmas tree with handmade ornaments and paper chains. The story sets the theme for the pages of chain strips that follow. Firm principal Mark Oldach and his staff used original illustrations and designs, as well as doctored clip art, to create the pages. The back of each

page is printed full-bleed with solid magenta.

The book was printed in green, magenta and black on an uncoated text. Its cover was printed on Wyndstone Facade, a stock with a pebbly texture. The books were spiral bound before they were packed in shipping boxes and mailed to clients and studio friends.

Design firm: Mark Oldach Design
Client: Mark Oldach Design
Art director: Mark Oldach
Designer: Don Emery
Materials: Gilbert Esse, Wyndstone Facade
Printing method: Sheetfed offset
Quantity: 500

Booklet Celebrates Christmas in Italy

Because of its founder's Italian heritage, Dallas-based Yaquinto Printing chose to focus on Italian Christmas customs in their production of this four-color, sixteen-page booklet.

The booklet was designed by Powell Design Office and contains seven illustrations, each depicting a different holiday custom. Illustrator Glyn Powell made clever use of hand-decorated papers in his production of charming, cut-paper illustrations. For a rich effect, Powell had each illustration printed with hand-rendered outlines in gold ink.

The booklets were printed in four-color process plus gold on dull-coated, cream-colored stock and saddle stitched into a kraft-colored, uncoated cover. A rendering of Christmas trees, in Italy's national colors of red, green and white, was printed on coated stock and glued to the center of each cover.

The holiday promotion was extremely well received. In fact, one recipient took it apart and had the individual illustrations matted and framed.

Design firm: Powell Design Office
Client: Yaquinto Printing Company
Art director: Glyn Powell
Designer/Illustrator: Glyn Powell
Materials: French Speckletone (cover), S.D. Warren Lustro Dull (interior pages)
Printing method: Sheetfed offset
Quantity: 2,000

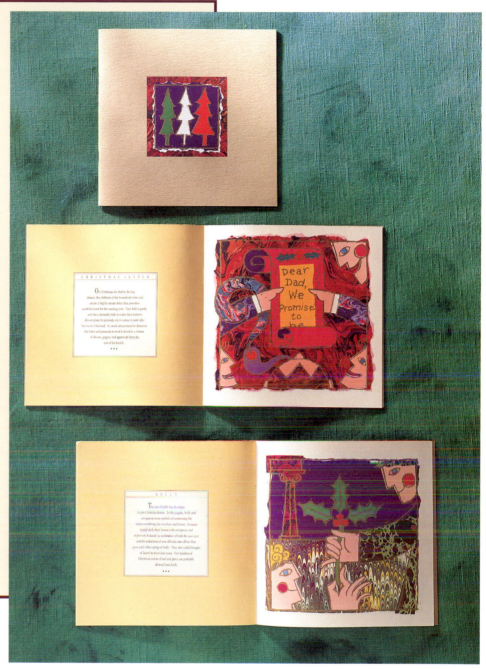

Promo Connects Chinese New Year's Symbol and Firm's Logo

This book, designed by Rod Dyer of Dyer Mutchnick Group, Inc., celebrates the Chinese year of the rooster, 1993. It was sent to clients and potential clients during the 1993-1994 holiday season to mark the end of the year. Given the fact that Dyer Mutchnick Group uses a rooster in its logo, the promotion was particularly appropriate.

The book starts with a description of how twelve creatures from the animal kingdom came to Buddha to distinguish themselves with their own year. The story is told in the same hand-drawn lettering as the book's title, "Many, many years ago…" . The ensuing pages display rooster illustrations, each rendered in a different style. Although all seventy-two roosters are black-and-white, the diversity of representations and styles, ranging from primitive sculptures to typographic renderings, makes the book visually interesting. The series of rooster illustrations culminates in the Dyer Mutchnick Group logo.

Measuring 5" x 5½", the book is far from diminutive—its 164 page count gives it a substantial thickness of almost an inch. The wire-bound book was printed on a conventional offset press in black. Soft color is provided by the olive-colored stock used for the book's interior pages.

Design firm: Dyer Mutchnick Group, Inc.

Client: Dyer Mutchnick Group, Inc.

Art director: Rod Dyer

Designer: Rod Dyer

Materials: French Dur-O-Tone (cover)

Printing method: Sheetfed offset

Quantity: 1,500

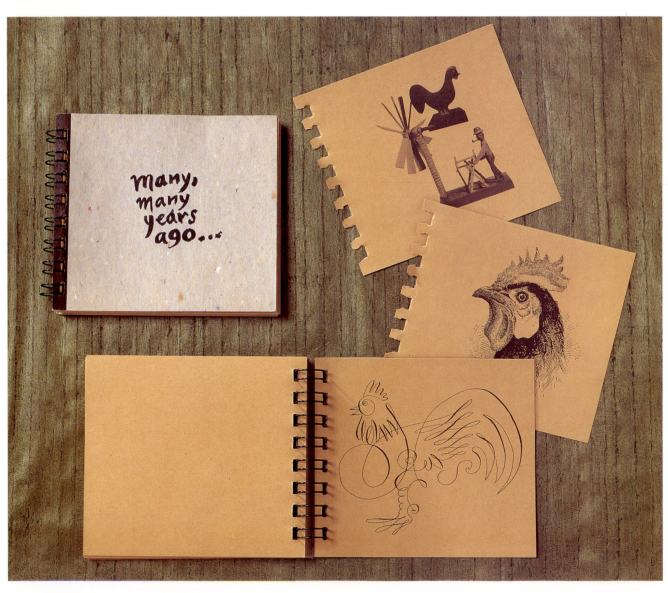

Holiday Booklet Celebrates World Religions

This brochure captures the spirit of the holidays by commemorating the religious celebrations that take place all over the world. Its copy describes Muslim, Jewish, Buddhist, Shinto and Hindu customs, and finishes with the Christian celebration of Christmas.

The booklet is printed in four-color process and four match colors on heavy, uncoated stock. Each page is french folded, so that the unfolded edges are bound. The booklet's cover combines type set in Futura with hand lettering and is offset printed on overrun stock donated by the printer. The binding was stitched by hand.

The booklet's outer wrapper is cut from French Dur-O-Tone. Before each booklet was inserted in its mailer, the outer wrapper was wrapped several times with green twine and taped in place by members of the David Carter Design staff. A press-apply sticker, printed with an illustration similar to those in the booklet, was affixed on top to conceal the tape.

The booklet was sent in its own custom mailer, manufactured from Strathmore Grandee Palacio.

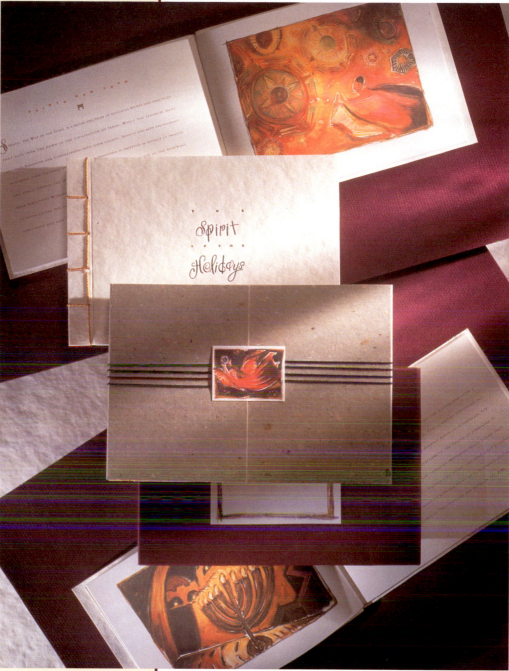

Design firm: David Carter Design Associates
Client: David Carter Design Associates
Art directors: David Carter, Lori B. Wilson
Designer: Brian Moss
Illustrator: Connie Connally
Materials: Gilbert Oxford (interior pages), Strathmore Grandee Palacio (mailer), Curtis Parchment Riblaid (flyleaves), French Dur-O-Tone (cover), twine
Printing method: Sheetfed offset
Quantity: 1,500

Holiday Stamps Showcase a Range of Illustration Techniques

As a holiday gift and greeting to clients and vendors, Chicago-based Pressley Jacobs Design, Inc. created this book of miniature illustrations in the form of a stamp book. Designers and illustrators who contributed to this promotion include twelve of the firm's staff members and four freelancers. The result is a rich mix of artistic styles and techniques.

To convey the look of a real stamp book, Pressley Jacobs had the art printed in four-color process on a gummed paper typically used for stamps. The stamp pages were perforated at tear lines and trimmed to 4¾" x 3" pages before they were side-stitched together and glue-bound into a foldover cover. A flyleaf of glassine was also bound into the booklet to further enhance the stamp book's authentic look.

The booklet's cover was affixed with a gummed stamp (ganged onto the four-color art for the other stamps) bearing only Pressley Jacob's name and the booklet's title. Additional copy bearing the firm's greeting and thanking contributors was printed

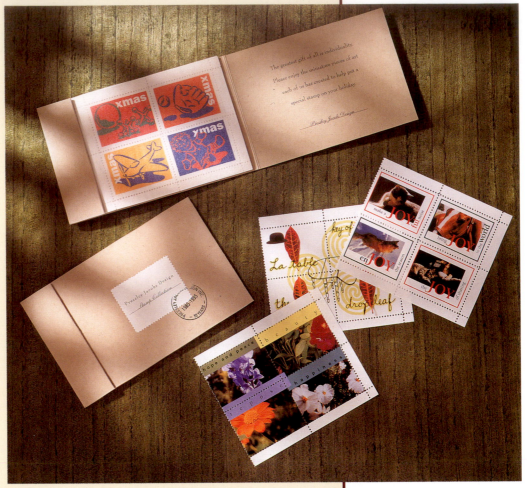

directly on the inner back cover.

In addition to gluing the gummed stamp to the cover of each stamp book, Pressley Jacobs staff members stamped each with a rubber stamp that simulates a cancellation mark. The stamp booklets were mailed in glassine envelopes purchased from a photo supply store.

Design firm: Pressley Jacobs Design, Inc.

Client: Pressley Jacobs Design, Inc.

Art directors: Craig Ward, Barb Bruch

Designers: Craig Ward, Bill Johnson, Mark Myers, Barb Bruch, Amy McCarter, Patrick Schab, Susie McQuiddy, Wendy Pressley-Jacobs, Saedene Yee, Kim Prickett, Jamie Gannon

Materials: French Dur-O-Tone (cover), Tro-Mark (interior pages), glassine sheets and envelopes

Printing method: Sheetfed offset

Quantity: 500

Holiday Flipbook Makes Merry

This holiday promotion uses the concept of a child's flipbook to make a greeting card that's as fun as it is creative.

Art director and firm principal Glyn Powell, of Dallas-based Powell Design Office, created three illustrations in oil pastel, one each of Santa, Rudolph and Frosty and had them printed on three separate panels of this gatefolded card. The card's two outer panels are slit in three spots so that portions of each face can flip back-and-forth. The head size and feature positioning is exactly the same on all three illustrations, so that eyes, noses, mouths and hats (or antlers, in the case of Rudolph) can be interchanged to make a new face.

The inscription, "What happens when Santa, Rudolph and Frosty put their heads together?" pulls together the card's playful concept. The card was printed on a glossy, coated cover stock in four-color process.

Design firm: Powell Design Office
Client: Powell Design Office
Art director: Glyn Powell
Designer: Glyn Powell
Illustrator: Glyn Powell
Materials: S.D. Warren Lustro gloss cover
Printing method: Sheetfed offset
Quantity: 1,000

Lavish Materials Make a Holiday Gift Special

For the 1994 holiday season, David Carter Design Associates gave clients and colleagues this gift of a holiday memento keeper. It's filled with pages for holding photos, recording holiday recipes, taking note of special events and tucking away precious keepsakes.

The book is actually a bound set of front and back covers that house a saddle stitched booklet. The last page of the booklet is tucked into a pocket on the interior back cover. The booklet showcases the capabilities of the design firm in its variety of stylistic interpretations and sensitive handling of typography and imagery.

The book's use of rich materials and finishing techniques achieves a lavish look that is very special. Its cover is made of binders board, wrapped with handmade paper from the Orient. The cover photo of candles is printed in four-color process and glued onto a debossed area on the cover. The book's cover inscription, foil-stamped in gold script, adds an additional layer of texture to the cover.

The book is bound with gold binder's tape and an elasticized black cord that holds the saddle stitched interior booklet in its cover. On the inside back cover, the cord's V-shaped configuration holds in place an envelope filled with picture corners. All of the work on the book's covers was accomplished by a book binder.

David Carter Design Associates spared no expense in the production of the book's mailer. Simpson Teton was used to construct a custom envelope that fits the exact dimensions of the book.

Design firm: David Carter Design Associates

Client: David Carter Design Associates

Art director: Lori B. Wilson

Designer: Lori B. Wilson

Photographer: John Katz

Materials: Simpson Starwhite Vicksburg (booklet), handmade paper (outer cover), Simpson Teton (envelope)

Printing method: Waterless lithography, foil stamping

Quantity: 1,500

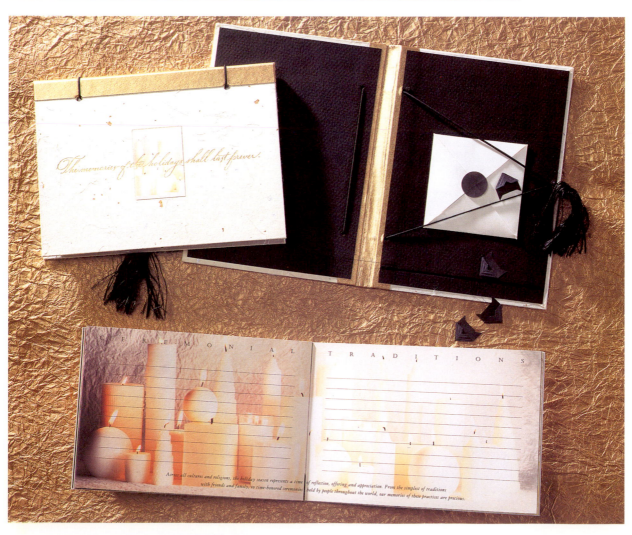

A Year of Recipes

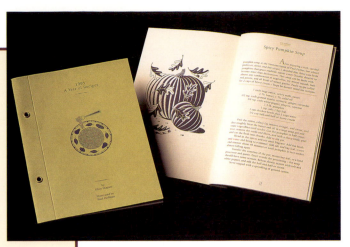

Shapiro Design Associates sought to satisfy the appetites of its clients, prospective clients, vendors and friends with this gift of a holiday cookbook. The book features twelve treasured recipes, one for each month of the year, that firm principal Ellen Shapiro has accumulated from family and friends over the years.

Each recipe in the twenty-eight-page book is flanked with a pen-and-ink illustration by Paul Hoffman and a personal anecdote related to the recipe. The book's two-color run in green and dark blue made it relatively inexpensive to produce five hundred grommet-bound copies.

"People called to chat about the recipes—how much they enjoyed the apple crisp, and so on," says Shapiro, describing the positive response the book received. In fact, the book's success prompted a related holiday gift the following year—jars of barbecue rub produced from one of the book's recipes. (The "not-yet-famous" barbecue rub is featured on page 70.)

Design firm: Shapiro Design Associates
Client: Shapiro Design Associates
Designer: Ellen Shapiro
Illustrator: Paul Hoffman

Materials: Mohawk Satin Leaf (cover), Mohawk Satin Cream White (text)
Printing method: Sheetfed offset
Quantity: 500

A Recipe Book With Hand-Lettering and Richly Textured Paper

This holiday recipe book's hands-on look and unusual, vertical format made it a memorable gift for clients and studio friends of Chicago-based Design Horizons, Intl.

The book is comprised of favorite recipes contributed by members of the firm's staff. Its pages are thematically linked by its red and green colors. For a personal touch, art director and designer Krista Ferdinand hand-lettered each recipe and embellished each with a small pen-and-ink illustration.

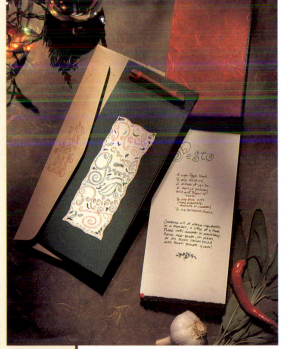

The recipe book's use of rich, handmade papers makes it special. Interior pages are of Strathmore Fiesta, a paper that is manufactured with a deckled edge. The pages were printed so that the deckled edge of the paper fell at the bottom of each page.

Design Horizons staff members hand-bound each book with a cover of dark green, uncoated stock and red flyleaf of a handmade Japanese paper. Red ribbon was looped through two holes drilled in the booklet and wrapped around a sprig of cinnamon to secure the pages and covers in place. Staff members also hand-trimmed pages with the book's title—which were printed on the same two-color run as the interior pages—and glued them to each recipe book's cover.

The recipe books were mailed in standard business envelopes of a tan color that complemented the book's natural look. The envelopes were rubber-stamped with the firm's return address and name rendered in the same script as the recipe book's copy.

Design firm: Design Horizons Intl.
Client: Design Horizons Intl.
Art director: Krista Ferdinand
Designer: Krista Ferdinand
Materials: Strathmore Grandee (cover), Strathmore Fiesta (interior pages), Japanese handmade paper (flyleaf), cinnamon sticks, red ribbon
Printing method: Sheetfed offset, rubber stamping
Quantity: 1,000

Angels Herald Joyous Greeting

Inspired by the story of the Christmas angel, Glyn Powell of Dallas-based Powell Design Office decided to create this holiday greeting celebrating angels.

He chose the format of a 9½" x 9½" booklet to showcase eleven pages of angel illustrations—each different in its attitude, style and rendering technique. Printed in four-color on dull-coated stock with touches of gold ink and glossy varnish, the book is a visually arresting collection of angels in all shapes and sizes.

The booklet is saddle stitched to include a flyleaf of flocked text-weight paper that carries the firm's holiday message, set in Caslon Open Face, a typeface with vintage charm. The booklet's cover matches the richness of its interior pages, printed with a golden halo against a moss green background. The interior portion of the cover is printed in solid black.

The angel book has had great success, in fact, some recipients have put it on their coffee tables every year during the holidays.

Design firm: Powell Design Office
Client: Powell Design Office
Art director: Glyn Powell
Designer: Glyn Powell
Illustrators: Glyn Powell, Richard Wilkes
Materials: Warren Lustro dull (interior), Hopper Cardigan (cover)
Printing method: Sheetfed offset
Quantity: 1,000

Holiday Promotion Encourages Recipients to Write Back

Chicago-based Mark Oldach Design sent out this holiday promotion to encourage recipients to share their thoughts on paper during the holiday season. The package included a pencil, a piece of note paper, a stamped envelope and a small booklet bearing the firm's message.

The promotion makes innovative use of a compact disc mailer by using the slot that would normally hold the CD to enclose the twelve-page booklet. For a personal look, Oldach hand-lettered the message and created loosely rendered illustrations to enhance the booklet's spontaneous feeling. On the cover of the mailer, a pencil with a rubber band looped around both ends holds the note paper and envelope in place.

Mark Oldach Design purchased the CD mailers from a packaging supplier. The booklet, envelope and note paper were printed in two colors on the same recycled stock. Oldach and his staff assembled the booklets and mailer contents in-house.

Many of the clients and studio friends who received the promotion did write back to Oldach and his staff thanking them for their thoughtful greeting.

Design firm: Mark Oldach Design
Client: Mark Oldach Design
Art director: Mark Oldach
Designer/Illustrator: Mark Oldach
Materials: Cross Pointe Genesis paper and matching envelopes, CD mailers, pencils, rubber bands
Printing method: Sheetfed offset
Quantity: 500

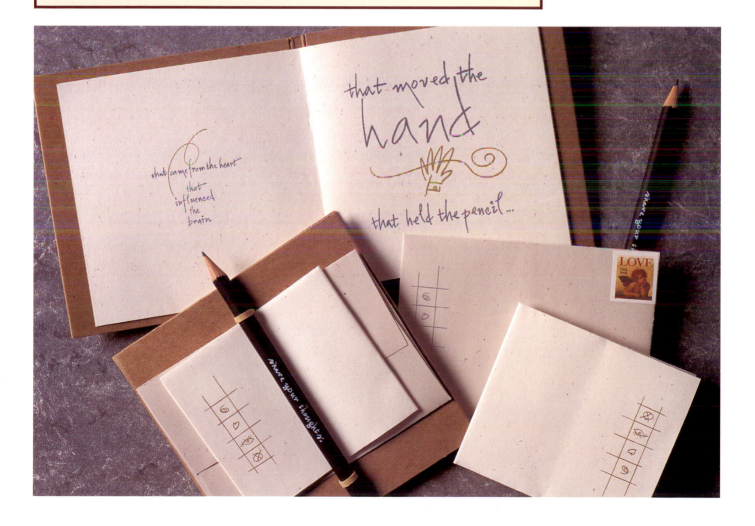

A Holiday Gift to Treasure Forever

This hand-crafted book served as Ultimo, Inc.'s 1993 holiday gift to clients and friends of the firm. The "Book of Hours" is actually a record book of life's great moments. "It starts with your birth," says firm principal Clare Ultimo. "It's meant to be a life history book of your family." The book offers pages for virtually all events that might happen throughout life.

The rich texture of the book's cover was achieved with hand-made paper made from bananas. The title and other cover graphics were letterpress printed in two colors.

Interior pages, decorated with whimsical illustrations, were printed in one color on a sheetfed offset press. The books were hand-bound by project manager, Shannon Rogan. To enhance the keepsake appeal of the books, Ultimo placed each one in a draw-string burlap bag.

The books were so well received, Ultimo has continued to produce more books as an ongoing retail project.

Design firm: Ultimo, Inc.

Client: Ultimo, Inc.

Art director: Clare Ultimo

Project manager: Shannon Rogan

Designers: Clare Ultimo, Adrienne Assaff, Susanne DiResta

Illustrator: Adrienne Assaff

Copywriter: Clare Ultimo

Editor: Christine Dimmick

Book binding: Shannon Rogan

Materials: Burlap, banana paper, chipboard, Beckett Concept Glacier Wove

Printing method: Letterpress, offset

Quantity: 125 hand-bound

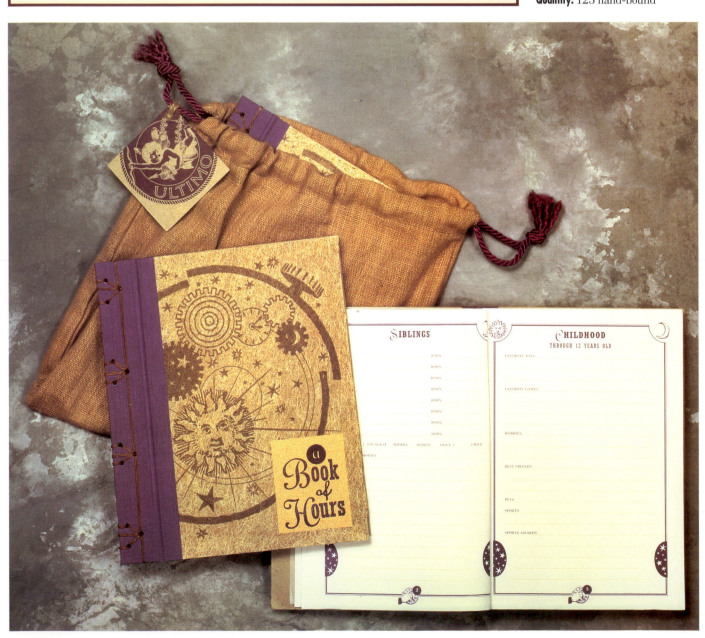

Holiday Greeting Incorporates Firm's Logo

Dallas-based Brainstorm, Inc. incorporates a symbol ot a vortex, much like a roughly drawn tornado, in its logo. So it was especially fitting for the design firm to use this symbol in a holiday greeting sent to current and prospective clients.

The firm used the vortex symbol to create icons of a star, plane, house, skater, horn and heart to represent the things that we encounter and cherish over the holidays: trimmings, travel, home, excursions, celebrations and friendships. The last page in this ten-page booklet pulls the booklet's theme together with the firm's greeting: "All of us at Brainstorm wish your trimmings, travels, surroundings, outings, celebrations and friendships are the warmest ever."

The booklet's limited palette of three match colors gives it a well coordinated, custom-designed look. To achieve bulk with such a limited number of pages, the booklet's pages are french-folded so that loose edges are bound and folded edges face outward. The pages are bound with thread-stitching. "Keepsake" status is conveyed through a jacket that wraps around the booklet's front and back covers, bearing the firm's vortex logo and the other icons printed on light green stock.

Design firm: Brainstorm, Inc.

Client: Brainstorm, Inc.

Art director: Chuck Johnson

Designer/Illustrator: Art Garcia

Materials: Champion Benefit (cover), French Dur-O-Tone (pages)

Printing method: Sheetfed offset

Quantity: 750

Stroke of Midnight Is Theme for New Year's Greeting

This unusual New Year's promotion uses midnight as a symbol and a way of gauging our sense of self as we go through life.

"Midnight December 31, Evermore" tells the story of how the passage into the new year might be regarded by individuals at different stages of life. The brochure plots points and attitudes at ages six, sixteen, twenty-six, forty-six and eighty-six, and tells the story of how each age group might typically regard staying up until midnight on New Year's Eve.

Photographic still lifes by photographer Anthony Arciero represent each life stage and appear opposite descriptive copy. The photos are dramatically enhanced by printing them as duotones in black and metallic mauve inks.

The promotion makes clever use of die cuts to convey its message and give the brochure multidimensional appeal. A clock—with its hands positioned at midnight—is printed on the back, inner portion of the booklet's wrap-around dust jacket, but it appears on every spread within a round die cut in the lower right portion of each page. On each left-hand page, a flower shows through the same round die cut of the booklet.

Design firm: Mark Oldach Design

Client: Mark Oldach Design

Art director: Mark Oldach

Designer: Mark Oldach

Copywriter: Linda Chryle

Photographer: Anthony Arciero

Materials: Simpson Evergreen (dust jacket), Reflections gloss text (interior)

Printing method: Sheetfed offset

Quantity: 1,000

Cookbook of the Stars Makes a Memorable Gift

This holiday recipe book is a follow-up to a successful cookbook promotion sent by Warner Bros. Records the previous year (see page 11). Both are titled "Holiday Favorites" and feature favorite recipes from Warner Bros.' recording artists. This 1994 greeting includes sixteen recipes from recording artists ranging from Madonna to Johnny Cash.

Designer Vittorio Costarella and Warner Bros. art director Jeri Heiden felt that such a diverse mix of personalities and recipes called for an upbeat, playful treatment. Costarella created whimsical illustrations for each recipe page in Adobe Illustrator, in many cases, personifying food items by adding faces and appendages.

The lively typeface used for the book's title was also drawn in Illustrator. A stitched outline around the cover graphics was added to give a bandanna-like look to the cover.

This saddle stitched booklet consists of sixteen pages plus front and back covers. It was run on an offset press in four-color process on a matte-finished, coated paper. The book was sent along with a refrigerator magnet, custom-made by a mail order marketing specialties firm from supplied art.

Design firm: Modern Dog
Client: Warner Bros. Records
Art director: Jeri Heiden, Warner Bros. Records
Designer/Illustrator: Vittorio Costarella
Materials: Simpson Evergreen Matte
Printing method: Sheetfed offset
Quantity: 10,000

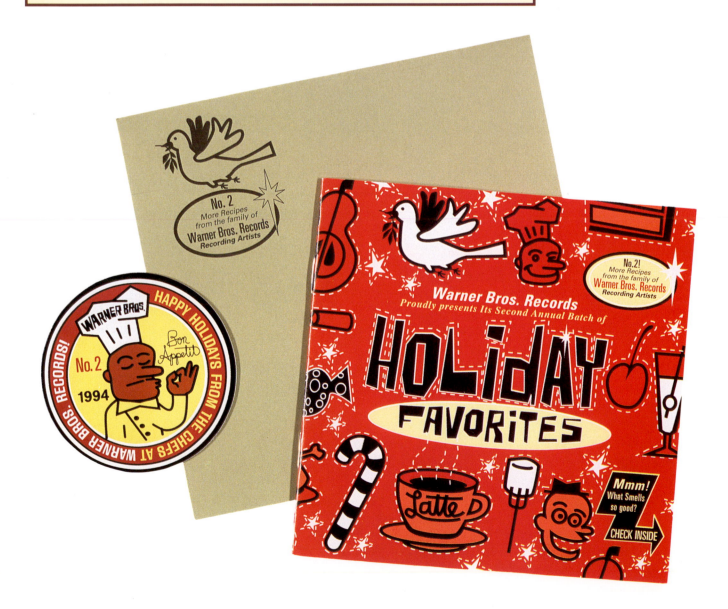

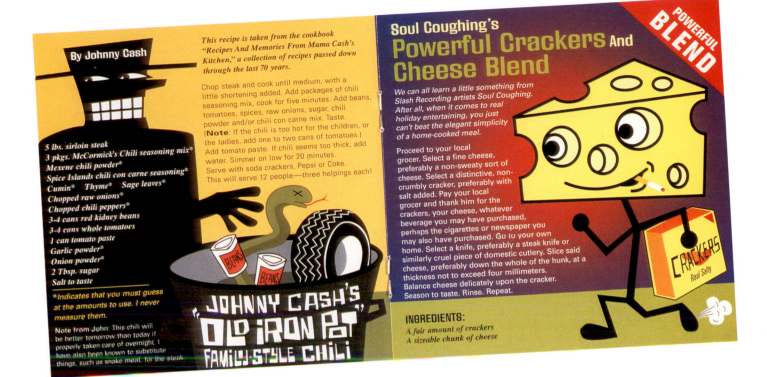

By Johnny Cash

This recipe is taken from the cookbook "Recipes And Memories From Mama Cash's Kitchen," a collection of recipes passed down through the last 70 years.

Chop steak and cook until medium, with a little shortening added. Add packages of chili seasoning mix, cook for five minutes. Add beans, tomatoes, spices, raw onions, sugar, chili powder and/or chili con carne mix. Taste. (**Note:** If the chili is too hot for the children, or the ladies, add one to two cans of tomatoes.) Add tomato paste. If chili seems too thick, add water. Simmer on low for 20 minutes.
Serve with soda crackers, Pepsi or Coke. This will serve 12 people—three helpings each!

5 lbs. sirloin steak
3 pkgs. McCormick's Chili seasoning mix*
Mexene chili powder*
Spice Islands chili con carne seasoning*
Cumin* Thyme* Sage leaves*
Chopped raw onions*
Chopped chili peppers*
3-4 cans red kidney beans
3-4 cans whole tomatoes
1 can tomato paste
Garlic powder*
Onion powder*
2 Tbsp. sugar
Salt to taste

*Indicates that you must guess at the amounts to use. I never measure them.

Note from John: This chili will be better tomorrow than today if properly taken care of overnight. I have also been known to substitute things, such as snake meat, for the steak.

JOHNNY CASH'S OLD IRON POT FAMILY STYLE CHILI

Soul Coughing's
Powerful Crackers And Cheese Blend

POWERFUL BLEND

We can all learn a little something from Slash Recording artists Soul Coughing. After all, when it comes to real holiday entertaining, you just can't beat the elegant simplicity of a home-cooked meal.

Proceed to your local grocer. Select a fine cheese, preferably a non-sweaty sort of cheese. Select a distinctive, non-crumbly cracker, preferably with salt added. Pay your local grocer and thank him for the crackers, your cheese, whatever beverage you may have purchased, perhaps the cigarettes or newspaper you may also have purchased. Go to your own home. Select a knife, preferably a steak knife or similarly cruel piece of domestic cutlery. Slice said cheese, preferably down the whole of the hunk, at a thickness not to exceed four millimeters. Balance cheese delicately upon the cracker. Season to taste. Rinse. Repeat.

INGREDIENTS:
A fair amount of crackers
A sizeable chunk of cheese

Cheap Trick's Zero Fat, No-Tomato, Bar-B-Que Sauce

Ingredients
2 cups brown sugar
1-1/2 cups grainy mustard
1/2 cup molasses
2/3 cup apple cider vinegar
3 Tbsp. dry mustard
4 tsp. kosher salt
1 tsp. fresh ground pepper
6 Tbsp. toasted sesame seeds (optional)

How do you spell Santa's Little Helper? Why, G-A-R-L-I-C

Preheat oven to 350°. Rub meat or vegetables with tons of garlic. Bake until cooked through, as follows: vegetables, 15-20 minutes; pork or beef, one hour; chicken, 35-50 minutes. To make sauce, bring all ingredients to a boil, then simmer. Dredge or baste meat or vegetables with half of the cooked sauce. On outdoor grill, grill until outside is carmelized. Repeat basting process. Grill 1-2 minutes more, then eat!

By Rick Neilsen of Cheap Trick

Madonna's
Cholesterol Cherry Torte

Madonna says: "This a recipe that has been in my family for years. The last time I made it, my brother, Christopher, had to run to my house to 'save the dessert.' He's a master at everything he does. Hate him. The current Ciccone Cherry Torte Champion is my sister, Melanie."

Crust:
2 cups flour
1/2 cup brown sugar
1 cup chopped pecans
1 cup butter or margarine
Mix ingredients and firmly pat down in a large baking dish. Bake at 400° about 15 minutes. Cool, then chop up the crust mixture and respread in the same pan.

Filling:
2 packages Dream Whip®
1 8 oz. package cream cheese
1 tsp. vanilla
1 cup powdered sugar
Cream filling ingredients together and spread on cooled crust.

Topping:
One can of cherry pie filling

Dollop each cherry individually onto cream filling about an inch apart. Refrigerate several hours, or overnight, and serve.

SECTION

2

Gifts and 3D
Promotions

Ginger Snap Treats Celebrate Year of the Dog

Boston-based PandaMonium Designs celebrated New Year's 1995 with this promotion commemorating the Chinese Year of the Dog. The package included a poster and a bag of bone-shaped cookies tagged with the firm's greeting. The promotion "begs" recipients to respond with phrases such as "Open Me" on the box and "Read Me" on the poster. The promotion gave the firm a chance to showcase a variety of design and production techniques and demonstrated its ability to pull them all together into a cohesive, well-designed package.

The doggie bones are actually gingersnap cookies inscribed with "Eat Me." Art director Raymond Yu located a local baker who was so tickled with the idea, that he baked the cookies free of charge. Locating an "Eat Me" die for stamping the cookies was more difficult. Yu finally purchased linoleum blocks from an art supply store and carved his own die for the cookie stamp. PandaMonium affixed a press-apply sticker to the cellophane wrapped cookies.

The four-color poster features a collage of dogs and tongue-in-cheek copy tied in with obedience commands. For instance, words such as "stay" are followed with, "staying ahead of the competition isn't easy." The posters were printed on a Heidelberg GTO-DI digital press on a glossy, coated paper. This printing option offers direct-to-press, four-color digital output for small quantities at a much lower cost than four-color offset.

The cookies were sent in a corrugated carton wrapped with a custom-designed label. What medium was used for illustration? The metallic "P" on the PandaMonium labels was created with Ray Dream AddDepth, a 3D drawing program.

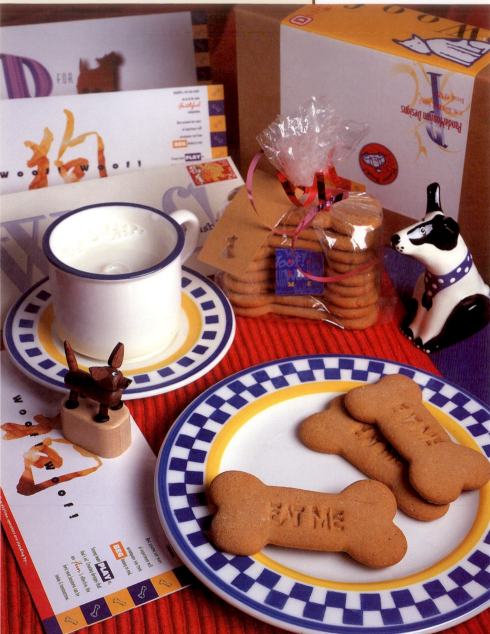

Design firm: PandaMonium Designs

Client: PandaMonium Designs

Art director: Raymond Yu

Designer: Raymond Yu

Photographer: Steven H. Lee

Materials: Corrugated box, S.D. Warren Patina (poster), Simpson Quest (gift tag), press-apply labels, cookies, ribbon, cellophane

Printing method: Offset, Heidelberg GTO-D1 digital press

Quantity: 500

A Rock & Roll Holiday

"We've never approached the holidays quite like anyone else," reads the inscription on this greeting from Powell Design Office.

The Dallas-based design firm put a "different spin" on their greeting by merging the names of recording industry giants with holiday traditions. For instance, an illustration of four dreidels is labeled "The Four Tops." Partying reindeer are depicted as "The Animals." The firm used a playful illustration style, rendered in oil pastel to complement the promotion's whimsical theme.

In all, eleven illustrations were created, each printed on its own 6¾" square of coated cover stock. The top card, which is printed to look like an old-fashioned 45 rpm record, brings back memories of the fifties and sixties.

The cards were printed in four-color process plus gold. They were slipped into an envelope die-cut on one side with a circle cut out in the center to resemble a record sleeve. The opposite side carried the address and postage.

Design firm: Powell Design Office
Client: Powell Design Office
Art director: Glyn Powell
Designer: Dorit Suffness
Illustrator: Glyn Powell
Materials: S.D. Warren Lustro Dull Cover (cards) and text weight (sleeve)
Printing method: Offset
Quantity: 1,000

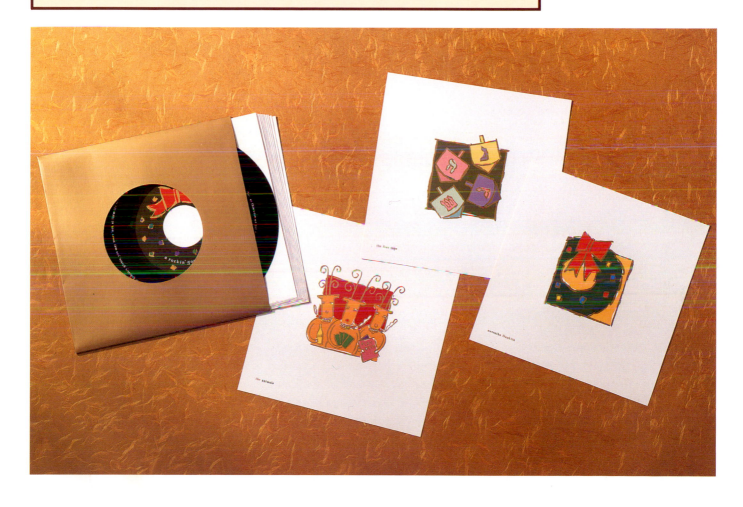

Animated Promotion Brings Snowman to Life

Courtney & Company's Snowman Kit contains step-by-step instructions plus everything you need to make a snowman.

The New York City-based design firm packaged a card with two black button "eyes" and a red "button nose," a corn cob pipe, an instruction sheet and disk in a gift-wrapped, chipboard box. The firm coordinated these items by designing item tags and a label for the box lid, all of which were printed on Courtney & Company's photocopier and applied by staff members.

After exploring the contents of the box and reading the instructions on how to build a snowman, recipients were instructed to insert the enclosed disk in their computers. The firm's animated greeting, a snowman rolling out of the chipboard box and coming to life to strains of Winter Wonderland, supports the promotion's tagline, "We bring your projects to life." The animation was created by firm principal Mark Courtney and designer Linda Baccari in Macromedia Director and StrataStudio Pro.

The promotion was hand delivered and mailed to current and prospective clients. "They all had a lot of fun with it," says art director Krista DeRuvo. "Opening a package full of 'toys' and using them for a game was a big hit with our clients."

Courtney & Company achieved a lot of impact for a minimal amount of money. Because the bulk of the design firm's energy was invested in creating the animation, Courtney & Company's only expenditures were for their purchase of buttons, boxes, floppy disks and giftwrap ribbon.

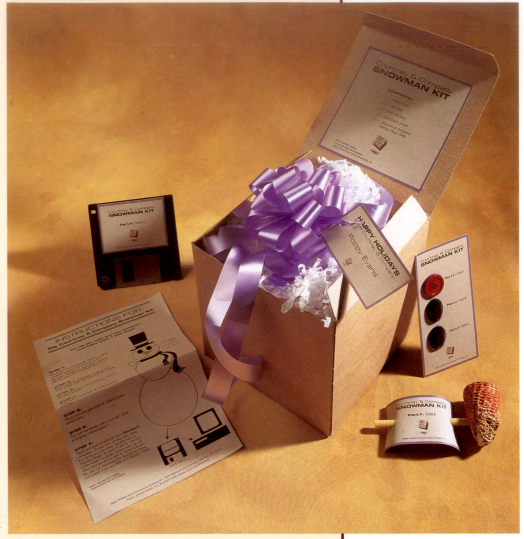

Design firm: Courtney & Company

Client: Courtney & Company

Art directors: Robert Adams, Krista N. DeRuvo

3D Rendering and animation: Linda Baccari

Multimedia presentation: Mark Courtney

Materials: Computer disks, chipboard boxes, giftwrap ribbon, Cross Pointe Genesis

Printing method: Photocopier

Quantity: 250

Holiday Wine & Gift Tag Promotion Satisfies Gift-Giving and Personal Needs

The Atlantic Group served its clients and studio friends well with this promotion. The firm sent each a set of gift tags and included a bottle of wine to be savored "when you've finished wrapping all your gifts."

This assortment of holiday items was artfully orchestrated into a well-coordinated package through the use of consistent typefaces and colors. Remedy, a distinctive typeface with a hand-drawn look, was used on the bottle label, greeting card and gift tags. To further achieve visual consistency, the design firm used the same four match colors on all three items. The job was economically printed by ganging all items on the same print run, but on two different papers: a cover stock for the card, and text weight for the bottle label and tags.

The gift tags were placed in glassine envelopes purchased from a photo supply store and glued to the inside of the accompanying card with instructions to "Tie one on!" Atlantic Group staff members stuffed the envelopes with the tags and glued the envelopes to the cards.

The design firm purchased bottles of commercially produced wine from a local retail outlet, removed the original labels, and affixed their own custom labels. The wine with its custom label has served as a year-round gift that the firm sends to preferred clients. "We designed the labels so they wouldn't look too seasonal," says art director Suzanne Cedro Haas. For the holidays, staff members wrap bottles in gold tissue and raffia to give them a festive look.

Design firm: The Atlantic Group
Client: The Atlantic Group
Art director: Suzanne Cedro Haas
Designer/Illustrator: Suzanne Cedro Haas
Materials: Champion Benefit, raffia, tissue paper, purchased wine, glassine envelopes
Printing method: Sheetfed offset
Quantity: 1,100

Custom-Packaged Christmas Chocolates

For a holiday gift, Ontario-based Aartvark Communications designed this custom-packaged box of Belgian truffles.

The container for the truffles is a triangular shaped box, designed by art director Jean-Luc Denat. Electronic files for the box's design were sent to a carton manufacturer who produced the cartons with their screenprinted box graphics.

The box illustration of Santa enjoying chocolates was hand-drawn in pen-and-ink by Danielle Monette and scanned into the computer. The box's background motif of pine needles and other images from nature was also drawn by Aartvark staff members.

The truffles were purchased from a local supplier and wrapped in cellophane by members of Aartvark's staff before they were inserted in each box. Most of the 250 boxes of candy were hand-delivered to Aartvark clients, staff and studio suppliers.

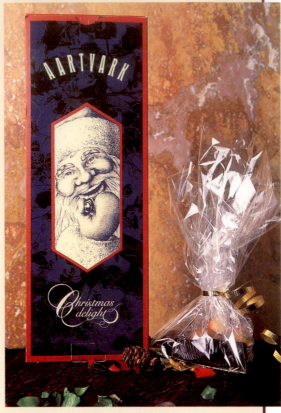

Design firm: Aartvark Communications
Client: Aartvark Communications
Art director: Jean-Luc Denat
Designer: Jean-Luc Denat
Illustrator: Danielle Monette
Materials: Manufactured carton, cellophane, ribbon
Printing method: Silkscreen
Quantity: 250

Dreaming of a Black-and-White Christmas

A compact disc of popular Christmas music recorded by Ella Fitzgerald helped to convey Paprika's holiday message of peace and harmony. The design firm purchased two hundred copies of the disc and custom packaged them to convey its own holiday message.

The Montreal-based design firm redesigned the CD's packaging to deliver their message. They took one of the CD cuts, "White Christmas" (Noël blanc) and contrasted it on the opposite side with Noël noir or "Black Christmas," accompanied by an illustration of Ella Fitzgerald rendered in watercolor.

The custom-made inserts for the CD package were run in four-color process on a conventional offset press.

The promotion's theme of celebrating diversity is an especially meaningful message for Paprika and its colleagues, who are situated in Montreal, a city revered for its multicultural diversity.

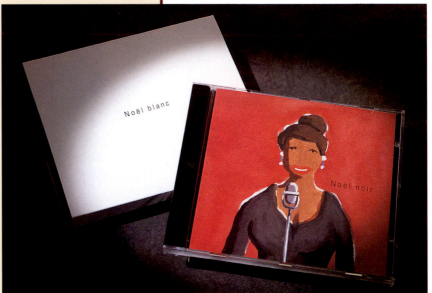

Design firm: Paprika
Client: Paprika
Art director: Louis Gagnon
Designer: Louis Gagnon
Illustrator: Drager
Materials: Condat Supreme Dull
Printing method: Offset
Quantity: 200

Hot Packaging for Holiday Lights

This attention-getting box with the hot-nosed reindeer contains a string of chili pepper lights. Sent by St. Louis-based Phoenix Creative to 150 clients and friends of the firm, the lights were spotted at a local retail establishment, and then purchased in bulk directly from their manufacturer in New Mexico.

Because Phoenix Creative specializes in package design, the firm designed the box for the lights and had a carton manufacturer produce the white, corrugated cartons.

The graphics for the boxes' labels were produced on the computer. The labels were printed in four colors plus a match color and then received a pass of aqueous varnish for a high-gloss finish. The press-apply labels were then sent to Phoenix Creative where staff members wrapped a label around each box.

The print run for the labels was piggybacked on a client's holiday promotion. As a result, the labels were printed for a fraction of what it would have cost had Phoenix Creative footed the bill for the entire job. Phoenix Creative incurred only the cost for the label plates and negatives, the manufacturing of the boxes and the cost of the lights.

Design firm: Phoenix Creative
Creative director: Eric Thoelke
Art director: Ed Mantels-Seeker
Design: Ed Mantels-Seeker
Copywriter: Ed Mantels-Seeker
Illustration: Mike Neville, Ed Mantels-Seeker
Materials: Custom-made boxes, chili pepper lights, Potlatch Quintessence Gloss
Printing method: Offset
Quantity: 150

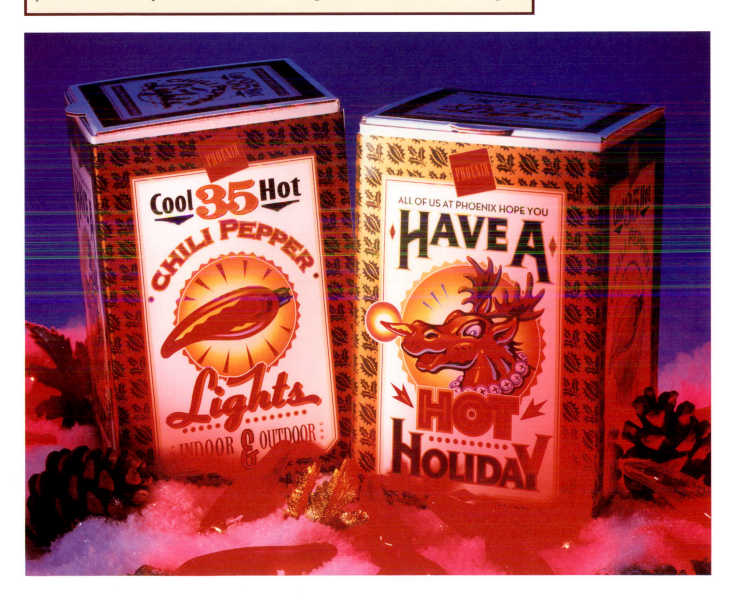

New Year's Mailer Celebrates With a Party-in-a-Tube

Dayton, Ohio-based Real Art Design intrigued and beguiled recipients to open this "Party-in-a-Tube." Contents include a 24" x 8" insert with cutouts, elastic string and instructions—for turning it into and wearing it as a party hat. Other items in the tube include a noisemaker and confetti.

The insert's party hat instructions include illustrations of how to wear the hat, includ-ing silly and fun options such as "The Bellhop," "The Feed Sack" and "No Face." The Real Art hat inscription and "Happy New Year!" headlines were hand drawn. Smaller copy was set in Template Gothic, a typeface with a raw, hand-rendered look. The insert was printed in silver and red on heavy, uncoated stock.

The design firm mailed the tube to five hundred clients, vendors and studio friends.

Design firm: Real Art Design Group, Inc.
Client: Real Art Design Group, Inc.
Art director: Chris Wire
Designer/Illustrator: Greg Tobias
Materials: Fox River Confetti, noisemakers, mailing tubes, confetti
Printing method: Sheetfed offset
Quantity: 500

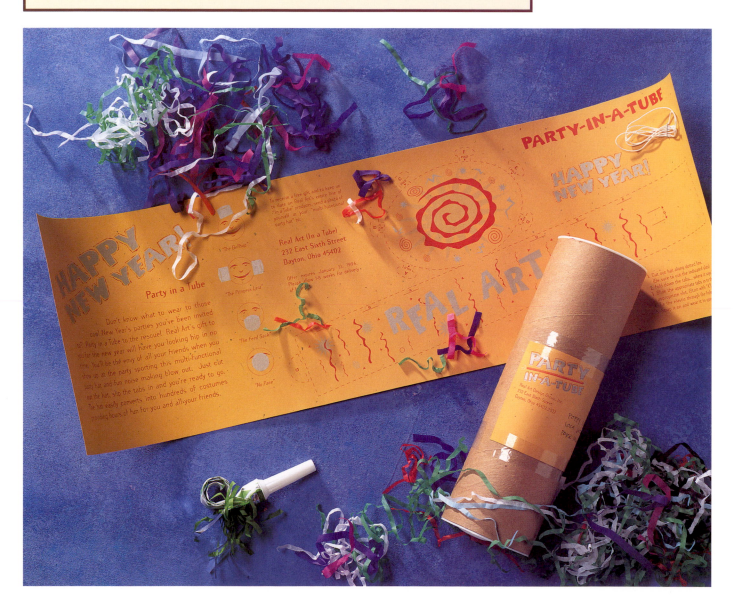

Design Firm Makes Its Own Baked Goodies

Albuquerque-based Vaughn Wedeen Creative likes to thank its clients and vendors with a holiday gift. For the 1993 holiday season, the firm chose to send this customized tin of home-baked cookies.

Each member of the Vaughn Wedeen staff contributed two hundred of their own home-baked cookies to the supply. The cookies are unique in that each is a visual representation of its name; for instance, Chocolate-Peanut Butter Cowboy Cookies are cut in the shape of cowboy hats. Each cookie tin was accompanied with a set of recipe cards—one for each type of cookie enclosed.

The firm designed its own label for the cookie tin, incorporating pen-and-ink drawings of the cookies and hand-lettered slogans. The labels were wrapped and glued by staff members onto aluminum cans normally used for packaging ink, purchased from an industrial container manufacturer. Each can was also filled with shredded corrugated paper.

The recipe cards and lid top repeat the graphic treatment used on the tin label, incorporating hand-lettering and whimsical illustrations. All of these items and the labels were all printed on the same three-color press run. The labels were affixed to tissue paper that was attached with jute twine to the top of each tin.

To keep the cookies fresh, Vaughn Wedeen staff members bundled them in foil bags and tied each bag with jute twine before placing the bags in their tins.

Design firm: Vaughn Wedeen Creative

Client: Vaughn Wedeen Creative

Art director: Rick Vaughn

Designers: Rick Vaughn, Nicky Ovitt

Illustrator: Nicky Ovitt

Materials: Ink cans, corrugated paper, French Speckletone, French Dur-O-Tone, jute twine, black tissue paper

Printing method: Sheetfed offset

Quantity: 200

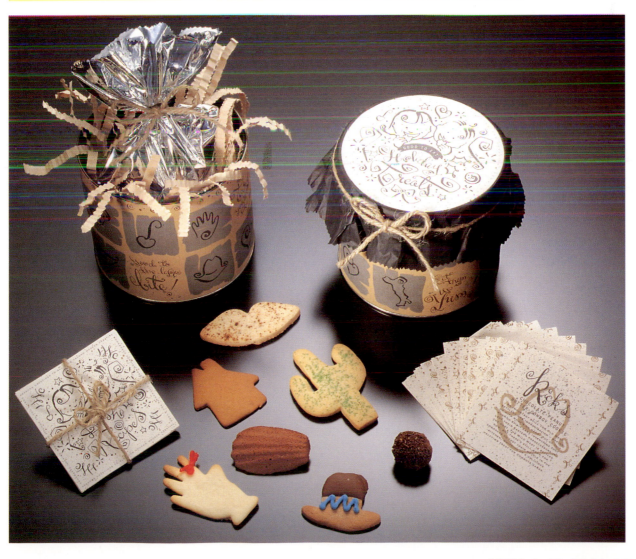

"Yulerule" Makes Cool Client Gift

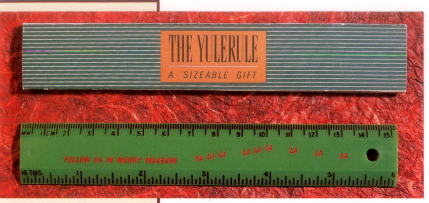

Over the years, Philadelphia-based Warkulwiz Design Associates has established a holiday tradition of sending its clients and studio friends a plastic gift. Their "Yulerule" continues this custom with a gift of a plastic ruler.

Warkulwiz ordered 750 green, six-inch rulers from a marketing specialties catalog and had them custom imprinted with the inscription, "Follow us in merry measure."

The custom ruler case was designed by Warkulwiz staffer Bill Smith, Jr., and printed on a coated cover stock in gold and forest green. The ruler cases were trimmed and scored at the fold lines at the printer, and then sent to Warkulwiz Design where staff members folded and glued each of the 750 cases.

Design firm: Warkulwiz Design Associates, Inc.

Client: Warkulwiz Design Associates, Inc.

Art director: Bob Warkulwiz

Designer: Bill Smith, Jr.

Materials: Champion Kromekote cover

Printing method: Sheetfed offset

Quantity: 750

Holiday Air Freshener

The Holiday "Sno Fresh'ner" that Warkulwiz Design Associates sent to clients and colleagues contains a white paper snowflake to be hung as an air freshener.

The six-sided foldover package, which itself resembles a snowflake, contains a die-cut snowflake with a hanging loop attached to the top. Touted as a "facsimile of nature's own crystal majesty," the paper snowflake is "perfect for home or car."

The snowflake and its package exemplify eco-friendly design. A minimal amount of ink was used to print the piece (two colors on one side of the packaging). Recycled paper with high postconsumer content was used for both the snowflake and its packaging.

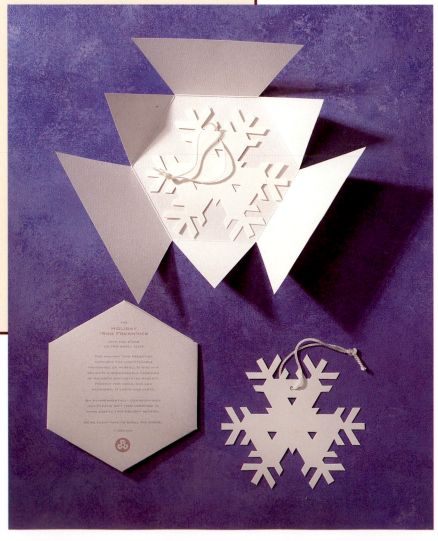

Design firm: Warkulwiz Design Associates, Inc.

Client: Warkulwiz Design Associates, Inc.

Art director: Bob Warkulwiz

Designer: Kirsten Engstrom

Illustrator: Bill Smith, Jr.

Materials: James River Retreeve (packaging), Mohawk Superfine (snowflake)

Printing method: Sheetfed offset

Quantity: 1,000

Gift Tag Promotion Encourages Holiday Giving

To encourage clients and studio friends to give generously over the holidays, Chicago-based Pressley Jacobs Design sent them this holiday greeting that includes eleven custom-designed gift tags.

Each of the firm's eleven designers designed their own tag, yielding a rich and varied assortment of design styles and rendering techniques. The individual cards were ganged onto the same four-color press run and trimmed to their finished, 2½" x 5" size, folding into a 2½" square. The firm chose a smooth, white uncoated paper rather than a coated stock so that it would be easy to write a message within each gift tag.

Pressley Jacobs staff members slotted a piece of string through a hole punched in the top of each gift tag and placed the assortment of tags in glassine envelopes purchased from a photo supply store. Before the envelopes were sealed for mailing, a card was inserted bearing the recipient's address label on one side, and the firm's holiday greeting on the opposite side.

Design firm: Pressley Jacobs Design, Inc.

Client: Pressley Jacobs Design, Inc.

Art director: Susie McQuiddy

Designers: Wendy Pressley-Jacobs, Jennifer Kahn, Jamie Gannon, Susie McQuiddy, Patrick Schab, Amy McCarter, Barb Bruch, Craig Ward, Mark Myers, Bill Johnson, Kim Prickett

Materials: Cougar Opaque, glassine envelopes

Printing method: Sheetfed offset

Quantity: 700

Halloween Mask Serves as Timely Illustrator's Promo

Illustrators have a hard enough time as it is trying to catch the attention of art directors with their promotional pieces. However, the flood of mail generated over the Christmas holidays can make it particularly hard to get noticed.

Illustrator Connie Helgeson-Moen has made a practice of sending her seasonally-themed promotions on holidays not ordinarily celebrated with a greeting or a promotional mailing. This mask, for example, was sent to prospective clients as a Halloween greeting.

To produce the promotion, Helgeson-Moen had 150 color photocopies made of her batik illustration of the devil. The relatively small quantity of her mailing made this a less-expensive option than four-color process. Each photocopy was spray-mounted to chipboard and then trimmed to mask-like dimensions. Holes were punched for ribbon ties.

Helgeson-Moen attached a tag to each mask with her greeting. Although the cards were printed on a photocopier, their red and white stickers bearing Helgeson-Moen's logo give the impression of a three-color run.

Design firm: Connie Helgeson-Moen/Batik Illustration

Art director: Connie Helgeson-Moen

Client: Connie Helgeson-Moen/Batik Illustration

Illustrator: Connie Helgeson-Moen

Materials: Red satin ribbon, Simpson Quest (hang tag)

Printing method: Black-and-white and color photocopiers

Quantity: 150

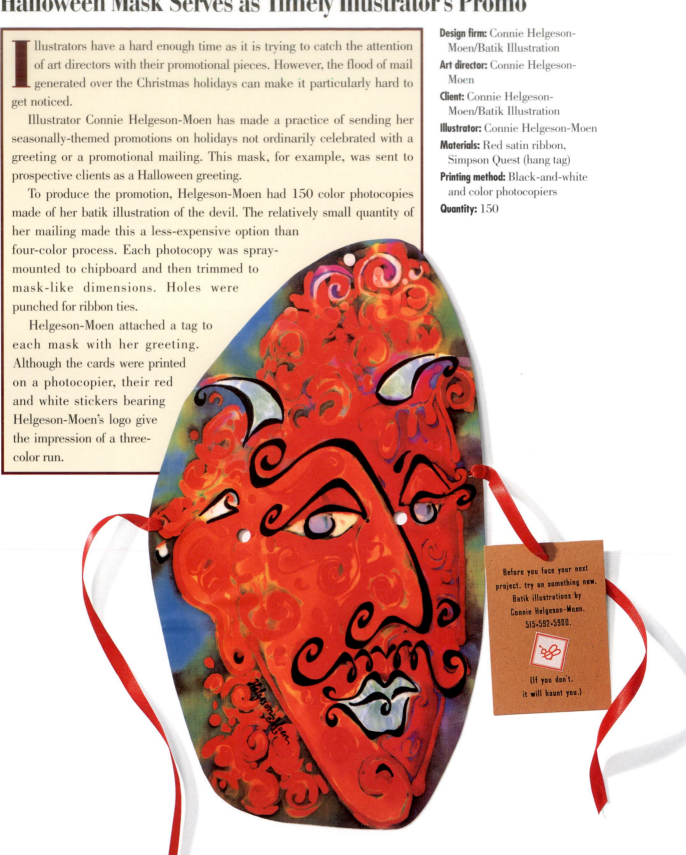

Before you face your next project, try on something new. Batik illustrations by Connie Helgeson-Moen. 515•592•5900.

(If you don't, it will haunt you.)

Talkin' Turkey

This Thanksgiving Day promotion, created by New York City-based Pisarkiewicz & Company, uses an authentic wooden turkey caller to make its point about effective communication.

Pisarkiewicz & Company purchased the turkey callers from a classified ad spotted in a hunting magazine and sent them to current and prospective clients as part of a coordinated package of materials. In addition to the turkey caller, the mailing included two cards, tags and custom labels that were pasted to the outside of each turkey caller's shipping box. The firm used rubber stamps to stamp a "Happy Thanksgiving" message on each turkey caller.

Although this promotion includes many components, its production was kept relatively inexpensive by printing all materials on the studio's laser printer. As an added bonus, the vintage clips of turkeys and other images appeared more authentic in black-and-white, and printing them on flocked recycled paper helped to complement the rustic look of the wooden turkey caller and its box. Pisarkiewicz staffers tore the edges of the illustrations before gluing them to the sides of each mailing box to further enhance the promotion's raw, natural look.

The illustrations on the box intrigued recipients to the point where they were quick to open it. Pisarkiewicz & Company also benefited from sending a Thanksgiving rather than a Christmas greeting. "We were able to get a jump on the holidays," says Pisarkiewicz designer Jennifer Marenberg.

Design firm: Pisarkiewicz & Company

Client: Pisarkiewicz & Company

Art director: Mary F. Pisarkiewicz

Designers: Mary F. Pisarkiewicz, Andrew Geroski

Materials: Gilbert Esse, Fox River Confetti

Printing method: Laser, rubber stamping

Quantity: 200

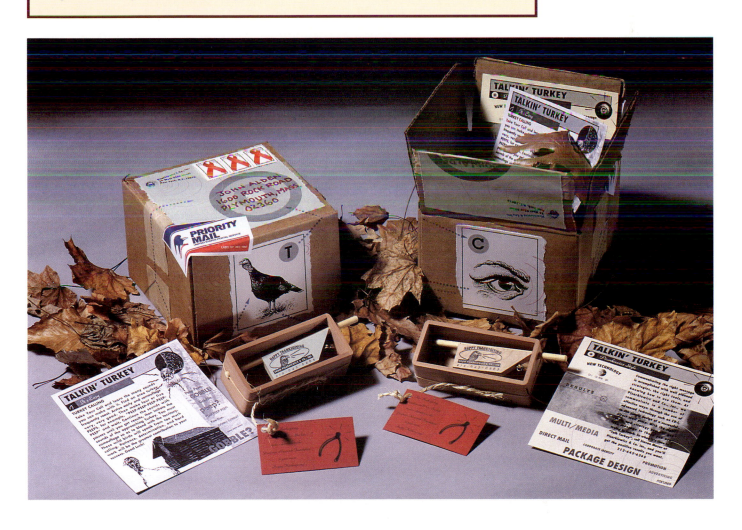

Gift of Parts Inspires Creativity

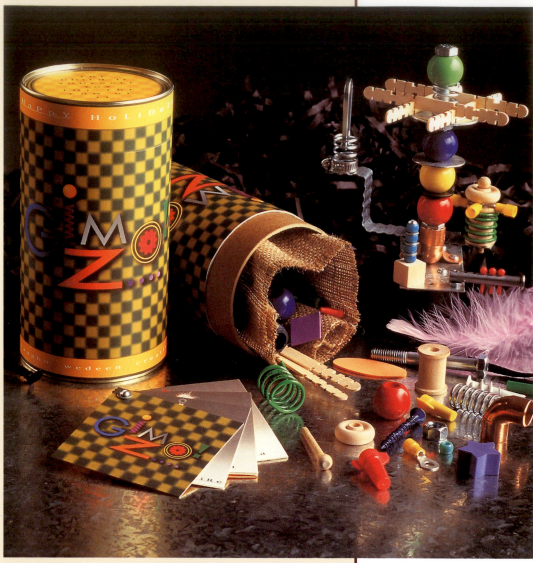

Clients and studio friends of Vaughn Wedeen Creative were prompted to ask, "What is it?" when they opened this assortment of nuts and bolts and various other items.

The Albuquerque-based design firm sent this package of parts as a holiday gift with the hope that recipients would use them to fashion their own unique toy. As inspiration, the design firm included a booklet showing examples of what could be constructed—actual toys that were made by members of the firm's design staff. The toys were photographed and printed one-per-page in four-color, with pages bound together with a screw and nut in one corner of the booklet cover. Vaughn Wedeen staff members did the binding in-house, as well as the hand assembly work the piece required.

Vaughn Wedeen Creative gave their collection of parts the name of "Gizmo" and designed a label and lid top for the the container that incorporates the same design motif used on the booklet cover. The container is actually a mailing tube with a metal top and bottom to which labels were glued. Before the parts were packaged in each can, they were placed in a burlap bag purchased from a cloth bag manufacturer. Vaughn Wedeen had each bag screen printed with the Gizmo name.

Firm principal Rick Vaughn says one of the biggest challenges in creating this promotion was finding and deciding upon the parts that would be included. "We scoured craft stores, building supply and hardware stores and plumbing and electrical supply outlets," he relates. "Hours were spent in deliberation over which pieces would make the final cut and become a part of the official Gizmo parts bag."

Design firm: Vaughn Wedeen Creative

Client: Vaughn Wedeen Creative

Art director: Rick Vaughn

Designer: Rick Vaughn

Illustrators: Rick Vaughn, Chip Wyly

Photographer: David Nufer

Materials: Simpson Starwhite Vicksburg, parts assortment, burlap bags, mailing tubes

Printing method: Sheetfed offset, silkscreen

Quantity: 200

A Holiday Meal for the Home-Bound

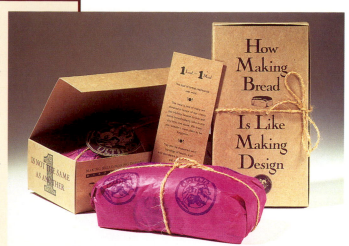

A loaf of banana/chocolate chip bread, fresh from the bakery, did more than satisfy the appetites of Ultimo, Inc.'s clients and friends—it was also a reminder of the need to feed the sick and home-bound elderly people living in their community. In this case, the Isaacs Center Meals on Wheels program was the beneficiary of a free meal, donated by Ultimo, on behalf of each of the promotion's recipients.

Clare Ultimo, principal of New York City-based Ultimo, Inc., has made a habit of helping non-profit causes with her firm's holiday promotions. "We find a not-for-profit group whose work relates to the concept of the piece, and we publicize their efforts," says Ultimo. "Our friends and clients can learn something about the group and contact them if they choose."

Chipboard boxes were printed in two colors on a sheetfed offset press, die cut and then assembled into boxes at Ultimo's studio. Each loaf was then wrapped in a purple tissue paper printed with a rubber stamp of the Ultimo logo. Ultimo continues to fill leftover boxes with cookies and other goodies to use as new client gifts.

Design firm: Ultimo, Inc.
Client: Ultimo, Inc.
Art director: Clare Ultimo
Designers: Clare Ultimo, Joanne Oborowski, Julie Hubner
Copywriter: Clare Ultimo
Materials: Chipboard, tissue paper
Printing method: Sheetfed offset, rubber stamping
Quantity: 300

T-Shirt Gets Eco-Friendly Gift Wrap

F or the 1994 holiday season, Aartvark Communications gave clients and studio friends this custom-designed and packaged T-shirt. In addition to designing a handsome package for the shirt, the design firm used eco-friendly materials in its production.

Shirts were shipped in natural, chipboard boxes, salvaged from a paper merchant. The boxes were left over from a previous job and were destined for the trash heap before Aartvark rescued them. Each box lid is decorated with cotton ribbon, a piece of corrugated cardboard and the triangular "Aartware" icon the firm uses to identify items from its own gift line.

The T-shirt is 100 percent cotton and is screen printed in three colors. A collage of famous art figures from works by Matisse, Dali, Gaughin and other well-known artists serves as a backdrop for the Aartvark logo. Each shirt was tagged with a numbered certificate bearing the Aartware logo. The tag and the Aartware logo that appears on the box lid were screen printed on a paper with a high recycled content.

Aartvark also enclosed a certificate of authenticity with each shirt, printed on Neenah UV/Ultra II, a translucent vellum with opaque stripes. The assembly of all components of the piece was done in-house by Aartvark staff.

Because all papers and materials used in this promotion were natural and recycled, the promotion's recipients were not only appreciative of their gifts—they also became aware of the firm's environmental concern.

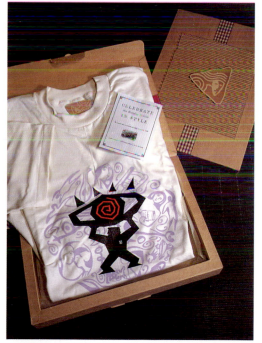

Design firm: Aartvark Communications
Client: Aartvark Communications
Art director: Jean-Luc Denat
Designer: Jean-Luc Denat
Materials: Chipboard box with lid, cotton T-shirt, Neenah UV/Ultra II, Domtar Naturals, jute twine, Neenah Classic Laid, corrugated cardboard, cotton ribbon
Printing method: Silkscreen, sheetfed offset
Quantity: 250

Prayer Cards Make Unforgettable Holiday Greeting

Unlike most printers, Diversified Graphics has made a habit of producing holiday and seasonal promotions that involve very little printing. "We have so many printed samples of our work," says specialty printing manager Lisa Henkemeyer, "we try to do something tactile and hands-on for special occasions."

This folder of prayer cards exemplifies the printer's penchant for producing holiday promotions with a hand-crafted look that sets Diversified apart from other printers. The idea of using prayer cards came to Henkemeyer when she found a large quantity of them at a surplus store. The cards were sorted into packets of nine and wrapped with glassine and gold twine. The cross charms tied to the card packs were purchased in bulk from a local craft supply store.

The folders are made from two pieces of binders board, which are held together with gold book binding. On the cover of each folder, Henkemeyer pasted down a printed photo, clipped from an old art history book.

Before closing each folder, Henkemeyer inserted a personal greeting written on a piece of translucent vellum and then looped black cord through drilled holes as a closure. Each folder was then mailed in its own glassine envelope sealed with a copper tape purchased from a stained glass supply house.

Design firm: Diversified Graphics
Client: Diversified Graphics
Art director: Lisa Henkemeyer
Designer: Lisa Henkemeyer
Materials: Binders board, metallic gold tissue, black cord, glassine envelopes, copper tape
Printing method: None
Quantity: 100

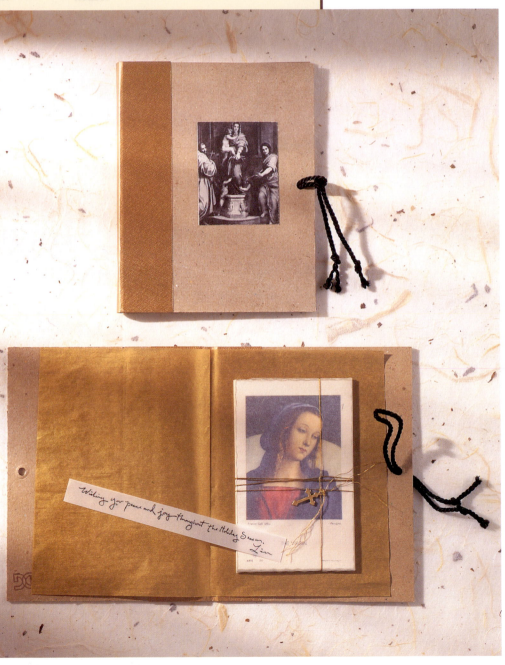

A Gift of Holiday Recipes From Around the World

Dallas-based David Carter Design Associates chose to share this gift of holiday recipes from around the world with its international clients and associates. In addition to the recipes, the design firm also enclosed an invitation to a holiday open house for an evening of culinary specialties from around the world.

Each recipe card features a dish from one of seven locations: France, Great Britain, Poland, South America, Africa, China and the United States. A representative visual, showing how the holidays are celebrated in each country, appears on the front of each card. The cards were printed in four-color process on one side, and a match color on the opposite side. David Carter Design

Associates pulled from the talents of many freelance illustrators and photographers to create these visuals, as well as the collage of holiday memorabilia that appears on the outside of the recipe holder.

The collage of colorful holiday items was printed in four-color process on French Speckletone. It was then sent to a book binder where it was glued to three pieces of binders board to form a front, back and spine for the recipe holder. An accordion-folded pocket was glued to the inside to form slots for each of the cards and the invitation.

Before each recipe holder was tied shut, a tag bearing the firm's holiday greeting was attached to its ribbon closure.

Design firm: David Carter Design Associates

Client: David Carter Design Associates

Creative directors: David Carter, Lori B. Wilson

Designer: Sharon LeJeune

Illustrators: Michael Crampton, Lynn Rowe Reed, Connie Connally, Rick Smith

Photographers: Grace Knott, Dick Patrick, Neal Farris, Ben Britt

Materials: Binders board, French Speckletone (recipe holder, tag), Simpson Starwhite Vicksburg (cards), satin ribbon

Printing method: Offset

Quantity: 1,000

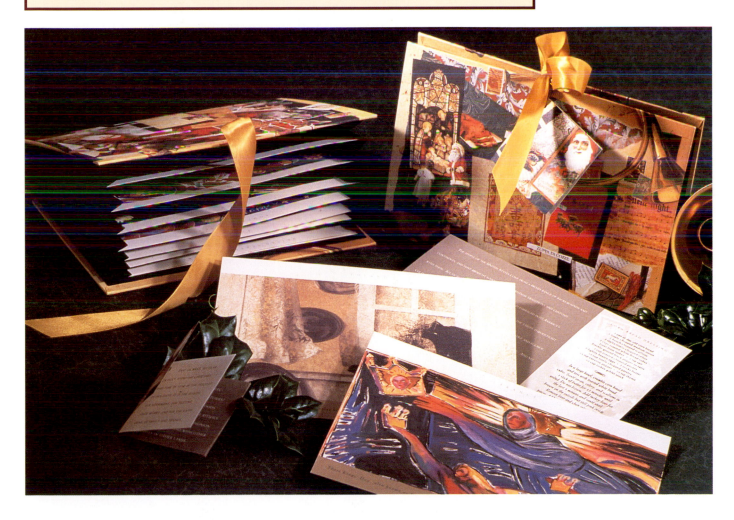

A Dozen Red Roses for Valentine's Day

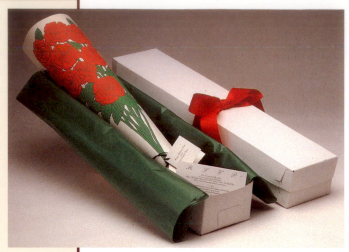

To show appreciation for clients and to help generate additional business, The Pushpin Group sent a dozen red roses to current and prospective clients just prior to Valentine's Day. Nearly three hundred ribbon-bedecked boxes of "roses" were hand-delivered to businesses all over the New York City area. However, when the boxes were opened, recipients discovered an illustrated bouquet of paper roses and an invitation from the illustrators' group to a special Valentine's Day luncheon.

The bouquet illustration was printed with two match colors on white, uncoated stock. Each printed illustration was hand-rolled and inserted in a white box lined with green florist's paper. The boxes were assembled at Pushpin Group's studio and tied with red ribbon to create the look of a florist's delivery.

The mailing did a good job of getting the attention of its recipients. The luncheon attracted a capacity crowd of sixty guests.

Design firm: The Pushpin Group, Inc.
Client: The Pushpin Group, Inc.
Designer: William Berington
Illustrator: Seymour Chwast
Materials: Florist's box, green florist's paper, satin ribbon, uncoated paper
Printing method: Sheetfed offset
Quantity: 300

Christmas Lantern Lights Up the Holidays

Montreal-based Paprika used the 1995 holiday season as an opportunity to send this very special aluminum lantern as a gift to clients. The lanterns were purchased wholesale directly from the manufacturer and engraved with "Paprika" by a local engraver.

The lantern boxes were constructed by a local carton manufacturer in a way that allowed the looped handle on the top of the lantern to emerge through a hole in the top of the box. The boxes are bottomless, and just slip over the top of each lantern. Each box was laminated with a sheet of Fox River Confetti that was foil-stamped with the firm's holiday greeting.

Paprika also inserted a rolled card within each lantern handle to carry its holiday message. The cards were also printed on Confetti in two match colors.

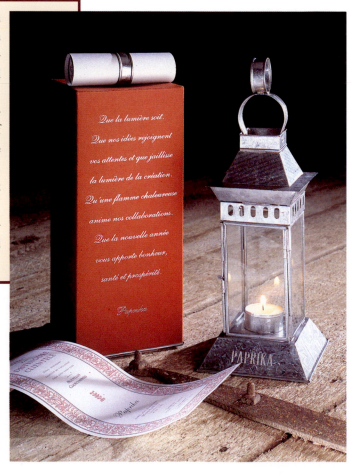

Design firm: Paprika
Client: Paprika
Art director: Louis Gagnon
Designers: Louis Gagnon, Francis Turgeon
Materials: Fox River Confetti Cover, purchased aluminum lanterns
Printing method: Offset (card), foil stamping (box), engraving (lantern)
Quantity: 150

Honey Makes a Sweet Holiday Gift

To celebrate New Year's 1996, New York City-based Pisarkiewicz & Company sent this custom-designed package of honey as a gift to clients and studio friends.

The design firm came up with the idea when it decided to make holiday donations to Meals On Wheels, an organization that delivers wholesome meals to the elderly. The tag attached to the package tells the story of an elderly woman who's shut-in and how she savors the honey in her tea, bringing sweetness to her life and a reminder of all things good. It also lets the recipient know that a donation was made to Meals On Wheels in the recipient's name.

Pisarkiewicz & Company purchased the bottled and boxed honey from a wholesaler and created its own bottle labels. The labels and tag illustrations bearing the image of the face and bee were created on the computer by manipulating clip art and adding an original illustration of a bee. The design firm ganged the labels and tags onto a single sheet and had them printed at a service bureau. Pisarkiewicz staff members hand-trimmed the labels and tags and did the other hand assembly work required to ready the piece for mailing. The promotions were padded with bubble wrap and shipped to current and prospective clients and studio friends in a cardboard box.

Design firm: Pisarkiewicz & Company
Client: Pisarkiewicz & Company
Art director: Mary F. Pisarkiewicz
Designers: Ann Marie O'Brien, Jennifer Harenberg, Nat Estes
Materials: Adhesive-back stock, 60-lb. bristol board, jute twine, bottles, wooden box
Printing method: Digital printer
Quantity: 300

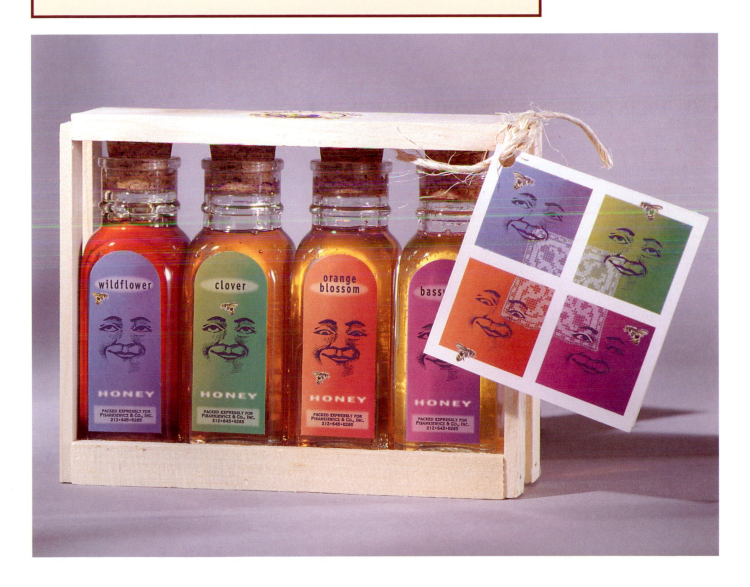

Sophisticated Print Campaign Celebrates Year of the Pig

Boston-based PandaMonium Designs has made a holiday tradition of sending a promotion that celebrates the Chinese New Year. For 1996, the firm sent its clients two posters and a custom-packaged flip book to celebrate the Year of the Pig.

To kick off the Year of the Pig campaign, a poster was sent at the beginning of the year as a New Year's greeting. The poster was folded to fit in a 6" x 6" envelope with a stamp affixed commemorating the Year of the Pig. The second poster was sent at the close of the year along with a gift of a flipbook. Both posters were printed in four-color process on coated stock and incorporate a collage of pig-related imagery, both original and borrowed, including a sketch of a flying pig.

The flipbook is a series of playful sketches of a flying pig. Each of the 124 pages is set up so that when the book is flipped, the pig becomes animated, flapping its wings and flying in circles. The book's covers are made from corrugated cardboard. Its pages were printed on a 600 dpi photocopier from PandaMonium's originals. The books were drilled and bound with screws by members of PandaMonium's staff. PandaMonium also enclosed a greeting card thanking clients for their patronage.

In addition to the posters and flipbook, this comprehensive campaign included custom stickers, envelopes and other shipping materials. The high level of craftsmanship and attention to detail demonstrated to clients that PandaMonium could take a thematic promotion and successfully carry it through a series of communication vehicles.

Design firm: PandaMonium Designs

Client: PandaMonium Designs

Art director: Raymond Yu

Designer: Raymond Yu

Illustrators: Steven H. Lee, Sue-An Tsan

Photographer: Steven H. Lee

Materials: Corrugated cardboard, Strathmore Elements (belly band), Simpson Evergreen (greeting card), laser-compatible bond, Condat Supreme Gloss (posters)

Printing methods: Offset, Heidelberg GTO-D1, photocopier

Quantity: 1,000

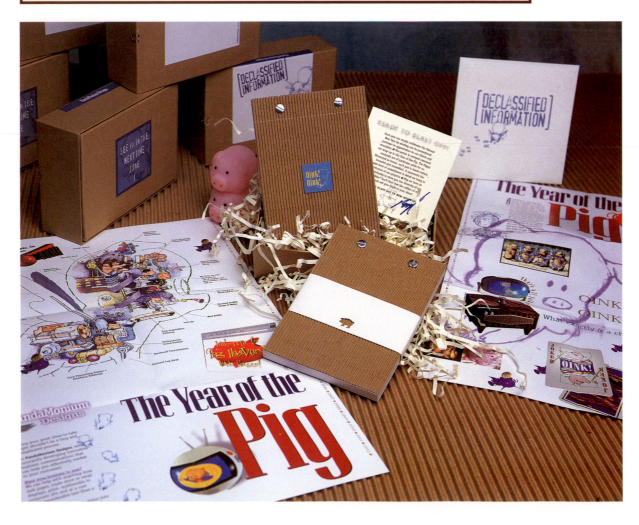

Gift Tags Ride for Free

As a holiday gift for clients and studio suppliers, Vrontikis Design Office created these holiday gift tags, custom-packaged in their own box.

The Vrontikis staff worked on the cards throughout the year, piggybacking them onto the wasted trim of client jobs. This way, they were able to get the gift tags printed for free, and the tag selection includes a broader assortment of colors and textures as a result of the different paper stocks involved.

The inside of the box is printed in two colors with the firm's holiday message. The box is made from a duplex stock, so the inside of the box is white, while the outside is a bright, geranium color. After the stock was die cut into a box configuration, firm principal Petrula Vrontikis and her staff hand-folded each box and filled each with an assortment of gift tags. The boxes were also packed with a loop of corrugated cardboard to contain the tags.

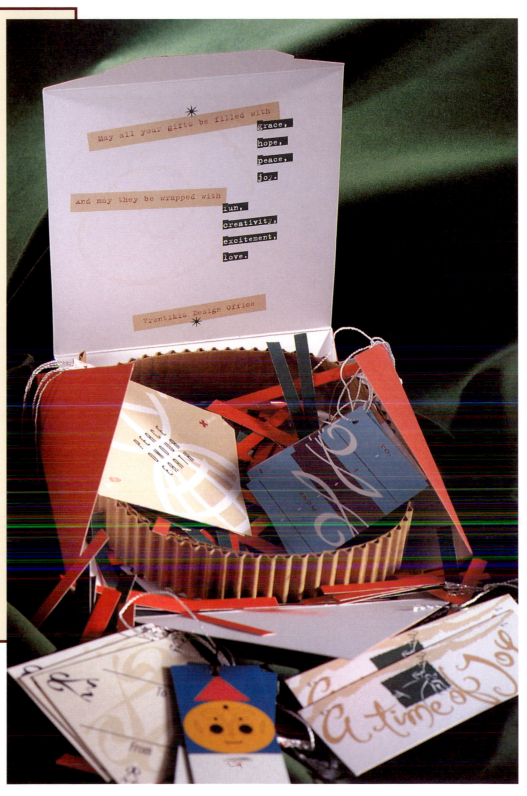

Design firm: Vrontikis Design Office

Client: Vrontikis Design Office

Art director: Petrula Vrontikis

Designer: Petrula Vrontikis

Copywriter: Kirsten Livingston

Materials: Neenah Environment (box), various (tags)

Printing method: Sheetfed offset

Quantity: 500

Agent X-Mas Badge Makes Unforgettable Gift

This "Agent X-Mas" badge was sent to clients and studio friends of Warkulwiz Design Associates. The design firm purchased custom-made badges from a badge manufacturer and furnished artwork for the Lenin image used in the center of the badge and on the cover of its vinyl case. The vinyl case was foil stamped with the Lenin image.

Warkulwiz designers further customized the badge and gave it a festive, Christmasy look by attaching it to a piece of coated card stock printed with a red-and-green *X* motif and inserting it within the badge case. The same card stock was also used for the red, black and green pattern that appears on the badge case's outer packaging.

Warkulwiz Design Associates has faithfully produced a seasonal promotion every year since the firm's inception. In fact, when the holidays approach, the studio's staff looks forward to designing yet another holiday promotion. "This is the one time of the year when we can really cut loose," states staff illustrator and designer Mike Rogalski.

Design firm: Warkulwiz Design Associates, Inc.
Client: Warkulwiz Design Associates, Inc.
Art director: Bob Warkulwiz
Designer: Matt Tullis
Illustrator: Mike Rogalski
Materials: Vinyl badge case, Warren Lustro Gloss Cover
Printing method: Sheetfed offset
Quantity: 1,000

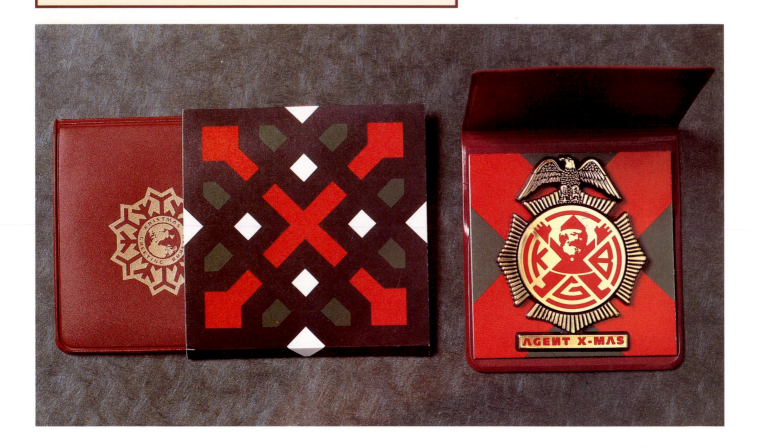

T-Shirt Gift Reinforces Design Firm's Identity

Rochester, New York-based K² Design incorporated its logo into this custom-designed T-shirt, which was a holiday gift to the studio's clients. The firm's distinctive mark, with its large *K*, was worked into a gear and clock motif made of modular units that could be broken down and reconfigured for each component of the T-shirt package.

The firm's T-shirt is screen printed with its holiday design in gold, aqua and black. Variations of the same design were printed on an accompanying 4" x 5" greeting card and gift tag in the same colors, plus purple,

on a light green, uncoated stock. The phrase, "It's That Time of Year," set in Brush Script, was used on the gift tag to support the gift's seasonal theme. A folder of illustration samples was also included in the package, printed on the same print run as the other items, and on the same uncoated stock.

The holiday mailing not only demonstrates how well K² Design can pull together a package of dissimilar printed items with the same graphic elements, but it also reinforces the firm's identity in the minds of its clients by subtly repeating elements of their logo.

Design firm: K² Design
Client: K² Design
Art directors: Claire Kaler, Kurt Ketchum
Designers: Claire Kaler, Kurt Ketchum
Illustrator: Kurt Ketchum
Materials: Cross Pointe Genesis, cotton T-shirts
Printing method: Sheetfed offset, silkscreen printing
Quantity: 500

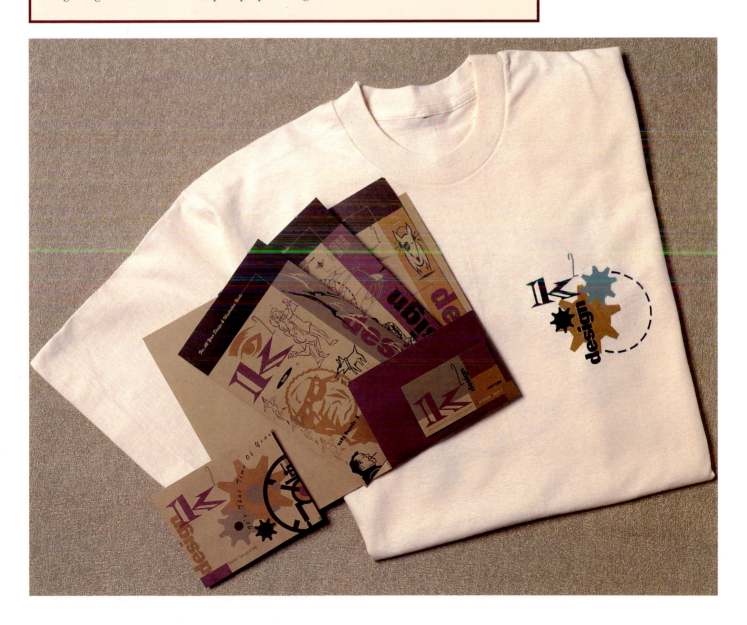

L.A. Firm Gives Gift of Its Own Designer Shirts

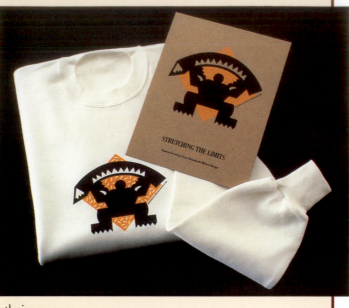

As a holiday greeting and gift to clients, Los Angeles-based Shimokochi/Reeves sent this screenprinted shirt along with an accompanying card that touts the firm's ability to "stretch the limits" of design.

Shimokochi/Reeves had three hundred shirts printed, but chose to divide the run into one hundred sweatshirts and two hundred T-shirts. The shirts were well-received; in fact, many of those who received the shirts requested an additional shirt for their spouse.

The firm's greeting card, printed in two colors on chipboard, went to all shirt recipients plus two hundred other studio friends. The shirts were folded around the chipboard cards by Shimokochi/Reeves staff members and then placed in plastic bags. Each shirt was then inserted in a Tyvex envelope for mailing. The firm benefited from the additional exposure they received after the holidays when recipients wore their "designer" shirts year-round.

Design firm: Shimokochi/Reeves

Client: Shimokochi/Reeves

Art directors: Mamoru Shimokochi, Anne Reeves

Designers: Mamoru Shimokochi, Anne Reeves, Tracy McGoldrick

Materials: Sweatshirts, T-shirts, chipboard, plastic bags

Printing method: Silkscreen

Quantity: 100 (sweatshirts), 200 (T-shirts), 500 (cards)

Holiday Mystery Capsules

For a "steady diet of fun," Warkulwiz Design Associates sent this package of "Insta-trim" capsules as a holiday gift to clients and friends of the studio. "It's a double entendre," says firm principal Bob Warkulwiz. "Is it a capsule to make you thin or one that houses tree trim items? Only time and warm water will tell."

Warkulwiz and his staff first became intrigued with the idea of the capsules when a staff member brought in a bag of capsules, marketed to children, that revealed different shaped sponges when dropped in warm water. Warkulwiz contacted the manufacturer of the capsules and contracted with the company to produce capsules with the firm's own designs as sponges.

Warkulwiz designer Mike Rogalski produced the art for the sponges—Christmas trees, snowmen, reindeer and other holiday icons—and printed them out as silhouettes to be supplied to the capsule manufacturer. When the capsules are dissolved in warm water ... instant trim!

The custom look was achieved by designing foldover cards that were stapled to each bag of capsules by members of Warkulwiz's staff. The cards were printed in red and green on Simpson Evergreen, a recycled paper with subtle, red-and-green flocking.

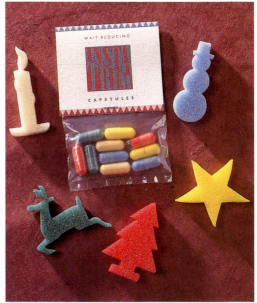

Design firm: Warkulwiz Design Associates, Inc.

Client: Warkulwiz Design Associates, Inc.

Art director: Bob Warkulwiz

Designer: Bill Smith, Jr.

Illustrator: Mike Rogalski

Materials: Simpson Evergreen, plastic bags

Printing method: Sheetfed offset

Quantity: 750

Designer Gift Wrap Makes an Impressive Holiday Gift

This package of gift wrap doubles as a holiday greeting card and gift to clients, suppliers and studio friends of Gahanna, Ohio-based Rickabaugh Graphics.

The firm chose to use a star as the theme for this unusual promotion. A piece of uncoated cover stock, folded on all four sides, carries the firm's "Star of Wonder" greeting, and contains two sheets of custom-designed gift wrap. The firm had a star-shaped die cut made on the front, so that a glimpse of the brightly covered gift wrap can be seen from within.

The gift wrap designs themselves are festive renderings that employ the star motif in their design. Created in Macromedia FreeHand, the designs make extensive use of gradated color. For high color impact, the gift wrap was printed in four-color process on a glossy, coated paper.

The gift wrap folder was also printed in four colors, and folds to 8½" x 11". Rickabaugh staffers sealed the back of each folder with a foil sticker before mailing each of the gift wrap packets in 9" x 12" envelopes.

Design firm: Rickabaugh Graphics
Client: Rickabaugh Graphics
Art director: Eric Rickabaugh
Designer: Mark Krumel
Materials: S.D. Warren Lustro Gloss (gift-wrap), Simpson Starwhite Vicksburg (folder)
Printing method: Sheetfed offset
Quantity: 150

Custom Packaging Transforms a Box of Chocolates

This box of chocolates was custom packaged to make a very special holiday gift. Conceived and designed by Paprika, a Montreal-based design firm, this delectable holiday gift was hand-delivered to 150 of the firm's clients and suppliers.

The chocolates were ordered in their aluminum boxes from a local candy supplier who sold them to the firm wholesale. Paprika customized the boxes by having a local vendor engrave the lids with the design firm's name.

The aluminum boxes are encased in an outer container—a knock-down box made from kraft board, produced by a carton manufacturer and screen printed in one color with an illustration by Gérard Dubois. The same illustration style is applied to a card that serves as a box liner and also carries the studio's holiday message. The box liner was printed in one color on Fox River Confetti on a sheetfed offset press.

When the chocolates are gone, the sturdy, aluminum box can continue to be used for storage. Its presence, over time, will no doubt serve as a constant reminder to clients and studio friends of the firm's gift.

Design firm: Paprika
Client: Paprika
Art director: Louis Gagnon
Designer: Louis Gagnon
Illustrator: Gérard Dubois
Materials: Kraft board, Fox River Confetti Cover, satin ribbon
Printing method: Offset (card), silkscreen (outer box), engraving (inner aluminum box)
Quantity: 150

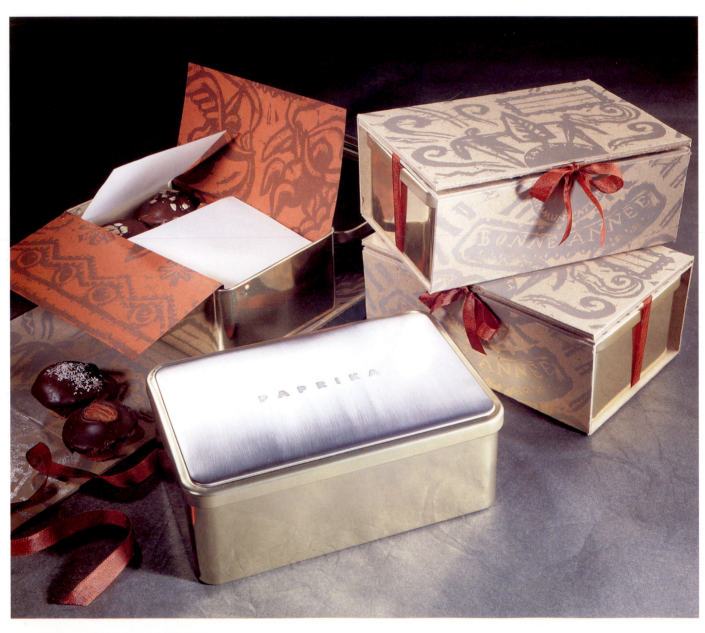

Deadline Conscious Clock

Phoenix Creative used this holiday gift to remind clients of the firm's commitment to meeting their deadlines. The firm sent clocks, purchased from a wholesaler and then customized, to communicate its "timely" message.

The clocks were purchased at a cost of four dollars each, and then customized for a one-of-a-kind gift by disassembling and replacing each clock face with an original Phoenix Creative design.

Ed Mantels-Seeker produced six colorful computer illustrations of a variety of male and female faces and various phrases, so that the clocks could be targeted to the various individuals who comprise the firm's client base. The clock faces were then printed out on the studio's color printer. Phoenix Creative's staff glued the custom-made clock

faces onto each clock before reassembling. The cards that accompany each clock were also produced on the computer and output on the studio's color printer.

The boxes for the clocks were designed by Phoenix Creative and produced by a carton manufacturer. Each box was screen printed in two colors. Phoenix Creatives' staff designed and printed outer and inner labels for the boxes on their studio's color printer and then affixed the labels with glue to the top and inside covers of each box.

The clocks have appeared on the walls of many of Phoenix Creative's clients and vendors. In fact, they've been so popular, the firm is continuing to merchandise the clocks, long after their initial delivery as holiday presents.

Design firm: Phoenix Creative

Creative director/designer: Eric Thoelke

Art director/designer/illustrator: Ed Mantels-Seeker

Copywriters: Ed Mantels-Seeker, Steve Springmeyer

Materials: Hammermill copier paper

Printing method: Screen printing (box), color copier (clocks, labels)

Quantity: 500

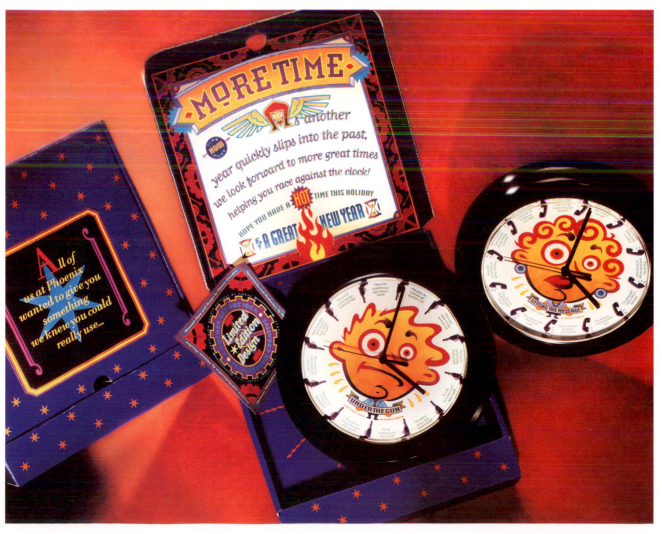

Soup Can Sets the Theme for Holiday Mailing

For its 1995 holiday greeting, Supon Design Group chose to send a gift of a watch and T-shirt to current and prospective clients. The design firm wanted to develop a graphic motif for these gifts that would play upon its name, so they came up with an image of a soup can (reminiscent of Andy Warhol's pop art soup cans of the sixties) and the phrase "graphic soup," which was reproduced on the watches and T-shirts. The watches and the sliding-lid wooden boxes that hold them were ordered through a promotions specialty company. The T-shirts were produced by a local screen printer.

The holiday card that accompanies these gifts also ties in with the soup can theme. The accordion-folded card, printed in two colors, leads the reader through a series of "souper" images. The last panel of the card shows an illustration of a bowl of alphabet soup spelling out the message, "Happy Holidays."

Individual gifts were dictated by the amount of business each recipient gave the firm: prospects received the T-shirt, current clients the watch, major clients received both. Firm principal Supon Phornirunlit says the holiday campaign has been very successful in two ways: The studio was flooded with requests from people wanting more watches, and they have also benefited from the exposure generated by several awards the promotion has received.

Design firm: Supon Design Group
Client: Supon Design Group
Art director: Supon Phornirunlit
Designers: Khoi Vinh, Brent Almond
Illustrators: Khoi Vinh, Brent Almond
Copywriters: Supon Phornirunlit, Brent Almond
Materials: Wooden box, T-shirt, French Speckletone
Printing method: Silkscreen, sheetfed offset
Quantity: 500 (each piece)

Holiday Gift Tags in a Can

One of Vrontikis Design Office's most appreciated holiday promotions was a collection of gift tags designed as a gift for clients and studio friends. For 1995, the firm decided to repeat its past success by packaging a new assortment of gift tags with a decidedly different twist.

The 1995 gift tag promotion came to recipients in a can with a peel-back lid. Vrontikis Design Office located someone who did home canning on a canning machine and contracted with that person to can and seal the gift tags. The firm created a stunning wraparound label for the can, printed in four metallic match colors, inscribed with "A Tin of Twenty Tags," which was glued to the sealed cans by staff members. In addition to the tags, Vrontikis also enclosed a tea bag in every can, which could be located amidst the tags by pulling on the "tea bag tag."

Each can is fitted with a circular piece of cover stock that falls beneath the can lid. This interior lid is slotted to hold the tie end of the gift tags and is printed with the same colors and motif as the can label. Before they were sealed, each can was lined with a piece of corrugated cardboard to cushion the tags.

The gift tags serve as a subtle way of showcasing the firm's range of capabilities on a variety of different colored papers. The firm also saved money by printing the tags on excess trim from other jobs. The variety of papers and color combinations yielded a rich palette of colors and design styles.

For mailing, Vrontikis Design staffers placed each tin in a corrugated shipping box lined with tissue paper and raffia.

Design firm: Vrontikis Design Office

Client: Vrontikis Design Office

Art director: Petrula Vrontikis

Designers: Petrula Vrontikis, Kim Sage

Materials: Potlatch Eloquence Silk (can label, interior lid), various papers (gift tags), silk cord

Printing method: Sheetfed offset

Quantity: 500 cans (with 20 tags each)

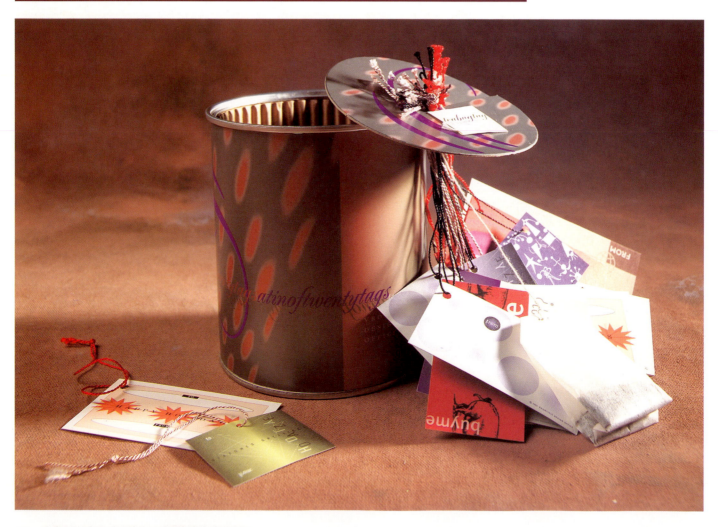

Holiday Tool Box Reinforces Studio's Image

Toronto-based Hard Drive Design takes an approach to serving its clients that emphasizes efficiency and a "fix-it" attitude to solving the communication challenge at hand. Consequently, the firm deemed it appropriate to send this "tool box" filled with tool-shaped cookies as a holiday gift to sixty of its preferred clients.

The tool-shaped gingerbread cookies were baked and frosted by Toronto-based Cake Artistry by Linda, an independent caterer. Each tool cookie was fashioned to the same size as a real tool. Hard Drive Design purchased sixty tool boxes from Home Depot, an East coast-based hardware retailer, and packaged the cookies in their boxes, cushioning them with excelsior. Each tool box was tied with a raffia bow and a tag was attached with the firm's greeting, printed on the firm's laser printer on French Speckletone. To soften the industrial look of the tool box and convey a personal touch, the tag's greeting was rendered in hand lettering.

Hard Drive Design did all of the hand-assembly work in-house and had the tool boxes couriered to their clients.

Design firm: Hard Drive Design
Client: Hard Drive Design
Art directors: Maureen Bradshaw, Miranda Poczak
Designers: Jeffrey Vanlerberghe, Scott McMann
Copywriters Julianne Smola, Tracy Childerhose
Materials: Cookies, tool boxes, excelsior, French Speckletone
Printing method: Laser printer
Quantity: 60

"Timely" Gift Bears Firm's Logo

This holiday gift of a watch features Shimokochi/Reeves' "marketing man" logo. The watch is the latest in a line of items the firm has produced bearing this motif. Previous promotions, including a T-shirt and lapel pin, were so well-received the firm was prompted to issue this watch in its own custom-designed tin to fulfill the demand for more items bearing the popular "marketing man."

The watches were ordered from a mail order company specializing in custom-face watches. Shimokochi/Reeves specified their watch model of choice and supplied the manufacturer with camera-ready artwork of their logo.

The watch's tin was located, after many phone calls, at a local manufacturer of tin containers. The tin, with its snap-top lid, is a sturdy, reusable container that has served as useful storage for many of the promotion's recipients.

Shimokochi/Reeves created lid labels with their holiday message and printed them on the studio's Canon laser printer. Staff members trimmed each label and affixed it to its tin lid. Each tin was lined with a piece of green corrugated stock before the watches were packaged for mailing in corrugated cardboard boxes lined with red and green tissue.

Design firm: Shimokochi/Reeves
Client: Shimokochi/Reeves
Art directors: Mamoru Shimokochi, Anne Reeves
Designers: Mamoru Shimokochi, Anne Reeves
Materials: Watches, laser paper, tins
Printing method: Laser printer
Quantity: 70

Yuletide Comb Serves as Holiday Gift

Philadelphia-based Warkulwiz Design Associates made a holiday gift of this custom-printed and packaged pocket comb to send as a greeting to clients and vendors.

The comb was ordered from a marketing specialties catalog that specializes in custom imprinting. Warkulwiz Design specified a comb in a "Christmasy" shade of dark green, inscribed with the phrase, "O Comb, All Ye Faithful."

The wintery landscape depicted on the comb's case is actually an illustration of hair and hair follicles, found in a medical text book. Warkulwiz illustrator, Mike Rogalski, scanned the illustration, and added a dusting of snow in Adobe Illustrator.

The illustration was printed in two colors on a coated cover stock. The comb cases were trimmed to the specified size and scored at the fold lines at the printer. The Warkulwiz Design staff then folded and glued each of the 750 comb cases, which were sent to clients and friends of the studio.

Design firm: Warkulwiz Design Associates, Inc.
Client: Warkulwiz Design Associates, Inc.
Art director: Bob Warkulwiz
Designer: Bob Warkulwiz
Illustrator: Mike Rogalski
Materials: Warren Lustro Gloss Cover
Printing method: Sheetfed offset
Quantity: 750

A Holiday Gift of Chocolate Coins

For a holiday gift to clients and vendors, Ultimo, Inc., sent this can of chocolate coins. However, the firm's gift went beyond the recipients of the chocolates— the homeless and needy benefited as well. In honor of its clients and colleagues, Ultimo made a donation to Common Cents, a New York City-based charity that collects pennies to help the needy and homeless.

Art director and firm principal, Clare Ultimo, achieved a vintage look for the can by printing cranberry and sage green inks on a natural parchment. She chose Engravers Roman as her headline typeface and antique, decorative borders to further enhance the nostalgic look.

Aluminum paint cans were used for the candy containers, obtained from Freund Containers, an industrial supply house. In addition to producing wrap-around labels and circular lid labels (attached to each can with a glue gun), Ultimo also designed a circular card that accompanied each can of coins. The card reminds its recipient of seven "small fortunes"—such as three meals a day—that we often take for granted but that are treasured by the poor and homeless. Each card was hand decorated with silk cord looped at seven points along its edge.

Design firm: Ultimo, Inc.
Client: Ultimo, Inc.
Art director: Clare Ultimo
Designers: Clare Ultimo, Joanne Obarowski
Copywriter: Clare Ultimo
Materials: Paint cans, Wasau Astroparch, silk cord, tissue paper
Printing method: Offset
Quantity: 300

A Mailing of Valentine's Day Mementos

Diversified Graphics, a Minneapolis-based printing company, wanted to send a memorable promotional mailing that would play up the company's reputation for using specialty techniques to produce printed pieces with a handmade look. The company saw Valentine's Day as an opportunity to mail an intriguing promotion that harmoniously combines contrasting textures and materials.

The company's Valentine's Day promotional mailer consists of a collection of mementos, contained within a business-card sized glassine envelope. Mementos sent include a nostalgic, black-and-white photograph mounted on Microvel, a velvet-covered board; a business card; a locket-sized

heart and a cover card, printed on Hopper Proterra. The card is inscribed with the phrase "Tokens from the Heart," hand-lettered by the piece's designer, Lisa Henkemeyer.

Producing the piece involved no time on press—the cover card was printed on a laser printer. The photos were clipped from a printed overrun of a self-promotion piece produced for photographer Paul Irmiter. Time was spent instead on sourcing out materials, such as the heart charms, which were purchased from a craft shop.

The promotion was mailed to a select list of two hundred of the company's existing and potential clients in a Kraftpak linerboard envelope.

Design firm: Diversified Graphics
Client: Diversified Graphics
Art directors: Lisa Henkemeyer, Janice Meintsma
Designer: Lisa Henkemeyer
Photographer: Paul Irmiter
Materials: Microvel board, Hopper Proterra, heart charms, Kraftpak linerboard envelopes, glassine envelopes, gummed stars
Printing method Laser printer
Quantity: 200

Candy Hearts and a Valentine

Illustrator Connie Helgeson-Moen has found that seasonal promotions are often most effective when they celebrate off-beat holidays. As a result, she has chosen holidays such as Valentine's Day and Halloween to send seasonally themed promotions.

For Valentine's Day, Helgeson-Moen sent a mailing tube containing a clear, acetate tube filled with candy hearts. Helgeson-Moen made the clear tubes herself and fastened them with grommets purchased from a fabric store. She tagged the candy with her greeting, "Get real. Be mine. Client, that is."

Wrapped around each tube of candy is a valentine with an illustration of cupid. The illustration is one of one thousand reprints that Helgeson-Moen received as a result of running an ad in the *Workbook*, a national creative directory. The tag copy was photocopied on 8½" x 11" sheets of paper and then trimmed down into 7" strips. Helgeson-Moen affixed a red-and-white sticker with her bee logo on it to each tag to give the impression of a multicolored run. The logo stickers were printed at a quick-print shop.

Helgeson-Moen says the response to the promotion was favorable. "I got several good jobs from clients I had been hoping to work with," she relates. The promotion was also inexpensive to produce. Hegelson-Moen says her primary expense was the mailing tubes at fifty-five cents each.

Design firm: Connie Helgeson-Moen/Batik Illustration
Client: Connie Helgeson-Moen/Batik Illustration
Art director: Connie Helgeson-Moen
Copywriter: Jennifer Radack
Illustrator: Connie Helgeson-Moen
Materials: Mailing tube, satin ribbon, Simpson Quest, acetate, grommets
Printing method: Offset (valentine), photocopier (hang tag)
Quantity: 200

Gift Bears Studio's Own Designer Label

Canadian design firm Aartvark Communications has made a holiday tradition of sending its suppliers and clients a custom-made gift of its own design. Under the name of "Aartware," the firm features its own designer label, a triangular-shaped icon, on these unique gifts and their packaging.

Among the gifts in the Aartware series is this copper-plated lapel pin, ordered from a promotional specialties firm in Toronto. Aartvark supplied the company with line art of their logo. Each of the 250 pins is individually numbered.

The packaging details make this gift uniquely special. The 4" x 4" x 1½" wooden box was ordered from a Toronto-based company that specializes in wooden boxes. The rustic look of the Aartware logo was created by the box manufacturer who burned the Aartware logo into the box lid with a heated die. Each box was filled with potpourri to cushion the pins.

Before they were packaged, each pin was attached to a card bearing the firm's message. The card is printed on a recycled paper and carries a swirl motif that ties in with the primitive look of the wooden box and pin. Aartvark printed the cards on its studio laser printer.

Design firm: Aartvark Communications
Client: Aartvark Communications
Art director: Jean-Luc Denat
Designer: Jean-Luc Denat
Materials: Wooden box with sliding lid, potpourri, Fox River Confetti (card)
Printing method: Laser printer
Quantity: 250

Eco-Friendly Gift-Wrap

For a better world, let's each do our part," is the inscription on this holiday gift of gift wrap, printed on recycled paper made from 100 percent post-consumer waste. Designed by Supon Design Group, the gift wrap was the design firm's way of expressing its concern for the environment and doing something to help.

The papers are decorated with images from nature. Each image was created as a pen-and-ink illustration, then multiple copies were sprinkled across the pages to achieve a patterned effect.

The gift wrap was printed in just three match colors, but because five different shades of paper were used, the package of wrap has far more color impact.

The individual sheets were folded and contained in a foldover cover sheet. To add a festive look, the Supon Design staff tied a glittery bow around each package before it was inserted into an envelope for mailing.

Design firm: Supon Design Group
Client: Supon Design Group
Art director: Supon Phornirunlit
Designers: Andrew Dolan, Dianne Cook, Dave Prescott
Materials: Neenah Environment
Printing method: Sheetfed offset
Quantity: 500

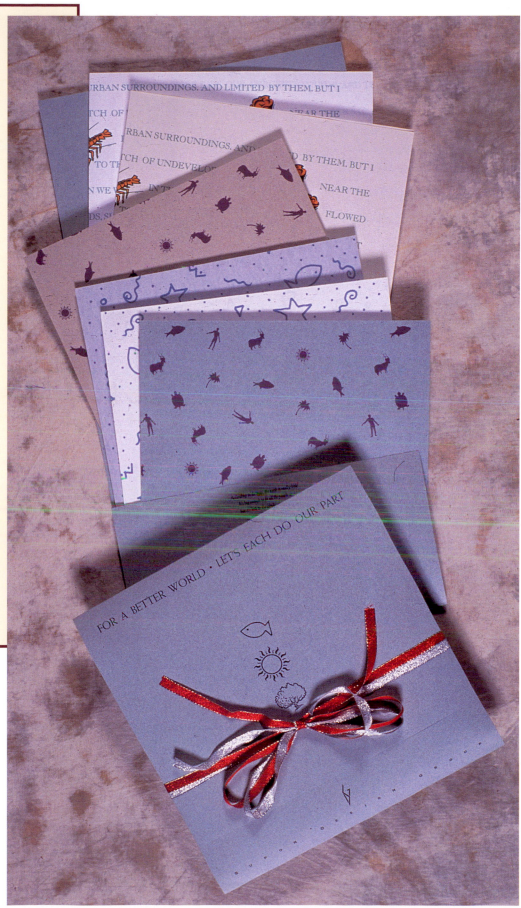

Holiday Spirits Get a Custom Touch

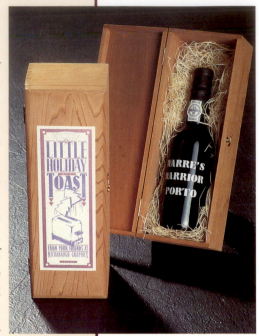

Rickabaugh Graphics' tongue-in-cheek gift of a "Little Holiday Toast" was much appreciated when clients opened it to discover a bottle of spirits.

The design firm purchased thirty bottles of a variety of spirits, ranging from champagne to port wine in wooden boxes from a local wine distributor. The boxes originally bore a logo that had been burned into the lid of each box, but designers at Rickabaugh Graphics customized the boxes by designing a label bearing an illustration of a toaster and the firm's "holiday toast" greeting. Art director and firm principal, Eric Rickabaugh, produced the toaster illustration and designed the label, which was printed in two colors on uncoated text. For a nostalgic, handcrafted look, the labels were printed on a letterpress, a vintage method of printing that leaves a soft impression in the areas that are printed. Rickabaugh and his staff trimmed each label and glued the labels to the individual boxes.

Although there was relatively little time involved in producing the box labels, the richness of the wooden box and its contents made the holiday gift a memorable one. Each wooden box was hand-delivered to clients, friends and suppliers of the Gahanna, Ohio-based firm.

Design firm: Rickabaugh Graphics
Client: Rickabaugh Graphics
Art director: Eric Rickabaugh
Designer/illustrator: Eric Rickabaugh
Materials: Wooden boxes, Simpson Gainsborough
Printing method Letterpress
Quantity: 30

That's the Rub

Ellen Shapiro, of New York City-based Shapiro Design Associates, doesn't consider herself to be a gourmet. "But I do enjoy food and cooking," she admits. After sending out a cookbook as a holiday gift to clients and vendors, Shapiro decided to follow up the next year by actually preparing one of the recipes in the cookbook and sending it out as a holiday gift.

Purchasing and blending spices to produce enough barbecue rub to fill seventy-five jars proved to be one of the least challenging tasks in the production process. Because no single source offered seventy-five snap-lid jars, Shapiro ended up visiting three different locations of Pier One Imports to purchase enough jars for the project.

To keep costs to a minimum, Shapiro carefully designed the three-color jar labels so that seven could be ganged on a tabloid-sized sheet. The labels were laid out in PageMaker and sent to a service bureau to be printed on a Cannon Fiery printer. After they were printed and trimmed, Shapiro and her staff glued the labels with rubber cement to each of the jars.

Before packaging, colorful fabric with a Southwestern feeling was cut into star-burst shapes and secured beneath the lid of each jar. The jars of barbecue rub were then placed in cardboard cartons, hand-delivered to local clients and shipped to those out of town.

The response to the "Not-Yet-Famous" barbecue rub was overwhelmingly positive. In fact, some recipients asked Shapiro if she planned to put it on the market.

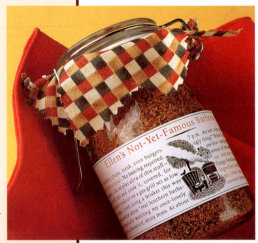

Design firm: Shapiro Design Associates
Client: Shapiro Design Associates
Designer: Ellen Shapiro
Illustrator: Paul Hoffman
Materials: Glass jars from Pier One Imports, fabric, color prints
Printing method: Cannon Fiery color printer
Quantity: 75

Cinco de Mayo Promotion Serves Dual Purpose

To celebrate Cinco de Mayo, a Mexican national holiday, Avon, Connecticut-based Williams & House threw a party featuring margaritas and Mexican food and sent this elaborately packaged bottle of margarita mix as a promotional gift and party invitation.

To create a custom-designed bottle, firm principal Pamela Williams purchased margarita mix and replaced the existing brand labels with her firm's own design. The label depicts Mexican food and margaritas on the front, and includes the party invitation on the back.

Williams had a specialty box maker from Bristol, Connecticut make wooden boxes with sliding lids for the bottles. The bottles were individually wrapped with a swatch of purple fabric, jute twine and a silver buckle, purchased from a fabric and craft store before being placed in their raffia-packed boxes.

Before being mailed, each box was sealed with strips of paper bearing the same motif as the border on the bottle label. The sealing strips were printed on the same coated stock and press run as the bottle labels. Before mailing, Williams & House staffers rubber stamped each box with the word "fragile" and affixed colorful postage stamps.

Recipients quickly opened the exotic-looking boxes. Out of three hundred clients and business associates who received it, 100 percent responded and 83 percent attended the party.

Design firm: Williams & House

Client: Williams & House

Designers: Pamela Williams (Williams & House), Karen Boyhen (Karen Boyhen Graphic Design)

Illustrator: Jane Winsor

Materials: Warren Lustro Gloss, wooden boxes, raffia, fabric, jute twine, margarita mix, buckles

Printing method: Sheetfed offset, rubber stamping

Quantity: 300

A Holiday Promotion to Sleep On

For the 1994 holiday season, Ultimo, Inc., chose to make its own "dream pillow" to give as a gift to clients and colleagues.

The pillow is decorated with images and a design that the firm produced on its studio computer. A black-and-white printout of the design was given to a screen printer who reproduced it in teal and metallic copper on cotton fabric.

The pillows proved to be quite an ambitious project—particularly when it became necessary to source out materials and services far beyond the realm of those associated with producing traditional print design. For example, Ultimo needed trim and stuffing. For the stuffing, they located recycled fiberfill and laced that with herbs noted for inducing drowsiness. Ultimo also needed to contract with a seamstress who stuffed and stitched the pillows, including a pocket on the back of each that holds six cards printed with dream-related facts.

The "charms" around the pillow's perimeter are actually key tags. Ultimo had images and sayings printed in copper and brown on circular, self-adhesive labels. She and her staff affixed the labels to each key tag and then attached the tags to the pillows.

Ultimo says the pillows were so well-received, one client wanted to have the studio design and produce them as a promotional piece. She declined the offer to preserve the "one-of-a-kind" integrity of the original piece.

Design firm: Ultimo, Inc.

Client: Ultimo, Inc.

Art director: Clare Ultimo

Designers: Clare Ultimo, Christine Cortina

Copywriters: Clare Ultimo, Eleno Olivares

Materials: Fabric, cord trim, key tags, fiber fill, herbs, Hopper Skytone cover stock

Printing method: Silkscreen, offset

Quantity: 300

Studio Relocation Inspires Compass Gift

Philadelphia-based Warkulwiz Design Associates sent this holiday gift of a "Pointsetter" to each of its clients and vendors. Because the design firm had recently moved, the box's enclosure of a car compass was a clever way of reminding recipients that the design firm had relocated.

The car compasses were ordered from the catalog of a marketing specialties company. Their custom gift boxes were constructed by Warkulwiz staff members from silver and metallic pink cover stock foil stamped in dark green. After the boxes were foil stamped, the metallic stock was die cut in a box configuration and scored at the fold lines. The cut-to-size pieces for the boxes and their lids were sent to Warkulwiz Design where staff members folded and assembled them. To pad the compasses, each box was stuffed with shredded road maps. The gift-boxed compasses were sent to studio friends and clients in a bubble-wrap envelope.

Was the gift successful in reminding its recipients of the firm's new address? "It seemed to work," says firm principal Bob Warkulwiz. "People found us!"

Design firm: Warkulwiz Design Associates, Inc.
Client: Warkulwiz Design Associates, Inc.
Art director: Bob Warkulwiz
Designer: Kirsten Engstrom
Illustrator: Mike Rogalski
Materials: Appleton Currency Cover
Printing method: Foil stamping
Quantity: 750

Chimney & Roof Appliqués Prevent Santa Skids

To "prevent nasty slips on roofs, decks and chimneys," Warkulwiz Design Associates sent these "Noël-Slip" appliqués to keep Santa from slipping as a humorous holiday greeting.

The snowflake images were created by redrawing scans of clip art from a book of design motifs. Creating a "Polarmaid" logo, a takeoff on the Rubbermaid logo, completed the look of a package of non-skid appliqués.

To achieve a raised surface that would give the effect of a true rubber appliqué, Warkulwiz designers had the snowflake images and other graphics printed with thermography. The paper they chose was a peel-back label stock. A set of three appliqué cards was sent to 750 of the firm's clients and vendors.

Design firm: Warkulwiz Design Associates, Inc.
Client: Warkulwiz Design Associates, Inc.
Art director: Bob Warkulwiz
Designer/illustrator: Mike Rogalski
Materials: Mactac Starliner permanent label stock
Printing method: Thermography
Quantity: 750

Wearable Gift Doubles Design Firm's Exposure

In response to the success of a past holiday gift of a custom-designed sweatshirt, Los Angeles-based Shimokochi/Reeves arrived at this design to serve as a motif for its 1993 holiday gift of a sweatshirt.

The "SR" design employs design elements of former self-promotion pieces in its embodiment of the Shimokochi/Reeves "look." Stair-stepped angles and the confetti pattern were all borrowed from an image established with previous holiday gifts and promotions. The design was printed in four match colors by a local screen printer.

The shirts were wrapped in tissue paper and placed in mailing tubes for shipping. Shimokochi/Reeves then added custom mailing labels created on the computer and printed them out on their studio's Cannon laser printer.

Current and prospective clients were not only grateful for their gift, many of them increased Shimokochi/Reeves' visibility by wearing their sweatshirts throughout the year.

Design firm: Shimokochi/Reeves
Client: Shimokochi/Reeves
Art directors: Mamoru Shimokochi, Anne Reeves
Designers: Mamoru Shimokochi, Anne Reeves, Tracy McGoldrick
Materials: Sweatshirts, mailing tubes, laser paper
Printing method: Silkscreen
Quantity: 100

Holiday Hot Seat

The Phoenix Creative "Hot Seat" was not necessarily perceived as such when it was delivered as a holiday gift. The packages of 3' x 6' sheets of cardboard were hand-delivered to current and prospective clients with an instruction sheet on how to assemble the pieces into a chair, but clients were reluctant to do the assembling themselves. "It became a spectator sport, watching us put it together," says Phoenix Creative principal, Eric Thoelke.

Because the design firm specializes in packaging, they chose to engineer and produce the chair as an example of their three-dimensional design capabilities. The components of the chair engage and delight with humorous text and graphics such as the bulls-eye on the chair's seat inscribed with "aah." The chairs were printed on corrugated cardboard by a carton manufacturer in two colors.

This promotion proved to be extremely successful. In addition to being memorable, it offered a chance for staff members to engage in conversation with recipients while they were assembling the chairs. "We got several new clients as a result of it, including a chair manufacturer," says Thoelke.

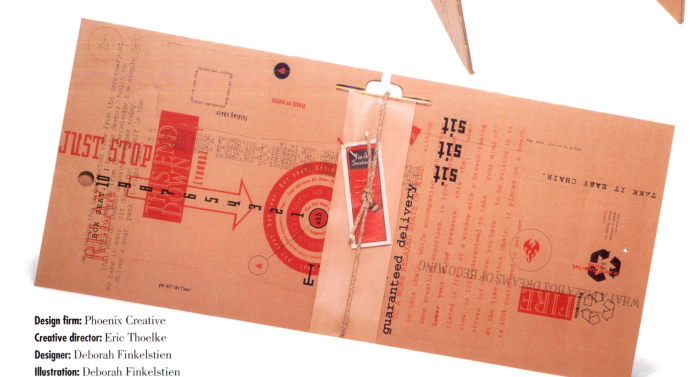

Design firm: Phoenix Creative
Creative director: Eric Thoelke
Designer: Deborah Finkelstien
Illustration: Deborah Finkelstien
Computer production: Ann Guillot
Materials: Corrugated cardboard, string, kraft paper
Printing method: Screen printing
Quantity: 500

A Folder Full of Gift Tags

Los Angeles-based Vrontikis Design Office created this folder of gift tags as a gift for clients and studio suppliers.

Firm principal Petrula Vrontikis and her staff did all of the work on constructing the folder, a piece of black corrugated board, folded and punched with a grommet. A piece of thin red ribbon looped around the grommet serves as the folder's closure. Vrontikis had her holiday greeting printed in silver on heavy sheets of red paper and folded the center of each sheet into eight accordion folds before gluing it to the inside of the folder. Each inward fold serves as a holder for the gift tags.

Vrontikis and her design staff then came up with eight different gift tag ideas and had them printed at one time as a four-color run. The printer was willing to print the tags at no charge in exchange for a holiday card design.

The Vrontikis Design staff stuffed all five hundred folders with the various gift tags and inscribed each with a personal greeting.

Design firm: Vrontikis Design Office
Client: Vrontikis Design Office
Art director: Petrula Vrontikis
Designers: Petrula Vrontikis, Kim Sage, Christina Hsiao
Copywriter: Kirsten Livingston

Materials: Corrugated cardboard, Fox River Confetti, red ribbon, French Dur-O-Tone (grommet)
Printing method: Sheetfed offset
Quantity: 500

No Holiday Pun Intended

Warkulwiz Design Associates makes a pun with its "stocking stuffer" gift of a shoe horn. The red shoe horns were custom imprinted with an inscription, "We Wish Shoe A Merry Christmas," by a catalog company that specializes in marketing aids.

Firm principal Bob Warkulwiz and his staff designed and produced the custom gift boxes for the shoe horns. A gold cover stock was printed in two match colors with Warkulwiz's design of Christmasy holly, which, upon closer inspection, looks suspiciously like tiny shoe prints. The stock was then die cut into the configurations necessary for folding them into boxes and lids and scored at the printer. Warkulwiz and his staff then hand assembled the boxes and their lids in their studio.

The boxed shoe horns were sent to one thousand of the studio's clients and friends in bubble-wrap mailers.

Design firm: Warkulwiz Design Associates, Inc.
Client: Warkulwiz Design Associates, Inc.
Art director: Bob Warkulwiz
Designers: Kirsten Engstrom, Bill Smith, Jr.

Illustrator: Mike Rogalski
Materials: Appleton Currency Cover, tissue paper
Printing method: Sheetfed offset
Quantity: 1,000

Montreal-Based Design Firm Sends Gift of French Paté

An article in a Toronto-based magazine on the design firm Paprika provided the source of inspiration for this Montreal design firm's holiday gift of foie gras, a duck meat paté traditionally served in France during the holidays. "When we read the article, we discovered that many people think of us as a 'French inspiration' design firm," says Joanne Lefebvre, firm principal.

The paté was purchased from a local supplier who specializes in French delicacies. Paprika designed its own labels for the jars and had wooden boxes with wire inserts specially made to encase each jar. After they were painted, the boxes were screen printed by another supplier with the Paprika logo.

Before they were hand-delivered to 150 of Paprika's clients and studio friends, each box of foie gras was tagged with the firm's holiday message, run in four-color on Byronic text stock.

Design firm: Paprika
Client: Paprika
Art director: Louis Gagnon
Designer: Louis Gagnon
Illustrators: Paprika staff
Materials: Wood boxes, Byronic text
Printing method: Offset, silkscreen
Quantity: 150

A Wish for the Future Serves as Promo Theme

As a holiday greeting, Washington, DC.-based Supon Design Group decided to visualize a child's dreams for the future in a "time capsule" filled with fantasy projections. The date is December, 1943. A twelve-year-old wishes for peace on earth and speculates on what life may be like in the 1990s.

The time capsule is a wooden box with a sliding top, purchased from a wine packager. To decorate the box, firm principal Supon Phornirunlit and his staff conceived nostalgic imagery, reminiscent of the forties, which was screen printed in holiday red and green on the box's lid, intentionally printed out-of-register for a hands-on, vintage look.

The box is filled with note cards that echo the forties look of the box's cover. Each card depicts an aspect of our life today as a child fifty years ago might have envisioned it. Illustrations of subjects such as household robots and vacations in space were rendered in watercolor to recreate a postcard style reminiscent of the forties.

To get the effect of more than one four-color run, Phornirunlit ran the cards on four papers that he calls "vintage-colored." Although all the cards in the series were ganged on a single plate and printed as a single four-color run, the impression is of several print runs.

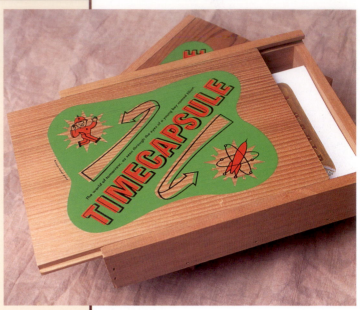

Design firm: Supon Design Group

Client: Supon Design Group

Art director: Supon Phornirunlit

Designer: Richard Boynton

Illustrator: Patrick O'Brien

Materials: Wooden box, Mohawk vellum and matching envelopes

Printing method: Silkscreen, sheetfed offset

Quantity: 500

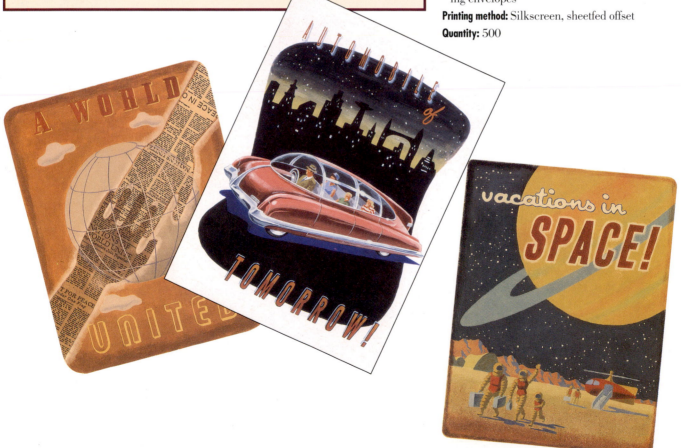

SECTION

3

Calendars
and Posters

✳

Rock and Roll Calendar Mixes Vintage With Contemporary

Nesnadny + Schwartz was not only honored but inspired when the firm was hired to design the first-ever calendar for the Rock and Roll Hall of Fame and Museum.

The 1996 calendar features historic photos of great recording artists in photographic settings that push the edge of today's technology. To accomplish this, creative directors Mark Schwartz and Joyce Nesnadny took vintage photos of recording artists captured in their prime—such as Chuck Berry and Janis Joplin—and combined them in Adobe Photoshop with other images and graphics (poster clips, etc.) from the appropriate era to create photo effects that attain far more dramatic impact than the photos would have alone.

Nesnadny + Schwartz scanned the photographs on their studio scanner and worked with them at low resolution to compose the collages. The firm used their studio's color printer to proof the results of their digital special effects. To achieve the kind of high quality only obtainable from professional four-color pre-press equipment, the Nesnadny + Schwartz designers used their scanned images as "for position only" indicators in their collages. The final images for the calendar were scanned at the printer and assembled on a professional system.

The calendar was printed in four-color process, one match color plus an aqueous varnish on a standard offset press and saddle stitched. It was sold at the Rock and Roll Hall of Fame and Museum.

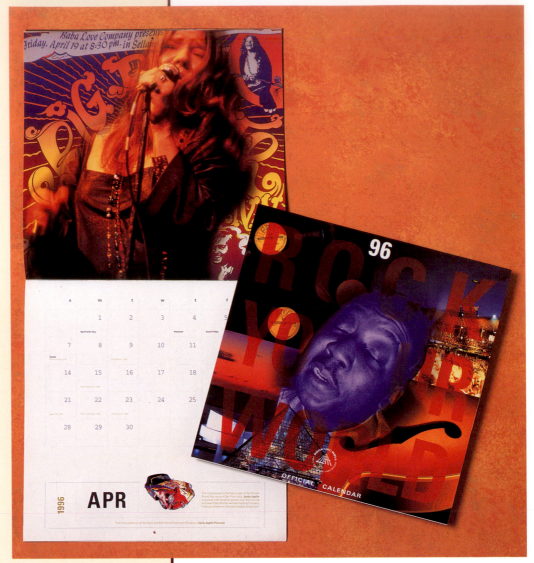

Design firm: Nesnadny + Schwartz
Client: Rock and Roll Hall of Fame and Museum
Creative directors: Mark Schwartz, Joyce Nesnadny
Designers: Joyce Nesnadny, Brian Lavy, Michelle Moehler
Photographers: Various
Materials: Mead Signature 80-lb. (cover), Mead Signature 100-lb. (interior)
Printing method: Sheetfed offset
Quantity: 4,000

Calendar Marks the Seasons With an Evolving Image

This unusual calendar for a Canadian printer portrays a single image, changing subtly over the course of twelve months, reflecting how nature changes during the course of a year. The nest perched on top of the cups in the April portion contains eggs in the May panel. By June, the eggs are broken and a bird is emerging from the nest. The configuration of pages was conceived so that the top portion of the calendar can be flipped to view the stack of cups as they evolve through the seasons.

The calendar is a collaboration between Louis Gagnon, art director of Montreal-based Paprika; Paul-Emile Rioux, the photographer; and Franáois Chartier, a computer designer/illustrator who created the photographic special effects using Adobe Photoshop. "It was really a team effort," says Paprika principal Joanne Lefebvre. "Louis directed everything and pulled it all together using the talents of the others."

The calendar was printed in four-color process on Condat Supreme Dull, a coated paper with a dull finish. It was hand-delivered as a holiday gift to Lithochrome-Boulanger clients.

Design firm: Paprika
Client: Lithochrome-Boulanger
Art director: Louis Gagnon
Designer: Louis Gagnon
Photographer: Paul-Emile Rioux
Illustrator: Franáois Chartier
Materials: Condat Supreme Dull
Printing method: Offset
Quantity: 3,000

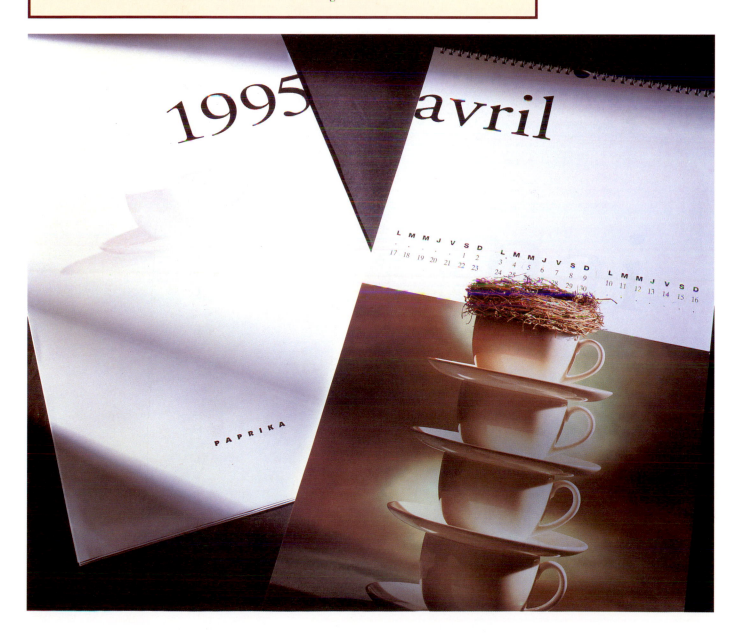

Red Hot Candy Gives Rudolph a Tasty Nose

"**H**ere's wishing you a red hot Christmas," says this holiday poster featuring a red-hot-candy-nosed reindeer. The poster was created by Dallas-based Powell Design Office and sent as a holiday greeting to one thousand clients, vendors and studio friends.

The poster's whimsical Rudolph illustration was created with brush and ink by firm principal Glyn Powell. It was reversed out to white for the printed version, which was silkscreened in metallic gold ink on glossy coated stock to achieve smooth, solid color.

After the posters were printed and delivered to the studio, the staff at Powell Design hand glued a red hot to each one, then rolled them up and inserted them in tubes for mailing.

The posters were displayed by many recipients, but several were stripped of their red hots by kids and other candy lovers who lacked the will power to keep hands off!

Design firm: Powell Design Office
Client: Powell Design Office
Art director: Glyn Powell
Designers: Glyn Powell, Dorit Suffness, Jon Buell
Illustrator: Glyn Powell
Materials: S.D. Warren Lustro Glossy Cover
Printing method: Silkscreen
Quantity: 1,000

Folk Art Calendar Gets Rustic Treatment

For the past several years, Toronto-based Viva Dolan Communication and Design has made a practice of sending a calendar to its clients as a New Year's gift and greeting. This 1995 calendar features Canadian folk art from the personal collection of firm principal Frank Viva.

Each piece of folk art appears on a calendar page embellished with hand-lettered sayings that match the crude look of the folk art. Type used on the calendar portion of each page is set simply in a contemporary sans serif face to complement rather than compete with the folk art images and hand lettering. Viva Dolan used blocks of screened color to separate days of the month.

The pages of the calendar were printed on a premium coated sheet and mechanically bound to a folded sheet of corrugated cardboard that functions as a display stand for the calendar. A matching corrugated shipping container with a tie-and-grommet closure was used for mailing the calendar.

The calendar's folk art theme ties in with the firm's greeting, printed on chipboard and glued to the calendar's corrugated backing. The inscription talks about the similarities between the pieces in the calendar and Viva Dolan's design capabilities.

Design firm: Viva Dolan Communication & Design
Client: Viva Dolan Communication & Design
Art director/designer: Frank Viva
Artists: Sid Howard, Mr. LaChance, F. Hanson, Garnet McPhail, M. Roach, Gordon Law
Calligrapher: Seth
Photographer: Hill Peppard
Materials: Corrugated cardboard, chipboard, Karma Supreme Matte
Printing method: Sheetfed offset
Quantity: 500

Intriguing Calendar Appeals to Creative Audience

To thank supporters and welcome in the new year, the Dallas Society of Visual Communications sent this 1996 calendar as a gift to its members. Designed by Brainstorm, Inc., the calendar is actually the January issue of *Rough*, DSVC's monthly magazine, which the design firm chose to publish in the form of a calendar.

Titled, "Kiss this year goodbye," each calendar page features the month at a glance at the bottom, in tiny, eight-point type. Centered above each month's dates is a small image. These images run the gamut, ranging from a caricature of Ross Perot to a silhouette of a nude woman. Each relates to an article that appears on the opposite side. The articles are copy-heavy and informative, in stark contrast with the graphically minimal representation of each month's calendar.

Printed in three match colors on gray and white uncoated text, the calendar showcases a broad range of stylistic interpretations and the firm's versatility in dealing with little or much copy. A black grommet centered at the top of the calendar secures its pages. The calendar was sent in a black envelope printed in a gloss varnish with the DSVC's name and address.

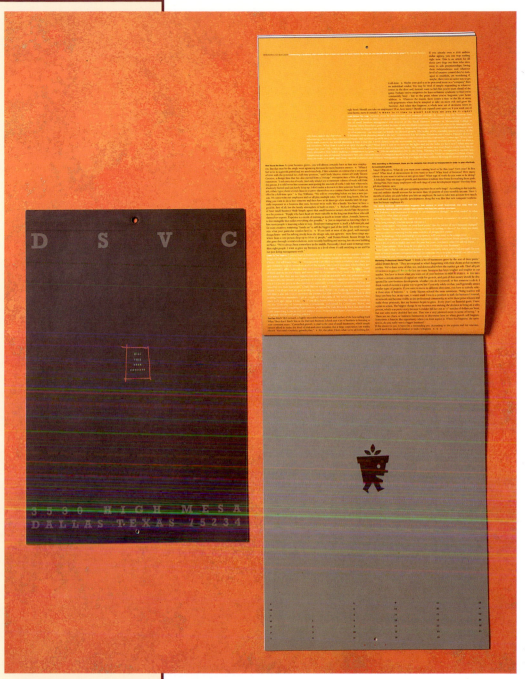

Design firm: Brainstorm, Inc.
Client: Dallas Society of Visual Communications
Art director: Chuck Johnson
Designers: Chuck Johnson, Art Garcia, Wayne Geyer
Illustrators: Chuck Johnson, Art Garcia, Wayne Geyer
Materials: Simpson Quest, Simpson Starwhite Vicksburg
Printing method: Sheetfed offset
Quantity: 2,500

Re-Thinking the Calendar

Copeland Hirthler Design + Communications reinvents the calendar with this selection of monthly cards encased in a plastic, compact disk jewel case. When the front cover of the jewel case is folded under, it creates a freestanding display case for the calendar pages. The Atlanta-based design firm sent this unusual calendar for the coming year as a gift to clients and studio friends for the 1995 holiday season.

Entitled "Time Re-Interpreted," each card displays a graphic interpretation of a calendar month on its facing side by one of the firm's fifteen designers. The opposite side of each card notes holidays and gives an explanation for why the designer chose their unique approach. As a result, the calendar exhibits the design firm's broad range of stylistic capabilities.

The card packet is unified by its consistent format for each card (4⅝" x 5⅜") and a consistent palette of six match colors. The cards were printed on a dull-coated cover stock and collated by staff members before being placed in their jewel cases. The cases were purchased from Viva Magnetics, Ltd.

The promotion has prompted many phone calls and letters from recipients complimenting the design firm on its unique interpretation of the traditional calendar.

Design firm: Copeland Hirthler Design + Communications
Client: Copeland Hirthler Design + Communications
Creative directors: Brad Copeland, George Hirthler
Designers: David Butler, Lea Nichols, Raquel Miqueli, David Woodward, Michelle Stirna, Todd Brooks, Sam Hero, Shawn Brasfield, David Crawford, Sean Goss, Sarah Huie, David Park, Melanie Bass Pollard, Mark Ligameri, Jeff Haack
Materials: Simpson Karma
Printing method: Sheetfed offset
Quantity: 1,000

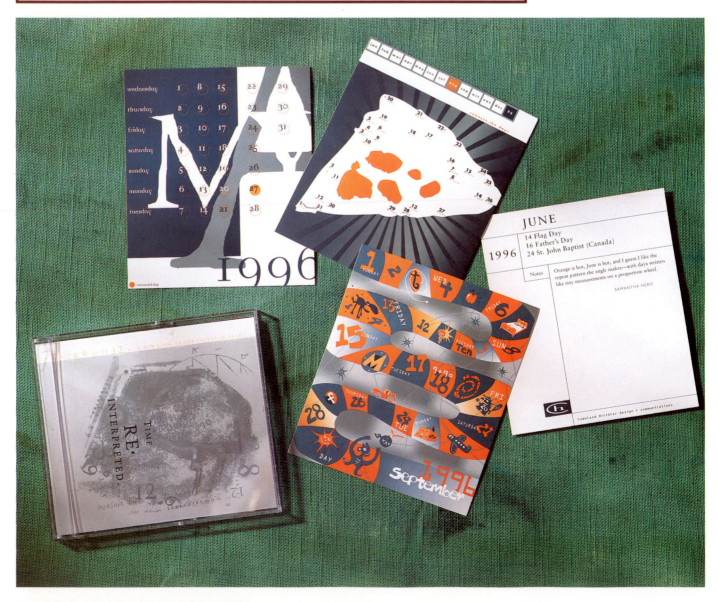

Food Distributor's Calendar Whets the Appetite

Food Services of America is a national distributor of institutional foods. Every year over the holidays, the food supplier sends a calendar to its customers to thank them for their business.

This 1995 calendar marks the fifth year Seattle-based Hornall Anderson Design Works has designed the annual Food Services calendar. Every year the calendar features stunning photographs of food and an elegant, understated design. It's been Hornall Anderson's challenge to come up with a fresh calendar design every year that builds upon the previous year's calendar.

Working with soft-focus photographic still lifes by photographer Tom Collicott, Hornall Anderson's designers made these the focal point of each calendar page. Crisply detailed shots of food products flank each still life, providing subtle contrast. For a refined, elegant look, the designers used Garamond italic for the calendar numbers and hand-drawn month names.

To obtain rich detail and optimum color reproduction, the calendar was run on premium quality coated paper in four-color process.

Design firm: Hornall Anderson Design Works, Inc.
Client: Food Services of America
Art director: Jack Anderson
Designers: Jack Anderson, Mary Hermes, Julie Keenan
Photographer: Tom Collicott
Materials: Weyerhauser Jaguar
Printing method: Sheetfed offset

Seasonal Posters Offer High Impact on a Regular Basis

DBD International, Ltd. designed this calendar/ poster series to be mailed at quarterly intervals during 1996. Each of the four posters is also printed with month-at-a-glance calendar pages for the next three months of the year.

Firm principal David Brier created each of the posters' Art Deco-style illustrations in Adobe Illustrator and Photoshop. Several of the Deco-era fonts used in the posters' headlines are original designs of Brier's, marketed under the name Avant Gartists. For three of the posters, Brier used QuarkXPress to add additional text and to assemble the illustrations and other graphic elements into a final layout.

The posters were printed in four-color process on a variety of papers, including a flocked recycled sheet and a dull-coated cover stock. They were folded in half and mailed in 9" x 12" envelopes.

The top half of the reverse side of each poster was printed with promotional copy that was immediately spotted when recipients opened the envelopes.

Brier has found that his design firm gets more promotional mileage from its series of quarterly calendar mailings than it would have if a single calendar had been sent at the start of the New Year. "We call it our quarterly reminder," he says. In the case of this series, several clients made references to these calendars when calling DBD to initiate new projects.

Design firm: DBD International, Ltd.
Client: DBD International, Ltd.
Art director: David Brier
Designer/illustrator: David Brier
Materials: French Rayon, Vintage Velvet Creme, Simpson Quest
Printing method: Offset
Quantity: 500

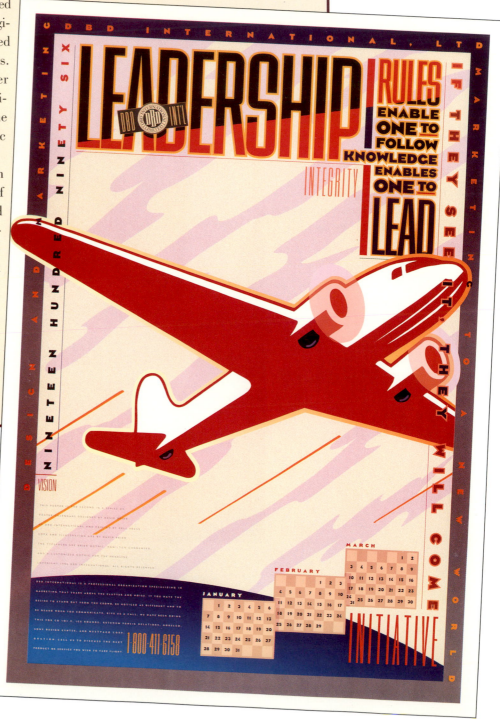

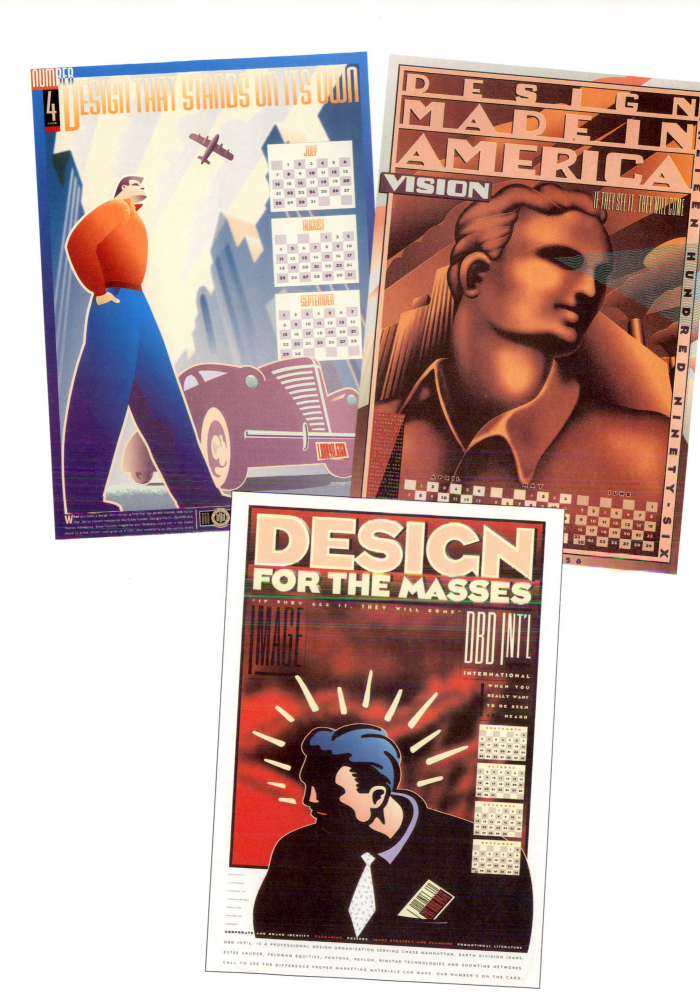

Asian New Year's Custom Serves International Audience

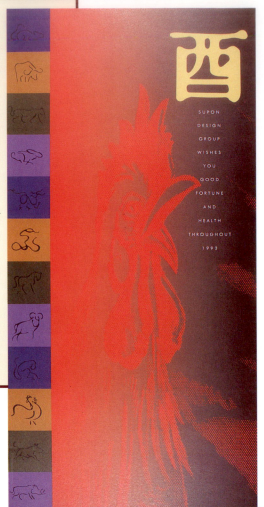

As a holiday greeting to celebrate the coming new year, Supon Design Group chose to send a greeting that the firm's Asian friends and clients could relate to. The firm conceived a poster celebrating 1993, the Chinese "Year of the Rooster."

To create the rooster image, firm principal Supon Phornirunlit and his staff brought an illustration of a rooster into Photoshop and enhanced it with the program's filters and posterization feature.

The icon in the upper right-hand corner of the poster is the Chinese symbol for "rooster." Other symbols for animals—stylized icons rather than Chinese symbols—run vertically on the poster's left-hand margin.

The 14" x 36" poster was printed on a white, uncoated stock and sent to five hundred of the firm's multinational clientele in mailing tubes.

Design firm: Supon Design Group
Client: Supon Design Group
Art director: Supon Phornirunlit
Designer: Richard Lee Heffner
Materials: French Speckletone, mailing tubes
Printing method: Sheetfed offset
Quantity: 500

Toy Soldier Salutes Clients and Studio Suppliers

This limited edition silkscreen print of a saluting tin soldier served as a holiday greeting for Sayles Graphic Design. The inscription, "A Time to Remember," lets clients and suppliers know that the design firm wishes to show its appreciation for their patronage and service.

Sayles produced the original illustration using charcoal and ink on vellum. The illustration was then screen printed in four match colors on dark green, 65-lb. uncoated cover stock. Each poster measures 28" x 37". A tag with the firm's message of appreciation, printed in gold ink, was attached to each print with red, gold and copper cord.

Design firm: Sayles Graphic Design
Client: Sayles Graphic Design
Art director: John Sayles
Designer/illustrator: John Sayles
Materials: Gilbert Oxford Cover
Printing method: Silkscreen
Quantity: 100

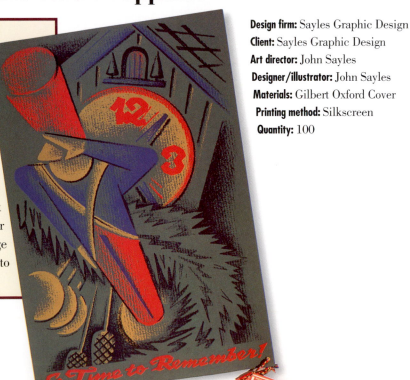

Team Effort Cuts Production Costs

This inventive calendar showcases the talents of two New York City-based freelancers: Paul Shaw, calligrapher, and Pamela Kogen, illustrator. Their collaborative effort yielded a beautifully rendered promotion that brought the team several awards and many freelance assignments. The team also benefited by sharing the production expenses for the job.

The calendar's theme of hats is established with a cover illustration of a hat box. Each of the calendar's twelve pages features a different hat appropriate to that season, starting in January with a New Year's Eve party hat and ending in December with a wool plaid Montero cap.

Most of the hats are realistically rendered in such an accurate way that their vintage needs no explanation. Nevertheless, each hat illustration is painstakingly labeled with a hand-lettered description as well as the hat's vintage. Each month's calendar is also hand-lettered beneath the hat illustrations.

Kogen's pen-and-ink illustrations and Shaw's calligraphy are remarkably compatible. Their hands-on look is further enhanced by the calendar's production methods and materials. Pages are letterpress-printed on watercolor paper—a technique that brings Kogen's ink washes to life. The use of letterpress printing, a technique used prior to the invention of offset lithography, further complements the calendar's hands-on look.

After the cover and interior pages were printed and trimmed, the calendars were spiral bound.

Design firm: Paul Shaw/Letter Design
Clients: Paul Shaw/Letter Design, Pamela Kogen, Illustration
Art directors: Paul Shaw, Pamela Kogen
Designer: Paul Shaw
Illustrator: Pamela Kogen
Materials: Arches watercolor paper (interior pages), matte board (cover)
Printing method: Letterpress
Quantity: 200

April

Fool's hat, c. 12th century.

S	M	T	W	Th	F	S
						1
2	3	4	5	6	7	8
9	10	11	12	13	14	15
16	17	18	19	20	21	22
23	24	25	26	27	28	29
30						

October

Genuine witch's hat.

S	M	T	W	Th	F	S
1	2	3	4	5	6	7
8	9	10	11	12	13	14
15	16	17	18	19	20	21
22	23	24	25	26	27	28
29	30	31				

Interactive Calendar Is Loaded With Fun and Creativity

Concrete Design Communications took a playful approach with its 1995 calendar design for Keilhauer, a Toronto-based company that specializes in contract seating.

The calendar features a colorful, child-like illustration of a city street. Die cut windows within the buildings and Keilhauer truck show different furniture—all printed on a rotating disk attached with a grommet to the illustrated front of the calendar. The disk encourages recipients to interact with the calendar, changing what is displayed in each of the windows. In addition to depicting Keilhauer's products, the edge of the disk that shows behind the buildings depicts a busy sky which also changes—revealing sun, moon, clouds and even an airplane as the disk is spun. The disk and street illustration were printed in four-color process on dull-coated stock adhered to heavy bristol board.

The actual calendar consists of a fourteen-page booklet comprised of a cover page, introductory page and a page for each month of the year, printed in green and black on a smooth, uncoated stock. The booklet is attached with staples to the rigid board bearing the illustration. An easel back, stapled to the back of each calendar, assured that the calendar would be displayed in the offices of its recipients—three thousand of Keilhauer's clients.

Design firm: Concrete Design Communications, Inc.
Client: Keilhauer
Art directors: Diti Katona, John Pylypczak
Designer: Susan McIntee
Illustrator: Jesse Hartland
Materials: Warren Lustro Dull (illustration), Domtar Plainfield (calendar)
Printing method: Sheetfed offset
Quantity: 3,000

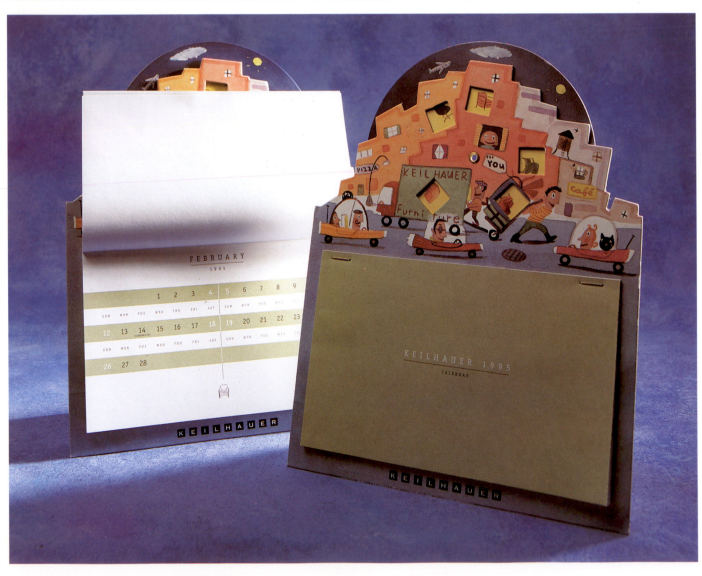

Retro Look Well Suits Calendar Full of Sage Advice

This calendar, titled "Cheap Advice," contains homilies, clever sayings and other words of wisdom acquired over the years and uncovered, through considerable research, by staff members of Concrete Design Communications.

Each page of the calendar is devoted to a month and a subject. Quotations from celebrities and luminaries ranging from Will Rogers to Mae West to Yogi Berra pertain to each calendar page's topic of wisdom. For visual interest, Ross MacDonald was hired to produce illustrations relevant to each month's topic. The nostalgic quality of MacDonald's illustrations is appropriate for the quotes, many of which date back to the turn of the century.

For the calendar's copy, designers Diti Katona and John Pylypczak used a san serif typeface with an industrial look that complements the retro style of the illustrations. The shadowed effect on the type was created in Photoshop.

The calendar was printed on a recycled stock in black, aqua, tan and opaque white. The white was used to visually "lift" the calendar's shadowed headlines from the tan background of the paper.

The 1996 calendar was mailed in February as a gift to clients of Toronto-based Concrete Design. It starts with the month of March and includes up to February, 1997. When asked why they chose to buck the traditional January through December calendar, Pylypczak admits they were too swamped to design their own self-promotion in the months leading up to January. "We were busy doing other people's calendars then," he says.

Design firm: Concrete Design Communications, Inc.
Client: Concrete Design Communications, Inc.
Art directors: Diti Katona, John Pylypczak
Designers: Diti Katona, John Pylypczak
Illustrator: Ross MacDonald
Materials: French Dur-O-Tone
Printing method: Sheetfed offset
Quantity: 1,000

Holiday Poster Gets High Exposure

"**O**ur Family Tree" expresses the delight and wonder children find in a decorated Christmas tree. John Sayles, of Sayles Graphic Design, chose to illustrate this joyful event in his creation of a limited edition poster as a gift to clients and vendors.

Sayles worked in ink and charcoal to create the illustration for the poster. His illustration, plus the mechanical for the inscription and type on the bottom of the print, were sent to a screen printer who printed the posters in five match colors on 80-lb. uncoated cover stock. The final poster measures 26" x 37"

The mailing was sent to generate goodwill and to thank studio friends for their help and support. A benefit of the poster format is that many recipients hung them in their offices as a holiday decoration, giving Sayles Design additional exposure.

Design firm: Sayles Graphic Design
Client: Sayles Graphic Design
Art director: John Sayles
Designer/illustrator: John Sayles
Materials: Curtis Tuscan
Printing method: Silkscreen
Quantity: 100

A Grand Undertaking

Pooling together the talents and products of many firms and individuals resulted in this award-winning calendar of heroic proportions.

Jointly produced by Hopper, Potlatch and Lithographix, the calendar features the work of twelve advertising agencies—one for each month of the year. Its huge 30" x 15" format allowed each agency to strut its stuff with an entire page of outstanding design and copy depicting the calendar's theme: the elements of time.

To demonstrate its printing capabilities, Los Angeles-based Lithographix printed the calendar in four color process plus two match colors and a varnish. To show how Potlatch and Hopper papers perform on press, each page is printed on a different paper line from each of the two mills.

Few of the calendar's forty-five hundred recipients failed to take notice of the over-sized calendar in its corrugated cardboard mailer, designed by Louey/ Rubino Design Group. Santa Monica, California-based Louey/ Rubino also designed the calendar's opening page and the January calendar page (both shown here) as well as providing art direction for the project.

Design firm: Louey/Rubino Design Group, Inc.

Client: Lithographix, Inc., Hopper Papers, Potlatch
 Corporation

Art directors: Robert Louey, Regina Rubino

Designers: Various

Illustrators: Various

Materials: Various Potlatch and Hopper papers

Printing method: Sheetfed offset

Quantity: 4,500

Air Carrier's Image Soars With High-Impact Calendar

To thank clients, suppliers and employees, Airborne Express sends a calendar to celebrate the coming new year. Seattle-based Hornall Anderson Design Works has produced the calendar for each of the past five years and has done such a splendid job, the Airborne Express calendar is eagerly anticipated every year by its recipients.

For this 1996 calendar, the designers at Hornall Anderson worked primarily with photographs supplied by Airborne to create visual interest and depict Airborne workers and vehicles on the job. They supplemented these visuals with studio shots that they art directed.

Futura, a clean, san serif typeface, was used to project a strong, industrial image in step with Airborne's reputation for expedient shipping. Bright, primary colors were employed to further enhance the calendar's streamlined, powerful look.

To achieve rich detail and optimal color, the calendar was printed on a high-gloss, premium coated paper.

Design firm: Hornall Anderson Design Works, Inc.
Client: Airborne Express
Art director: John Hornall
Designers: John Hornall, Heidi Favour, Lisa Cerveny
Materials: Potlatch Vintage Velvet Cover
Printing method: Sheetfed offset

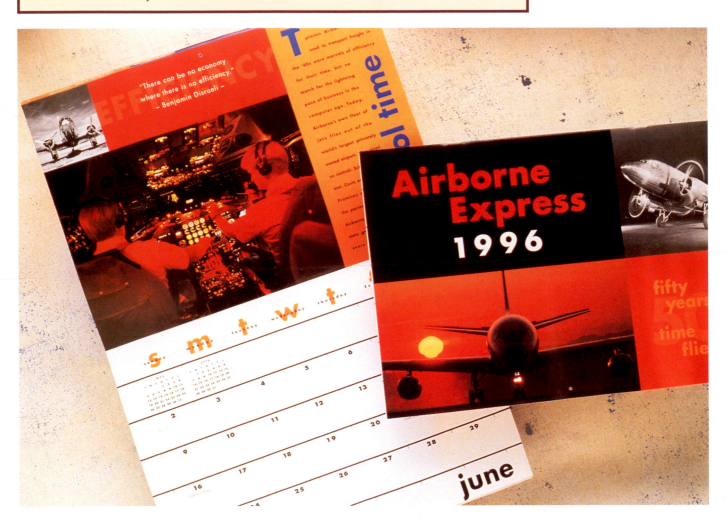

Budget-Wise Promotions

New Year's Promotion Gives 1995 the High Five

Pisarkiewicz & Company took its cue from the coming year, 1995, in its design of this New Year's promotion.

The New York City-based design firm developed a symbol for the new year by showing a hand with five fingers raised in place of the 5 in "1995." The symbol was used on a shipping carton containing a bag of herbal hand soak purchased from a gift catalog as well as other items, including a booklet that points out how—in spite of the conveniences of modern technology—our hands still take a beating.

The twelve-page booklet that accompanies the hand soak makes tongue-in-cheek references to the promotion's "handy" theme. Firm illustrators created original illustrations and made use of clip art to get their ideas across. For example, a man falling into a barrel of water supports the statement, "Pisarkiewicz promises to never let client spending get out of hand, however, just this once we're going to soak you."

Pisarkiewicz saved money on the promotion by having the booklet cover printed by a quick-print service. The booklet pages were printed on the studio's laser printer and assembled by Pisarkiewicz staff members. To tie-in the promotion's shipping box with the promotion's theme of hands, the design firm had a rubber stamp made of its 1995 "hand" symbol and used this, as well as other stamps, to decorate the box's exterior.

Design firm: Pisarkiewicz & Company
Client: Pisarkiewicz & Company
Art director: Mary F. Pisarkiewicz
Designers: Joe Dzialo, Luca Gasperi, Jennifer Harenberg
Illustrators: Joe Dzialo, Luca Gasperi, Jennifer Harenberg
Materials: 65 lb. bristol board, laser paper
Printing method: laser printer, photocopier, rubber stamping
Quantity: 250

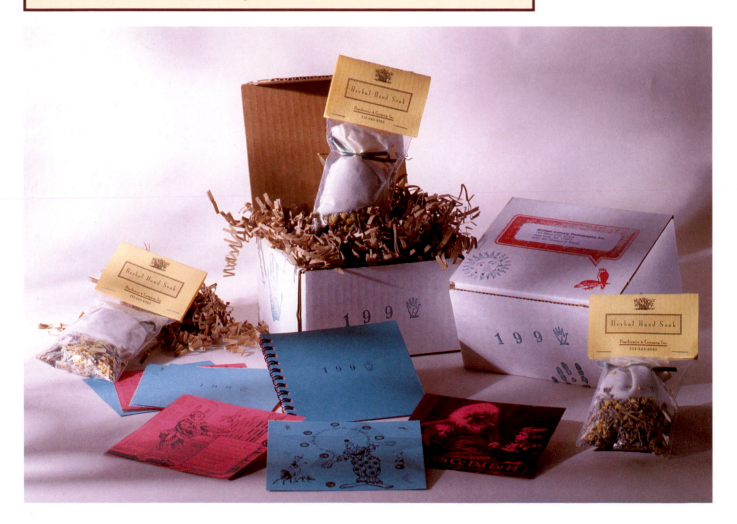

Gift Tag Promotion Makes Economical Use of Wasted Trim

This holiday present of gift tags gave Los Angeles-based Vrontikis Design Office a chance to showcase a variety of design applications. Clients and studio friends received four sets of four tags each, sixteen tags in all. Each tag demonstrates a different design style and color combination.

The firm was able to achieve this variety in part by ganging the tags onto the excess trim from client jobs. As a result, the tags are printed on four types of paper and use various colored inks. Vrontikis Design paid to have the printer trim the tags to their final size and drill holes for cord, but incurred no other charges for the printing of the promotion.

The firm purchased silk cord and threaded the tags in-house. The tags were mailed to clients and studio friends in shipping cartons.

Design firm: Vrontikis Design Office
Client: Vrontikis Design Office
Art director: Petrula Vrontikis
Designers: Petrula Vrontikis, Kim Sage
Copywriters: Tom Devine, Kirsten Livingston
Materials: Various papers, silk cord
Printing method: Sheetfed offset
Quantity: 500

Gift of a Picture Frame Includes Mini-Portfolio

K² Design made innovative use of a common picture cube with this holiday gift the firm sent to fifty of the firm's most valued clients.

The design firm purchased fifty picture cubes in primary colors from a local home furnishings retailer. Rather than portray a single image in the picture area of the cube, the firm decided to take advantage of the promotion as a chance to send a mini-portfolio of its illustrations. Illustrator Kurt Ketchum produced ten pen-and-ink renderings, one of which was used as the promotion's gift tag, another was used within the cube. The remaining eight were packaged in a simple folder which accompanied each picture cube.

The eight illustrations were photocopied and hand-trimmed to their 4" x 4" size. The K² design team chose a blue, uncoated stock for the portfolio folder, and trimmed this stock to produce fifty of the folders.

Multiple copies of a pen-and-ink bee illustration were ganged together and then photocopied onto yellow self-adhesive labels purchased from an office supply store. These were used to seal all of the portfolios. The completed cubes were wrapped in blue tissue paper, tied with jute cord and hand-delivered to clients. Because K² Design did all assembly and printing in-house, the firm incurred no expenses other than the cost of materials.

Design firm: K² Design

Client: K² Design

Art directors: Claire Kaler, Kurt Ketchum

Designer/illustrator: Kurt Ketchum

Materials: Cross Pointe Genesis, picture cubes, jute twine, tissue paper, self-adhesive labels

Printing method: Photocopier

Quantity: 50

A Pro-Environment Gift of Christmas Tree Seeds

Red Hook, New York-based I & Company and freelance illustrator Daniel Baxter collaborated on this holiday gift of evergreen seeds. The design team's custom seed package and fold-out tag made the gift a very special way of demonstrating their capabilities to clients and studio friends while also showing their commitment to the environment.

The design team purchased its own seeds wholesale from a distributor in Massachusetts and then fashioned its own seed packets by taking an existing seed packet, disassembling it and using it as a pattern for a new packet design. The pen-and-ink illustration on the front of the packaging shows a star shooting over the top of Christmas trees. Handlettering the team's own "4-Evergreen" brand name complements the illustration's rustic appeal.

An accordion-folded tag, employing the same illustration style as the seed packet,

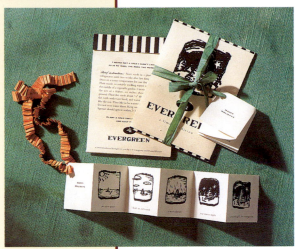

depicts the growing stages of the tree in six panels. The tags and seed packets were printed on I & Company's studio laser printer on a flocked, uncoated paper with high recycled content. The pieces were then trimmed, folded, glued and assembled by hand. The 4-Evergreen packets were filled with seed, tied with ribbon and tagged before they were mailed in an invitation-sized envelope of the same stock as the packet and its tag.

Designer Carol Neiley says the cost of mailing the promotion came to fifty-two cents per piece. She estimates the cost of the entire promotion to be at less than a dollar per piece.

Design firm: I & Company
Clients: I & Company, Daniel Baxter
Art director: Carol B. Neiley
Designer: Carol B. Neiley
Illustrator: Daniel H. Baxter
Materials: Seeds, ribbon, Cross Pointe Genesis
Printing method: Laser printer
Quantity: 250

Mooing Box Begs to be Opened

"Happy Noo Year" is the greeting on this New Year's promotion that literally "moos" when handled. Carol Neiley, firm principal of I & Company, purchased noise-making "moo makers," that moo like a cow when jostled, from a novelty store in New York City. To customize the moo makers, Neiley and freelance illustrator Daniel Baxter created a visual theme for the piece that incorporates Baxter's illustrations. The wrapper is printed with Baxter's playful pen-and-ink illustration of cows singing to an old-time victrola. The illustration was step-repeated so that several could be ganged onto one 8½" x 11" sheet. Neiley and Baxter printed enough copies of the illustration to wrap and glue the printed illustration onto 250 of the moo makers. A small label bearing I & Company's address and phone number was also glued to the bottom of each moo maker.

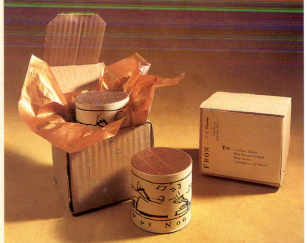

The moo makers were wrapped in copper tissue paper before being placed back in their original boxes for mailing. Neiley and Baxter customized each box by gluing on a mailing label, printed on the same stock as the illustration and identification label.

The sealed boxes made a mooing sound whenever they were handled, so that those who received the promotion couldn't resist opening it to see what was making the mysterious noise.

Design firm: I & Company
Clients: I & Company, Daniel Baxter
Art director: Carol B. Neiley
Designer: Carol B. Neiley
Illustrator: Daniel H. Baxter

Materials: Moo toys, cardboard boxes, tissue paper, Canson paper
Printing method: Laser printer, rubber stamping
Quantity: 250

Postcard Celebrates New Year With Double Entendre

New York City-based Mike Quon Design Office celebrated the Chinese New Year by heralding in 1996 as "The year of the mouse." The firm created a tongue-in-cheek portrayal of the mouse with this holiday postcard that was sent to an international clientele encompassing both Asian and Western cultures.

Firm principal Mike Quon created the playful marker rendering of the mouse and duplicated it in Adobe Illustrator to create a shadowed effect. Other graphics on the front of the card include the firm's logo and a 3D rendering of a mouse created on the computer in Adobe Dimensions. The copy on both sides of the card gives a description of the personality traits common to people born during the year of the mouse.

The card was offset printed on a glossy, coated stock and trimmed by the printer into postcard-sized cards. Mike Quon Design Office mailed close to two thousand of the cards to clients, friends and colleagues.

Design firm: Mike Quon Design Office

Client: Mike Quon Design Office

Art director: Mike Quon

Designer: Mike Quon

Illustrators: Mike Quon, R. Castilho

Materials: Champion Kromekote

Printing method: Sheetfed offset

Quantity: 2,000

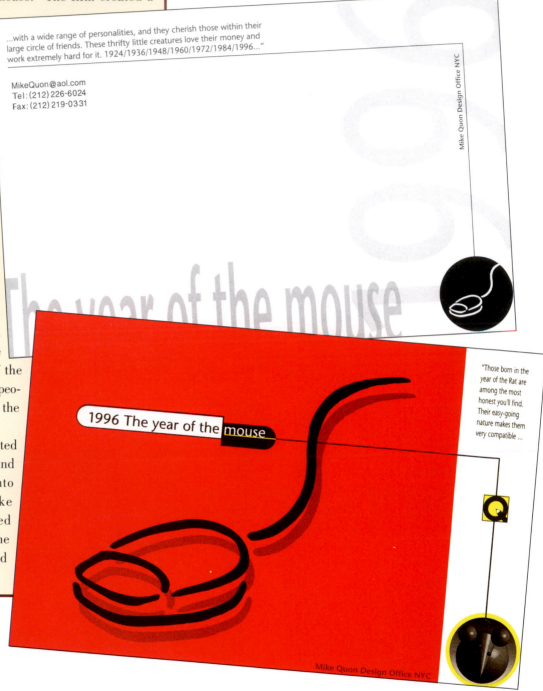

...with a wide range of personalities, and they cherish those within their large circle of friends. These thrifty little creatures love their money and work extremely hard for it. 1924/1936/1948/1960/1972/1984/1996..."

MikeQuon@aol.com
Tel: (212) 226-6024
Fax: (212) 219-0331

Mike Quon Design Office NYC

1996 The year of the mouse

"Those born in the year of the Rat are among the most honest you'll find. Their easy-going nature makes them very compatible ...

Mike Quon Design Office NYC

Common Nails Dress Up for the Holidays

Phoenix-based Richardson or Richardson effectively transformed common nails into festive "ornaments" for this holiday greeting for a construction firm.

The story behind the "Mistletoenails" and the firm's greeting are printed in gray on a richly textured, uncoated stock to which the ornamental nails were attached with wire. Richardson or Richardson purchased the nails from a local hardware store and gave them a festive look with embellishments of holiday ribbon and artificial holly berries. The card is fitted to the bottom of a 4" x 8" shipping box, purchased from a shipping supply company, for easy mailing.

The promotion was mailed by Rowland Constructors to five hundred of its clients. The construction firm and Richardson or Richardson received many appreciative letters from recipients who were delighted by its wit.

Design firm: Richardson or Richardson

Client: Rowland Constructors

Art director: Forrest Richardson

Copywriter: Valerie Richardson

Materials: Simpson Gainesborough, shipping boxes, nails, ribbon, purchased decorations

Printing method: Sheetfed offset

Quantity: 500

"Brilliant" Design Is Also Cost-Effective

This budget-minded holiday greeting card achieves a rich look through its use of metallic silver ink on color-flecked, dark blue paper.

Designed by New York City-based Platinum Design, the card features a star-shaped configuration of holiday Christmas light bulbs on the front. The card's interior greeting supports the light bulb theme with its inscription, "Have a brilliant holiday!"

The card's elegant look cost no more than a one-color run. The rich textural look of the card's flocked cover stock was enhanced by mailing the card in a contrasting envelope made from the same line of flocked paper.

Before mailing the cards to one thousand clients and studio friends, Platinum designers embossed the firm's name and address on the back of each envelope with a hand embosser.

Design firm: Platinum Design, Inc.

Client: Platinum Design, Inc.

Art director: Vickie Peslak

Designer: Kelly Hogg

Materials: Fox River Confetti

Printing method: Sheetfed offset, hand embossing

Quantity: 1,000

Holiday Gift Is Cost-Efficient and Practical

Whoever said we weren't practical," claims this holiday gift of a crocheted satchel. I & Company and freelance illustrator Daniel Baxter, of Red Hook, New York, conceived this clever gift as a means of promoting their services to current and prospective clients over the holidays.

The satchels were purchased wholesale from New York City-based Kate's Paperie. They fold neatly within themselves to form a small pouch which Baxter and Neiley could stuff inside a 6" mailing tube.

The promotion's greeting rides on a hang tag designed by Neiley. The tag is decorated on the opposite side with illustrations by Baxter. The tags were inexpensively printed on red and green uncoated stock on Neiley's studio laser printer. The paper was hand-trimmed to conform to the shape of the tag. Neiley and Baxter attached each tag to its satchel by placing a grommet hole on the top of each tag and threading a ribbon through it. To coordinate the promotion's mailing tubes with its contents, Baxter's illustrations on the tag were made into rubber stamps so that each tube could be stamped with multi-colored images.

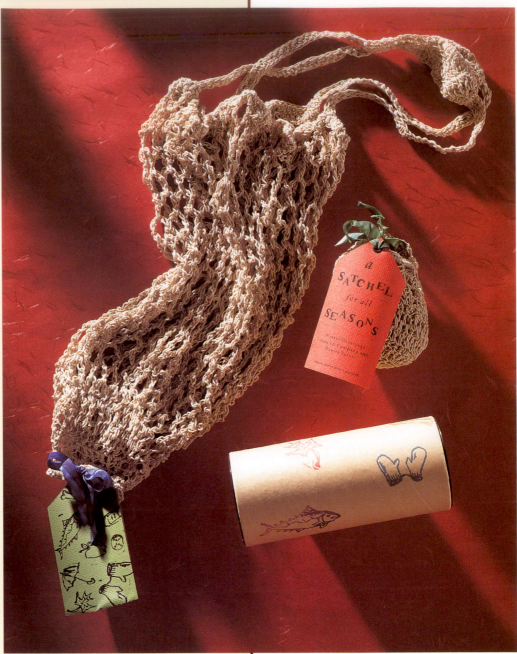

Design firm: I & Company
Clients: I & Company, Daniel Baxter
Art director: Carol B. Neiley
Designer: Carol B. Neiley
Illustrator: Daniel H. Baxter
Materials: Ribbon, mailing tubes, Cross Pointe Genesis, satchels
Printing method: Laser printer, rubber stamping
Quantity: 250

Holiday Card Brings Good News

This holiday card brings glad tidings in the form of actual newspaper clippings that report only good news.

This simple yet powerful card was also easy and cost-efficient to produce. Art director Barry Shepard and designer Nathan Joseph, of SHR Perceptual Management, first had sheets of recycled cover stock printed in red and green and accordion-folded into five panels. Four news stories were chosen for their positive impact and photocopied onto newsprint paper. Staff members hand tore and glued each story onto the center of each panel. The final panel of the card carries the firm's greeting: Peace on earth, good will toward men.

In addition to receiving a positive response from clients, suppliers and others who received it, the card has received recognition in the form of several awards.

Design firm: SHR Perceptual Management
Client: SHR Perceptual Management
Art director: Barry Shepard
Designer: Nathan Joseph
Materials: Newsprint paper, Fox River Confetti
Printing method: Sheetfed offset, photocopier
Quantity: 500

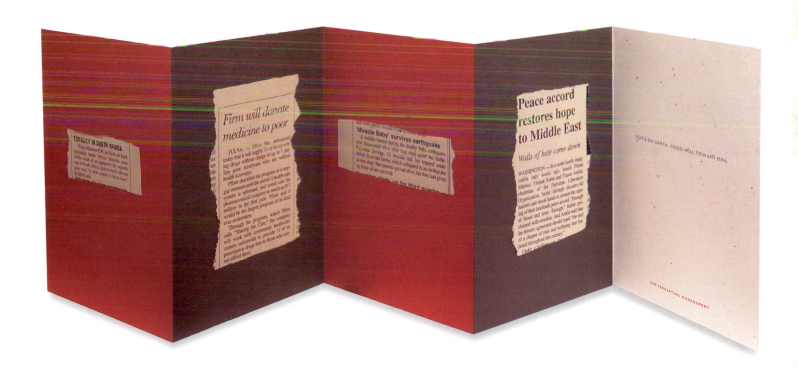

Design Firm Makes a Holiday Gift of Its Morning Indulgence

As a holiday gift, St. Louis-based Group C Design presented this gift-wrapped box of custom-labeled coffee to 250 current and prospective clients. The coffee is a favorite of the design firm and one that is constantly brewed in its studio coffee maker.

The coffee was purchased from Kaldi's, a local coffee shop, in brown kraft-paper flavor-seal bags. Using Adobe Illustrator and QuarkXPress, firm designer Jenny Azubike created a custom label with Group C Design's name on it for the two types of coffee. The label art was ganged onto an 8½" x 11" area so that several could be printed at one time on a color printer at a local service bureau. Group C Design staff members trimmed the labels and glued each to its appropriate bag.

Staff members packed the coffee bags in cardboard boxes filled with corrugated paper and wrapped each with a sheet of red, uncoated stock printed with a coffee cup motif and the firm's greeting. Azubike printed these sheets on the firm's laser printer. Staff members wrapped each box of coffee with red and tan raffia tied into a festive bow before hand-delivering each package.

Design firm: Group C Design
Client: Group C Design
Designer/illustrator: Jenny Azubike
Materials: Fox River Confetti, laser paper, raffia
Printing method: Dye sublimation printer, laser printer
Quantity: 250

SECTION

5

Cards

Inventive Card Gives Santa's Reindeer Alter-Identities

Dallas-based Brainstorm, Inc., created this holiday greeting featuring Santa's reindeer as "Braindeer."

Each of the piece's three designers contributed to this unique promotion by creating two reindeer illustrations. The illustrations cover a broad range of mediums and stylistic interpretations ranging from traditional gouache to computer-generated images. The end result is a rich showcase of the firm's illustration and design capabilities.

The Braindeer illustrations were printed in four-color process on white uncoated stock. The firm saved money by printing just one side of the sheet and accordion folding it into eight panels—one for each of the six illustrations and two for copy. The printer glued each end of the illustrated panel to a 7" x 12" piece of French Dur-O-Tone cover stock, a recycled stock that simulates the look of industrial chipboard. To customize the piece, a four-color graphic of reindeer encircling the globe was glued to the outside of each cover board as well. The piece was mailed to one thousand current and prospective clients in a 9" x 12" envelope.

Design firm: Brainstorm, Inc.
Client: Brainstorm, Inc.
Art directors: Chuck Johnson, Ken Koester
Designers: Chuck Johnson, Ken Koester, Rob Smith
Illustrators: Chuck Johnson, Ken Koester, Rob Smith
Materials: French Dur-O-Tone (cover), white uncoated text (interior pages)
Printing method: Sheetfed offset
Quantity: 1,000

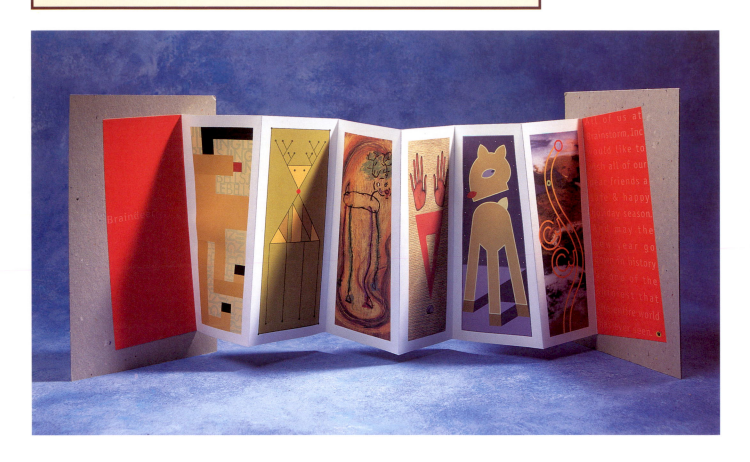

"Peek-a-Boo" Card Reveals Surprises

When Massachusetts Mutual Life Insurance commissioned Boston-based Stewart Monderer Design to design its holiday card, Monderer was given a sizeable budget and free rein to come up with a non-denominational concept. Monderer and staff designer Ellen Conant conceived an interactive card with die-cut windows that, when opened, reveal illustrations of the sun, moon and stars.

Producing the card required custom die cuts and gluing a separate sheet printed with the sun, moon and stars to the back of each card. Although the high cost of producing such a card wasn't off-putting for a large corporation such as Massachusetts Mutual, its production budget would've been far beyond the means of a design firm the size of Monderer's. However, Monderer was able to produce the same card for his firm by piggy-backing his card on the press run of his client's card. With Massachusetts Mutual's permission, Monderer produced the art for a separate plate with his firm's name for the front of the card. Monderer incurred only the cost of the extra plate, additional press time and paper to produce five hundred extra cards for his

firm—a figure he estimates to be less than two hundred dollars.

To avoid a conflict of interest, Monderer sent his firm's card out the following holiday season—a year after Massachusetts Mutual Life sent out its card.

Design firm: Stewart Monderer Design, Inc.
Client: Stewart Monderer Design, Inc.
Art director: Stewart Monderer
Designer/illustrator: Ellen Conant
Materials: Monadnock Astrolite
Printing method: Sheetfed offset, die cutting
Quantity: 500

Three-Dimensional Star Has Universal Appeal

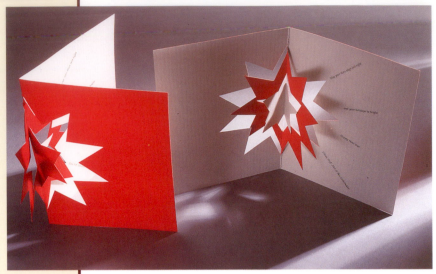

Steff Geissbuhler created this three-dimensional card with a multi-denominational die cut star as its focal point.

The series of die cuts at the card's center fold actually incorporates a five-pointed American star, a six-pointed Jewish Star of David, an eight-pointed Bethlehem star and a ten-pointed Islamic star. Producing the card on red and white duplex cover stock enhances the three-dimensionality of the piece.

Geissbuhler originally designed the card for Continental Anchor, Ltd., a company that specializes in engraving, printing and die cutting. Continental Anchor not only produced enough cards imprinted with its name for its corporate clients, but also produced extra cards that were engraved with Geissbuhler's personal greeting in addition to the greeting from Continental Anchor's president, Gerry Schneiderman. As a result, both were able to send a custom-designed personal card at a fraction of what it would have cost had they produced the cards on their own.

Designer: Steff Geissbuhler
Clients: Continental Anchor Ltd., Schneiderman family, Geissbuhler family
Art director: Steff Geissbuhler
Designer/illustrator: Steff Geissbuhler
Materials: Neenah Classic Columns Cover and matching envelopes
Printing method: Engraving
Quantity: 750

Card Depicts Studio Staff as Kids

This card from The Dunlavey Studio declares that "Christmas is for Kids," and backs it up with childhood photos of its staff members.

The card's message on the first panel is hand lettered in the kind of scrawling print typical of children first learning how to write. Its realistic look was no accident—it was done by the five-year-old son of a Dunlavey staffer. Lines from loose leaf paper printed in a screen of black complete the look of childish printing on primary school paper.

The second and third panels show childhood portraits of each Dunlavey staff member identified by their signature beneath each photo. Drop shadows in a screen of black were created to suggest the look of haphazardly scattered snapshots. The card closes with the firm's holiday greeting rendered in the same childish scrawl.

The card was printed in green and black on uncoated white cover stock and accordion folded into its four-panel configuration.

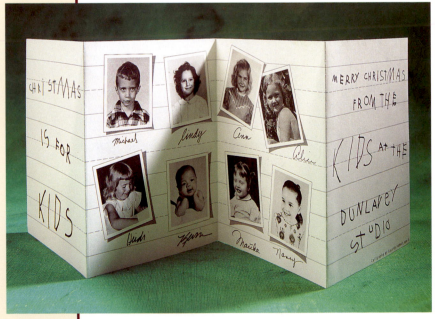

Design firm: The Dunlavey Studio
Client: The Dunlavey Studio
Art director: Michael Dunlavey
Designer: Lindy Dunlavey
Photographers: Various
Materials: Simpson Starwhite Vicksburg Cover
Printing method: Sheetfed offset
Quantity: 500

Holiday Card's Jingle Bell Makes Merry Music

Rickabaugh Graphics assured its holiday greeting would get attention when the firm designed this card with a jingle bell attached. Clients and suppliers who received the promotion couldn't resist opening it to see what was within an envelope that jingled.

Focusing on holiday bells as its theme, the card features lyrics from "Silver Bells," "Jingle Bells" and other holiday songs about bells. Ingenious folds and die cuts create a window for the bell so that it's clearly visible before the card is opened.

The card was printed on a duplex stock so the exterior is red, and the interior white. The card's opening inscription was printed in silver on the red side, while the interior was printed in deep green. Spire, a typeface with an antique look, was used to create first initial caps while a holly pattern, created from clip art, was used to decorate the card's opening message and song titles.

Before mailing, Rickabaugh Graphics staff members tied each jingle bell with green ribbon to a separate piece of cover stock and inserted it within the center of each card. Staff members also assembled the cards and stuffed them in their envelopes.

Design firm: Rickabaugh Graphics
Client: Rickabaugh Graphics
Art director: Eric Rickabaugh
Designer: Tina Zientarski
Materials: Strathmore Grandee, satin ribbon, jingle bells
Printing method: Sheetfed offset
Quantity: 150

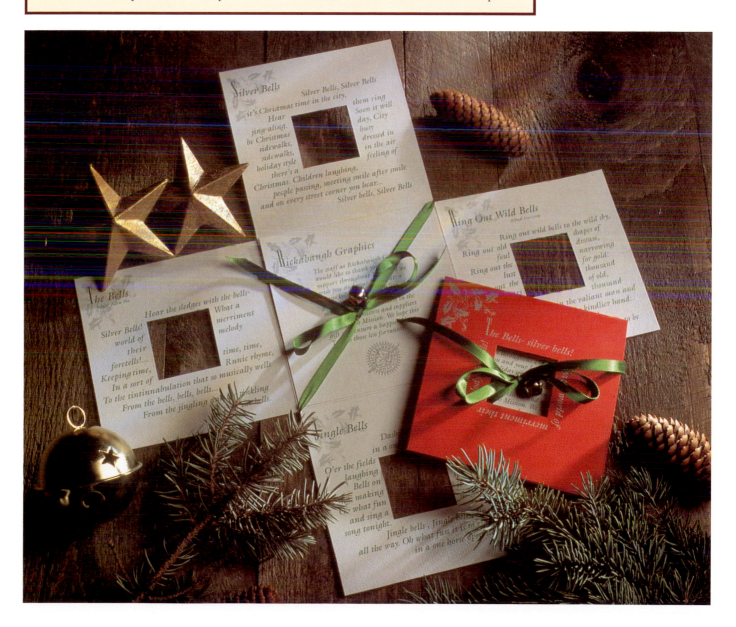

Photoshop Enhancements Yield a Dramatic Holiday Card

Margo Chase Design chose a quote from Emily Dickinson about hope, "the thing with feathers that perches in the soul," to serve as the theme for this unusual holiday card.

Chase chose to personify hope as it is depicted in Dickinson's verse by stylizing a photo of an angel created by photographer Merlyn Rosenberg. Chase brought the photograph into Photoshop to create a solarized effect. Dramatic background effects on the front and back of the card were also created in Photoshop.

Chase's unique design sensibility is expressed in the elaborate motif that appears opposite the image of the angel. She repeats this design element on the message side of the card where it is treated with a softer palette of pastel blues and greens.

The card is printed in four-color process plus copper on the image side, four-color process plus gold on the message side. It was mailed in a standard business envelope to one thousand of Margo Chase Design's clients, vendors and colleagues. Chase also had a miniature version of the card printed on a tag. The tag was attached to bottles of spirits that were given to preferred clients and vendors.

Design firm: Margo Chase Design

Client: Margo Chase Design

Art director: Margo Chase

Designer: Margo Chase

Photographer: Merlyn Rosenberg

Materials: Simpson Kashmir Cover

Printing method: Sheetfed offset

Quantity: 1,000

Simple Message Expressed with Elegant Rendering Style

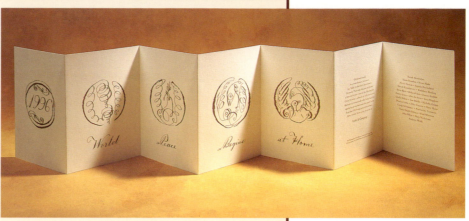

Minneapolis-based Little & Company produced this New Year's card that uses an evolving image in a circle to communicate its wish for world peace.

The card starts with "1996" hand-lettered in a circular frame. Illustrator Jack Molloy continues the circular frame in brush-and-ink illustrations on the following panels, which depict the world, a dove bearing an olive branch, an embryo and finally a dove with its young. The series of circular renderings illustrate the card's message: "World Peace Begins at Home." The final two panels bear the firm's closing message and the names of Little & Company's staff members, set in a circular configuration.

The card's simple yet elegant design was printed in gold on a smooth, uncoated cover stock. Its 30" length was folded into seven accordion-folded panels. The folded card was mailed in a 6½" x 4¾" invitation-sized envelope to Little & Company clients.

Design firm: Little & Company
Client: Little & Company
Art director: Paul Wharton
Designer: Lisa Hagman
Illustrator: Jack Molloy
Materials: Simpson Starwhite Vicksburg Cover
Printing method: Sheetfed offset
Quantity: 800

A Wolf in Angel's Clothing

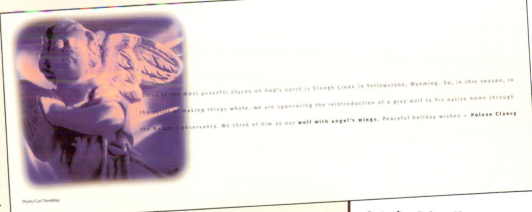

Photo/Carl Tremblay

How do you let people know you've given a holiday gift of a wolf? This card makes the announcement with sensitivity and an artfully reproduced image of an angel.

Boston-based Polese Clancy has made a practice of contributing to a charity at Christmas time. This holiday promotion lets the firm's clients and studio friends know that a gray wolf has been reintroduced to its native home as a result of the firm's donation to the Nature Conservancy. Clever copy ("We think of him as our wolf with angel's wings") and an intriguing image of an angel successfully marry the firm's mission with a holiday theme.

The photo of the angel was supplied by photographer Carl Tremblay. Designer and firm principal, Ellen Clancy, used Photoshop to enhance and vignette the angel image. The card was printed on one side in five match colors on an ivory cover stock.

The strong horizontal thrust of the card is due to the firm's decision to use its business envelopes for the card's mailing. As a result, the card's colors and typography were chosen so they would coordinate with the firm's existing envelopes.

Design firm: Polese Clancy
Client: Polese Clancy
Art director: Ellen Clancy
Designer: Ellen Clancy
Photographer: Carl Tremblay
Materials: Hopper Kiana Cover
Printing method: Sheetfed offset
Quantity: 750

Summer Hours Postcard

Boston-based Polese Clancy has made a studio tradition of closing shop at 3:30 on Fridays from mid-June to the first week in September. "We do a lot of annuals, so people tend to work a lot of overtime during the winter," says firm principal Ellen Clancy. To make up for the winter overload, the design firm lets its employees leave early on summer Fridays. The summertime hours help staff beat rush hour and weekend traffic for trips to the seashore and mountains.

During the month of May, the design firm makes an announcement of its summertime hours with a postcard mailing to clients and suppliers. The postcard gives the firm a chance to showcase its capabilities when it comes to designing clever and cost-effective direct mail.

This postcard features a computer-generated illustration, created in Photoshop, of a photo of a daisy combined with a clip art image of an antique watch face. To save money, the card was printed in one color, a summery shade of green, at a quick-print shop.

Design firm: Polese Clancy
Client: Polese Clancy
Art director: Ellen Clancy
Materials: Bristol card stock
Printing method: Sheetfed offset
Quantity: 700

Halloween Card Features Fly-Away Ghost

Pasadena, California-based Smullen Design caught current and potential clients off guard with this Halloween card containing a pop-up, flying ghost.

Although it looks complicated, the card was actually rather easy to produce. It was printed in three match colors on two pieces of 100-lb. coated cover stock glued together at both ends. The piece of stock used for the inside portion of the card is slightly larger and folds in the opposite direction of the card fold. A die-cut slit in the middle holds a cut-out of the ghost. Recipients were surprised to find that when the card is folded shut, the ghost actually flies out of the card.

Firm principal Maureen Smullen says the card cost her firm very little to produce. The printer ran extra copies of the card with their name on it as a trade-off for free printing of Smullen's cards.

Design firm: Smullen Design
Client: Smullen Design
Designer: Maureen Smullen
Materials: Potlatch Vintage Gloss
Printing method: Sheetfed offset
Quantity: 2,000

Autumn Promo Celebrates Nature

Anyone who has ever picked up an autumn leaf and treasured it for its brilliant color can appreciate this fall promotion celebrating the season's colorful foliage. Minneapolis-based Diversified Graphics sent this promotion to 150 of its select clients. The mailing included a real leaf along with an autumn poem by Ralph Waldo Emerson.

The leaves were gathered by art directors Lisa Henkemeyer and Janice Meintsma and pressed between books to flatten them. Each leaf was then tied with jute twine to a copy of the poem which was laser printed on Yukou Bamboo, a machine-made paper manufactured in China. The poem was set in Stemple Garamond Bold and then manipulated on the computer for a distressed, antique look.

The pieces were enclosed in a clear, cellophane envelope purchased from a local envelope supplier so the leaf would be visible from the outside of the promotion. To add substance to the mailing and protect the leaf, a same-sized sheet of binder's board was inserted along with a sheet of glassine. Each envelope was sealed with a strip of copper tape purchased from a stained glass supply house.

Design firm: Diversified Graphics
Client: Diversified Graphics
Art directors: Lisa Henkemeyer, Janice Meintsma
Designer: Lisa Henkemeyer
Materials: Binder's board, glassine, Yukou Bamboo
Printing method: Laser printer
Quantity: 150

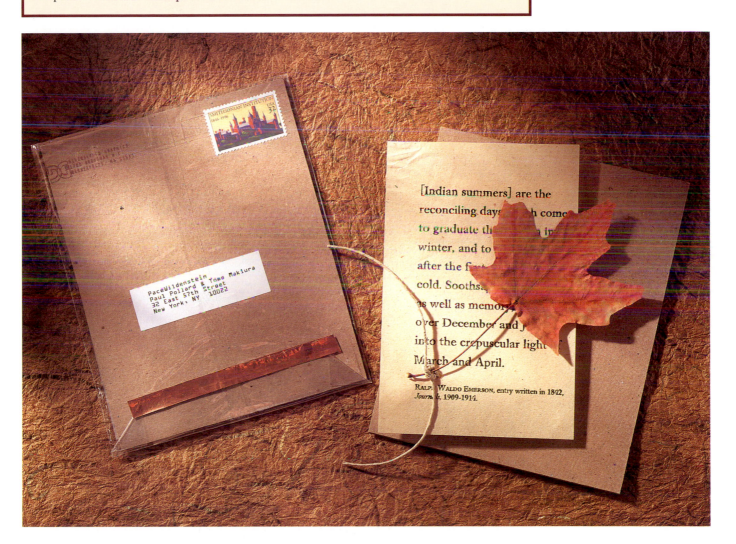

Stand-Up Card Offers High Exposure

Anchor Engraving, a New York City-based company that specializes in die-cutting, engraving, and printing, commissioned local design firm Chermayeff & Geismar to design a card that would showcase all of the firm's capabilities. Art director Steff Geissbuhler chose to incorporate clever die cuts into a holiday promotion that could stand alone as a three-dimensional card. The display aspect of the card resulted in far more visibility than most holiday greeting cards receive.

The card was produced from two sheets of uncoated cover stock printed in four match colors and engraved on both sides. The printed sheets were then die cut into a three-candle configuration. Notches at juncture points were cut and scored folds were added. The two pieces were assembled together into a stand-up configuration, but folded flat for mailing.

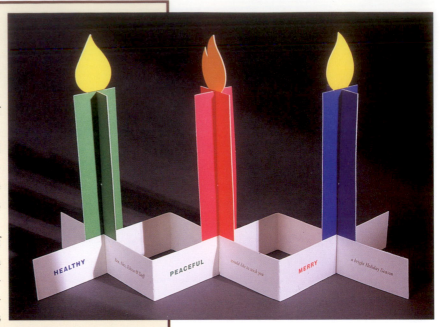

Design firm: Chermayeff & Geismar, Inc.
Client: Anchor Engraving
Art director: Steff Geissbuhler
Designer: Petra Klusmeyer
Materials: Curtis Tweedweave Cover
Printing methods: Offset, engraving, die cutting
Quantity: 750

A Holiday Card Made From Studio Trash

Seattle-based Hornall Anderson Design Works is known for its sophisticated holiday promotions, faithfully designed and sent to clients and vendors every Christmas season. The 1993 holidays, however, found the firm's staff swamped with client projects and searching for a holiday promotion idea at the last minute.

In order to produce five hundred cards within a two-week time frame, designers Jack Anderson and Mary Hermes devised a card made from scrap paper from previous jobs and other items found in their studio: translucent vellum and raffia. The card's inscription, wishing clients a warm holiday season and a "resourceful" New Year, is underscored by its use of materials that were otherwise destined for the trash can.

The card's materials and production support its eco-friendly theme. The red paper is Fox River Confetti, a 100 percent recycled paper. Its inscription was printed on a letterpress, a printing process which is easier on the environment than conventional offset printing. The three layers of paper were trimmed and torn in a variety of shapes and were then tied together by Hornall Anderson's staff.

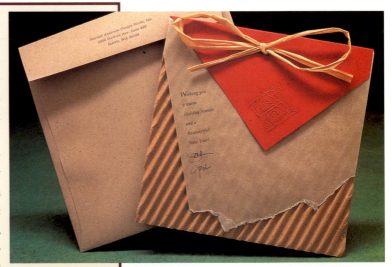

Design firm: Hornall Anderson Design Works
Client: Hornall Anderson Design Works
Designers: Jack Anderson, Mary Hermes
Materials: Corrugated cardboard, raffia, vellum, Fox River Confetti
Printing method: Letterpress
Quantity: 500

A Politically Correct Christmas Card

It's Beginning to Look a Lot Like Correctness," is the title of this holiday card that makes tongue-in-cheek commentary on our culture's current penchant for being "politically correct."

Warkulwiz Design Associates uses the card to portray how holiday icons might be portrayed in a politically correct manner. For instance, Santa Claus is depicted as a "polar-based seasonally active person of noncolor" and Rudolph the red-nosed reindeer is described as "nasally inconvenienced."

The focal point of the card is a set of four illustrations, tagged with their politically correct labels. These illustrations consist of doctored clip art, as well as original illustrations that imitate the clip art's vintage style. The card was printed in two match colors on an "ecologically correct" cover stock with high recycled content.

The card must have struck a familiar chord. Firm principal Bob Warkulwiz says it was one of the firm's "most successful holiday promotions."

Design firm: Warkulwiz Design Associates, Inc.
Client: Warkulwiz Design Associates, Inc.
Art directors: Bob Warkulwiz, Mike Rogalski
Designer: Kirsten Engstrom
Illustrators: Mike Rogalski
Materials: Cross Pointe Genesis
Printing method: Sheetfed offset
Quantity: 1,000

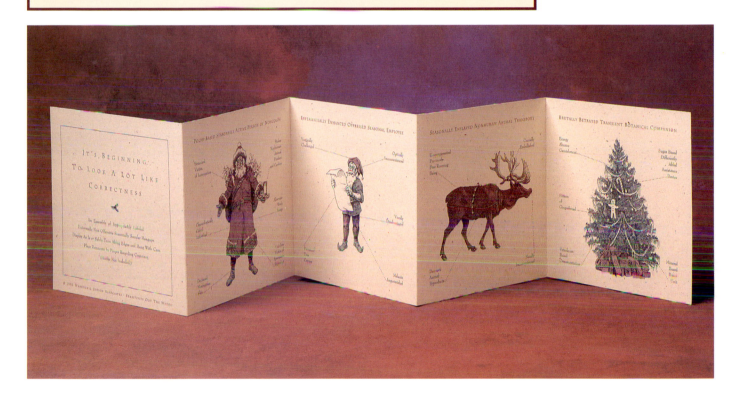

Clever Folding Reveals Multidimensional Message

S ent during the 1995 holiday season to celebrate the new year, this unusual card is totally reversible. Its unique configuration of die cuts and folds gives messages on both sides equal impact.

Designed by Stan Brod of Cincinnati-based Wood-Brod Design for Berman Printing, this three-dimensional card looks more complex than it actually is. The card is configured as a four-panel, accordion-folded piece with three sets of parallel die cuts made at each of three folds. The three-dimensionality of the piece comes into play with the direction of the folds: each die-cut area folds in the *opposite* direction of the fold of the card.

The card's message on one side reads simultaneously as "Hope" and "Peace." Brod contrasted these messages by setting one word as a positive image in silver, while the other word reads as a reverse in white against a silver ground. On the opposite side, the same treatment is given to the word "Joy" and "1996," printed in gold ink.

The card is printed on 100 lb. Mohawk Astrolite. Although it looks bulky, it folds compactly, fitting neatly into a no. 10 envelope. It was mailed to over two thousand of Berman's and Wood-Brod's clients for no more than what it costs to send standard first-class mail. In fact, the cost for mailing and producing the cards was relatively inexpensive—well under a dollar per card.

Design firm: Wood-Brod Design
Client: Berman Printing
Art director: Stan Brod
Designer: Stan Brod
Materials: Mohawk Astrolite Cover
Printing method: Sheetfed offset
Quantity: 2,450

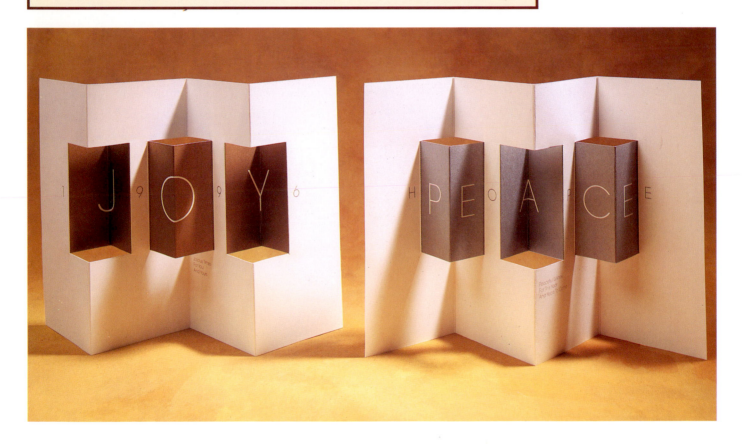

An International Wish for Peace

Cincinnati-based Zender + Associates' wish for world peace is expressed in eleven different languages on this holiday postcard.

The card has no top or bottom, and reads just as effectively no matter how it is turned. Many clients and suppliers who received the card made a connection between the card's multidirectional layout and its multilingual message—that people of different cultures approach peace with their own unique vision.

The card was printed on dull-coated cover stock in metallic green and dark red.

Design firm: Zender + Associates, Inc.

Client: Zender + Associates, Inc.

Art director: Nancy McIntosh

Designer: Nancy McIntosh

Materials: S.D. Warren Lustro Dull Cover

Printing method: Sheetfed offset

Quantity: 500

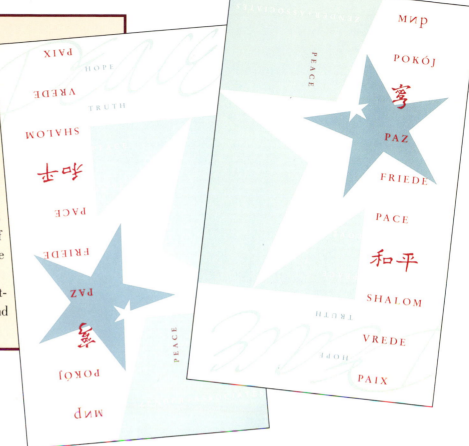

Printer's Holiday Card Demonstrates Press Capabilities

This holiday card for Donahue Printing plays on the company's name in its suggestion to "Don A Hue" and celebrate diversity.

The card was designed by Los Angeles-based Vrontikis Design Office to show off the printer's press capabilities. The design firm chose metallic inks and embossing to demonstrate Donahue's range of services. An ornate script typeface, Poppyl Residenz, was chosen for the "Don A Hue" message. Designer Kim Sage used Photoshop to create the interesting background and border effects.

The card achieves a shimmery look as a result of printing metallic gold and copper along with purple, olive green and black. A premium coated cover stock was used for additional sheen. The card's focal point, the scripted "Don A Hue," was embossed after the card was printed so that it stands out in relief against its background.

Design firm: Vrontikis Design Office

Client: Donahue Printing

Art director: Petrula Vrontikis

Designer: Kim Sage

Materials: Potlatch Eloquence Cover

Printing method: Sheetfed offset

Quantity: 1,000

Holiday Cards Are Studio's Marketing Venture

Houston-based [Metal] Studio designed and produced this line of holiday cards representing prominent art movements throughout history.

Every card depicts essentially the same image—a Christmas tree—but each renders it in a different way, typical of a particular movement's style. A surrealistic tree floats in a manner similar to Magritte's famous paintings. Another tree is abstracted into panels of primary colors, in the spirit of Mondrian's explorations of color and depth. Twelve different cards were created for the set in styles ranging from a primitive cave painting to pop art.

In some instances, illustrators Scott Head and Fotis Gerakis were faithful to the Old Masters, painting or using other hands-on media to recreate a particular style. Other illustrations were produced on the computer, using a variety of programs to achieve a particular effect.

The cards are printed in four color process on one side, while the interior of each card is printed with a holiday greeting printed in black. The card stock chosen is a recycled grade, coated on one side.

"It was our own project," says [Metal] Studio principal Peat Jariya. "We contacted the museums and funded our own production." The firm has been successful in marketing the cards to art museums across the country, where they are sold individually and as a boxed set.

Design firm: [Metal] Studio, Inc.
Client: [Metal] Studio, Inc.
Art directors: Peat Jariya, Scott Head
Designer: Scott Head
Illustrators: Scott Head, Fotis Gerakis
Materials: S.D. Warren Lustro Gloss
Quantity: 5,000 of each card

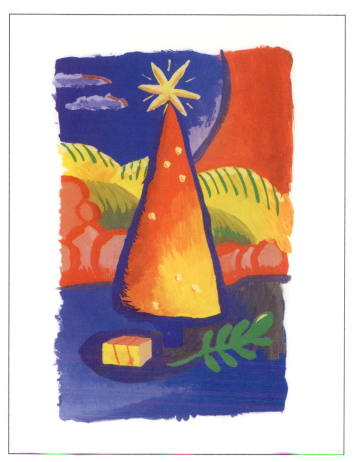

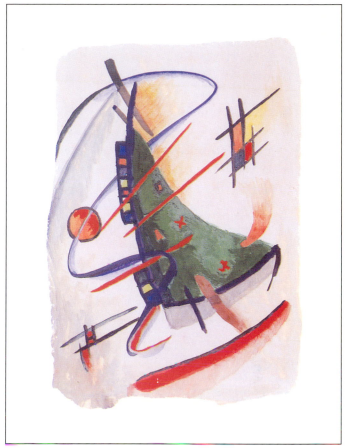

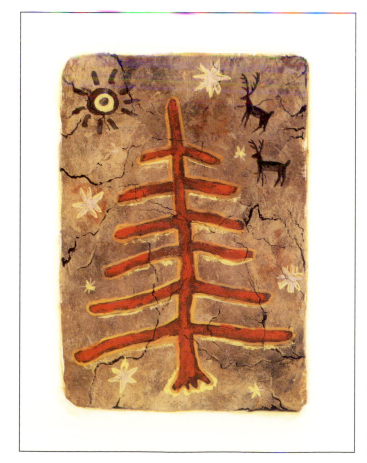

Holiday Card Shows Attitude

Why send a traditional holiday card when you can send one with attitude?

Alexandria, Virginia-based Grafik Communications chose to send their clients and vendors this card with its greeting in rap verse. Among its declarations, the card proclaims, "Our favorite color's purple and bright lime green. When we design with these, we make our clients scream."

Grafik Communications designers chose a variety of typestyles, set in rhythmical curves to punch up the card's rap theme. All twenty-two of the firm's staff members appear scattered throughout the card striking defiant poses. Photographer David Sharpe shot the staff in sunglasses and punk gear—even the studio's Labrador Retriever, Alex, appears in shades on the card's back panel.

The card was printed in three match colors on a cast-coated cover stock and accordion-folded into eight panels. The reverse side of the card features a playful pattern incorporating the words "Designer Wrap" and tiny reproductions of the figures featured on the front of the card.

Clients reacted positively to the card's irreverent humor. Designer Gregg Glaviano says the card received "Laughs, rap phone calls, fan mail and a contract with Motown."

Design firm: Grafik Communications, Ltd.

Client: Grafik Communications, Ltd.

Art directors/designers: Gregg Glaviano, Ned Drew, Judy Kirpich

Photographer: David Sharpe

Materials: Champion Kromekote

Printing method: Sheetfed offset

Quantity: 500

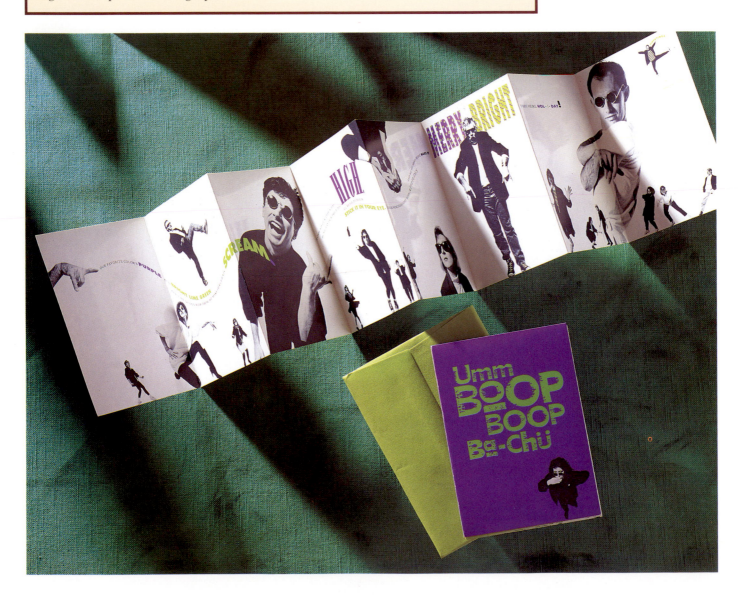

A Wish for Harmony

Boston-based designer Stewart Monderer's card demonstrates that a holiday card needn't be colorful to have impact. By using accordion-fold panels, Monderer effectively contrasts reversed pages of black and white to make a dramatic statement on racial harmony.

Monderer came up with the concept for the card during the O.J. Simpson trial. "Diversity was something that I wanted to address," he explains. "I wanted to integrate that concept with the design process." The card's message of understanding and acceptance stands out in contrast among typical holiday cards filled with predictable holiday iconography in green and red.

Printed in black on Monadnock Astrolite, the card's run of five hundred cost Monderer less than two hundred dollars. Monderer mailed the card in a plain, white envelope to current and potential clients.

Design firm: Stewart Monderer Design, Inc.
Client: Stewart Monderer Design, Inc.
Designer: Stewart Monderer
Materials: Monadnock Astrolite
Printing method: Sheetfed offset
Quantity: 500

Satirical Card Makes Fun of Itself

The Dunlavey Studio decided to take a satirical look at its own holiday card by presenting a series of cartoon frames that poke fun at it.

The self-referential card starts with two recipients engaged in a critical discussion of the merits (or lack thereof) in the card's design. The last frame shows the card being pitched into a wastebasket. The card closes with the firm's greeting and its name, followed with "designers of great things (except, maybe, Christmas cards)."

Michael Kennedy used a casual style to render the pen-and-ink cartoon illustrations. Hand-drawn quotes for the cartoon figures support the card's light-hearted look. Firm principals, Michael and Lindy Dunlavey chose to print the cartoon figures against a loosely rendered rectangle printed in a solid color to offset the linear cartoon images. For a contemporary look, they eschewed the traditional holiday red and green in favor of fluorescent pink and green. To create visual interest and variety, the application of these colors was alternated on each page. The card was printed in two colors on an uncoated cover stock and saddle stitched into an eight-page booklet.

The card's self-deprecating humor was a big hit with its recipients. Firm principal Michael Dunlavey says that he saw many cards posted in studios and offices all over town.

Design firm: The Dunlavey Studio
Client: The Dunlavey Studio
Art director: Michael Dunlavey
Designer: Lindy Dunlavey
Illustrator: Michael Kennedy
Materials: Neenah Classic Laid cover stock
Printing method: Sheetfed offset
Quantity: 500

Team of Santa's Helpers on Baseball Trading Cards

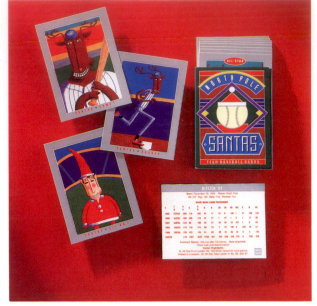

What if there was a baseball team called the "North Pole Santas"? This holiday promotion, created by Powell Design Office, answers that hypothetical question with this selection of twelve baseball cards highlighting the North Pole Santa's top players.

The cards' faces display whimsical illustrations of Santa's helpers as baseball players. The reverse side of each card shows what you would expect to find—the player's stats. The cards were printed in four-color process and silver on the type of bristol board typically used for trading cards. A wraparound folder with the team name on the front contains them. To duplicate the look of real baseball trading cards, each package was shrink-wrapped.

Art director and firm principal Glyn Powell, who conceived the idea and created the illustrations, drew his inspiration for the promotion from his son's baseball card collection. Once the cards were printed, his son took a set to school. Although the cards were extremely well-received by clients and vendors, the response from his son's classmates was overwhelming. "Every 10-year-old boy in my son's school wanted a set of cards," he relates.

Design firm: Powell Design Office
Client: Powell Design Office
Art director: Glyn Powell
Designer/illustrator: Glyn Powell

Materials: Bristol board, shrink-wrap plastic
Printing method: Sheetfed offset
Quantity: 1,000

Christmas Card Lets Clients Do the Designing

Warkulwiz Design Associates' "Create-A-Card" is the perfect holiday card for burnt-out designers. The design firm sent a sheet of blank, folded card stock along with rubdown transfers as a holiday greeting to clients and colleagues.

Although the card appears to involve little effort on the part of the design firm, there actually was quite a bit of work involved in the promotion. The illustrations were doctored clip art, brought into QuarkXPress and set up in a 4" x 5" format. The block of art was then stepped and repeated so that four copies fit on an 8½" x 11" sheet. The digital files for the transfer art were given to a service bureau who generated enough INT transfer sheets to supply the firm with seven hundred. Individual 4" x 5" sheets were trimmed from the larger sheets at Warkulwiz's studio.

Did recipients actually make cards from these supplies? According to illustrator Mike Rogalski, many did. "We had cards sent back to us that used all of the transfers. Other people used them very sparingly," he relates.

Design firm: Warkulwiz Design Associates, Inc.
Client: Warkulwiz Design Associates, Inc.
Art director: Bob Warkulwiz

Designer: Bill Smith, Jr.
Illustrator: Mike Rogalski
Materials: Wausau Astro Bright Cover
Printing method: Rubdown transfer
Quantity: 700

Postcards Celebrate Midwest's Grazing Pastures

Rickabaugh Graphics is based in a suburb of Columbus, Ohio, an area surrounded with miles of grazing pastures ideally suited for raising cows. So for its 1995 holiday greeting, the firm chose to poke fun at Columbus's reputation as a "cowtown." The firm designed and sent clients and studio friends this set of postcards in a package printed with "Seasons Greetings from Cowtown U.S.A."

The promotion unfolds to show four postcards, each honoring a noteworthy cow. Notable bovines range from the famous to the notorious, including Borden's Elsie and Elmer, as well as a cow which served as Ohio State's 1926 Homecoming Queen (no joke!).

Each card's image side portrays a colorful illustration. A variety of mediums were used, ranging from scratchboard illustration to computer manipulated clip art. The reverse side of each card includes a biography of the featured cow as well as an area for the address and postage. Recipients are urged to "Become an ambassador of goodwill" by "steering these cards in the direction of your out-of-town friends."

Although printed in four-color process, the cards are unified by their use of a consistent palette of orange, red, blue and violet. Before mailing, each card packet was sealed with a gold foil sticker by members of Rickabaugh Graphics' staff.

Design firm: Rickabaugh Graphics
Client: Rickabaugh Graphics
Art director: Eric Rickabaugh
Designer/illustrator: Eric Rickabaugh
Materials: Simpson Evergreen, gold foil stickers
Printing method: Sheetfed offset
Quantity: 150

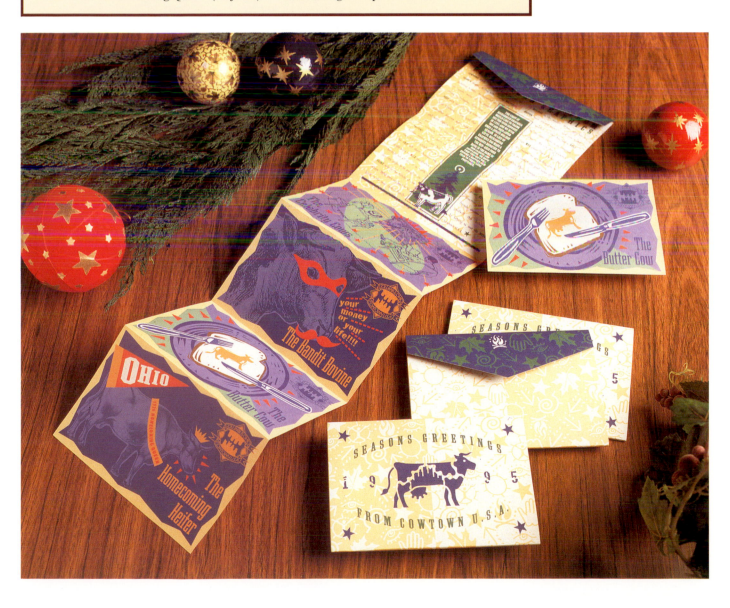

Unusual Materials Make a Memorable Mailer

This holiday promotion's contrast of interesting textures is the result of a rich mix of unusual materials. It starts with an outer sleeve made from a crepe-like material normally used for germinating seeds. (It was found at a local supplier of industrial paper.) Within the outer sleeve is a second sleeve that vertically binds the card within. This sleeve is made from Indian batik paper, purchased from a local art supply store.

The card insert was made from a sheet of binder's board colored at one edge with metallic gold marker. A pocket made from the same germination paper as the outer sleeve was hand stapled to each card so that a star and printed greeting could be inserted. The star was die cut from overage stock leftover from a job that had been printed with gold ink. Each star was tied with a loop of gold twine before it was inserted in its pocket.

The card was sent to eight hundred clients and suppliers of Diversified Graphics, a Minneapolis-based printer. Although it serves as a printer's promotion, the card actually involved no offset printing. The holiday greeting enclosed in the card's pocket was printed on a laser printer.

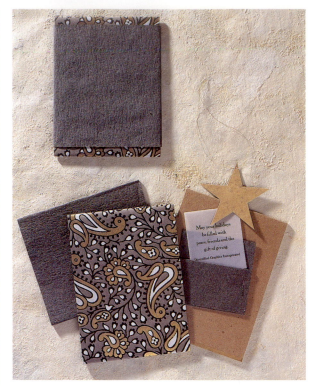

Design firm: Diversified Graphics
Client: Diversified Graphics
Art Director: Alyn Shannon
Designer: Alyn Shannon
Materials: Binder's board, seed germination paper, Indian batik paper, gold twine, translucent vellum
Printing method: None
Quantity: 800

Kwanzaa Card Celebrates African-American Culture

This holiday promotion observes Kwanzaa, an African-American celebration of the holidays. The promotion was inspired by Hotep House (which means "Peace House")—an emergency shelter in the Minneapolis area that houses African-American children who have been temporarily removed from their homes. Diversified Graphics made a donation to the shelter and used this holiday greeting to promote its cause.

A high level of emotional appeal is achieved by recreating the look of a scrapbook—printed photographs are attached to the card with gummed gold stars. The spirit of Kwanzaa is expressed in the photographs of and drawings produced by African American children at Hotep House.

The card's grass roots appeal is enhanced

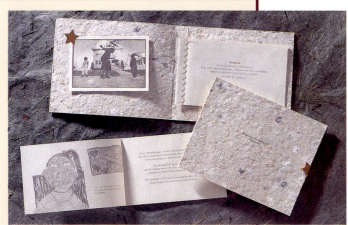

by its use of natural materials and hands-on production techniques. The outer card is a Japanese handmade paper created from unbleached, recycled papers. The booklet within the pocket is printed in two match colors and machine-stitched in a zigzag configuration with gold thread.

Design firm: Diversified Graphics
Client: Diversified Graphics
Art director: Alyn Shannon
Designer: Alyn Shannon
Illustrators: Children of Hotep House
Photographs: Courtesy of Hotep House and Turning Point, Inc.
Materials: Echizen Washi, gummed foil stars, Hammermill Unity
Printing method: Sheetfed offset
Quantity: 1,000

Note Cards Demonstrate Broad Range of Design Capabilities

This assortment of note cards represents an all-studio effort where every member of the Copeland Hirthler Design + Communications staff contributed their own design to the collection. The cards were packaged in a custom-designed box, and sent to clients and vendors as a holiday gift.

The designers used a variety of mediums, ranging from computer-composed photo collages to traditional pen and ink, to express their design sensibilities in an original card image. To unify the diverse assortment of styles and images, the cards were printed on the same white, laid-textured cover stock and printed in a coordinated palette of four match colors. Most of the cards bear the theme of the set: "I hope to be remembered as someone who made the earth a little more beautiful."

Copeland Hirthler saved money by using donated paper, photography and printing services. The firm enclosed a cover card with the collection thanking the other firms that donated their services and materials to the effort.

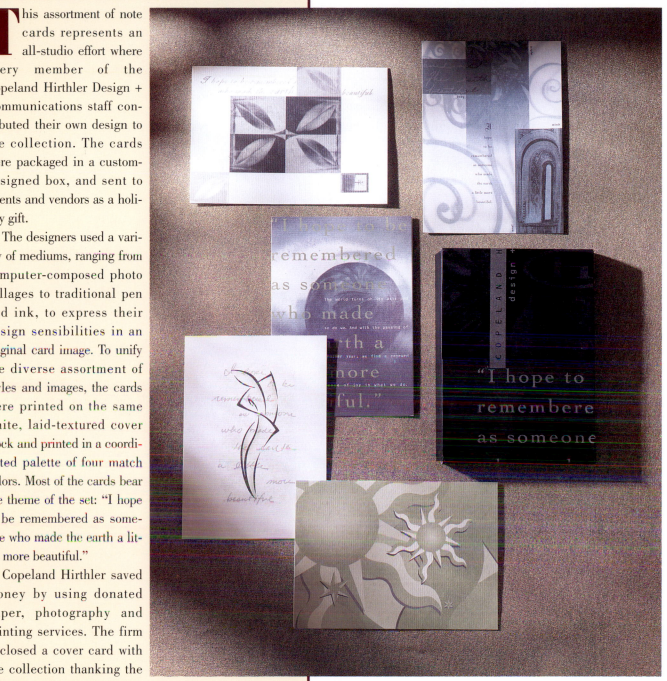

Design firm: Copeland Hirthler Design + Communications

Client: Copeland Hirthler Design + Communications

Designers: Raquel Miqueli, Todd Brooks, Michelle Stirna, David Woodward, Sam Hero, Shawn Brasfield, David Crawford, Suzy Miller, Alun Owen, Sean Goss, Sarah Huie, David Park

Photographers: Sonny Williams, John Grover, Michelle Stirna

Materials: Neenah papers

Printing method: Sheetfed offset

Quantity: 1,000

Numerical Collage Sets Theme for New Year's Greeting

Margo Chase Design achieved dramatic results with numbers in this holiday card designed for Westland Graphics, a Los Angeles-based printer.

Designer Margo Chase started by photographing paper cut outs of numbers in a haphazard arrangement. The photographs were scanned and then brought into Photoshop where they were colorized and enhanced with the program tools and filters. Chase used the same numerical collage and incorporated it into a design for a gift tag that was attached to bottles of spirits for preferred clients.

The card's New Year's greeting, "Consider the past," which appears on the cover, is carried into the interior of the card with the inscription, "Affect the future." Both were set in Gill Sans.

Westland Graphics printed the card and gift tags on a smooth uncoated stock in four-color process plus gold and blue metallic inks. The card's matching envelope was printed in the same colors.

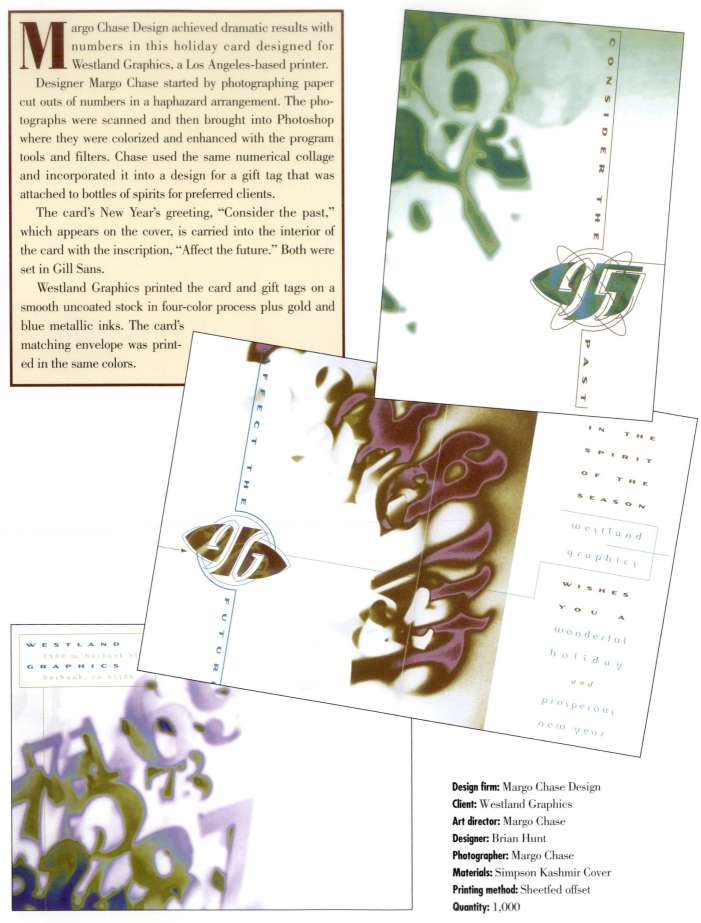

Design firm: Margo Chase Design
Client: Westland Graphics
Art director: Margo Chase
Designer: Brian Hunt
Photographer: Margo Chase
Materials: Simpson Kashmir Cover
Printing method: Sheetfed offset
Quantity: 1,000

Paper Snowman Card Speaks of Helping the Less Fortunate

A snowman, formed from looped paper and a twig, graces the cover of this greeting card designed by Minneapolis-based Little & Company. Freelance photographer Steve Kemmerling formed the snowman by taking paper strips and securing them into loops with a glue gun. Kemmerling used special lighting to create the snowman's bluish shadow.

The card's interior carries Little & Company's holiday message. In addition to thanking clients and suppliers, the card lets them know that Little & Company has made a donation in their name to Sharing & Caring Hands—a charity that provides warm clothes and hot meals to the homeless. The message is set in Suburban, a typeface that combines characteristics of a script face with those of a san serif. The look is one that is at once warm and friendly, yet crisp and contemporary.

The card was printed in four-color process on uncoated 100 percent recycled cover stock, and was mailed in a blue, invitation-sized envelope.

To share the joy of the holiday season, we have given a donation in your name to Sharing & Caring Hands — an organization that provides warm clothes and hot meals for the homeless.

Thank you for the wonderful relationships that enable us to share our success with those less fortunate.

Happy holidays and best wishes for a great New Year from your friends at Little & Company.

LITTLE & COMPANY
1010 SOUTH SEVENTH STREET
MINNEAPOLIS, MN 55415

Design firm: Little & Company
Client: Little & Company
Art directors: Paul Wharton, Michael Lizama
Designer: Michael Lizama

Photographer: Steve Kemmerling
Materials: Cross Pointe Synergy Cover
Printing method: Sheetfed offset
Quantity: 40,000

Holiday Card Recognizes the Homeless

This card from Boston-based Polese Clancy uses a no-frills approach to make its point. The design firm wanted to help the homeless, so it gave a gift of a thousand pairs of mittens to a local homeless shelter.

The card's raw, in-your-face typography was generated on a manual typewriter and then scanned. Enlarging the type in the computer to a size several times larger than the original resulted in its rough, degenerated look.

The card's accordion fold enabled the firm to print its opening message on one panel, and then use the entire opposite side to run a dramatic image of a homeless man warming his hands with his breath, full-bleed across the card's full 14¼" x 11¼" format. For added depth, the photograph was run as a duotone using black and silver. A dull varnish was also used on the photo to reduce the reflective quality of the card's coated stock.

The card fits neatly into a standard, no. 10 envelope so it could be mailed at regular, first-class postage rates.

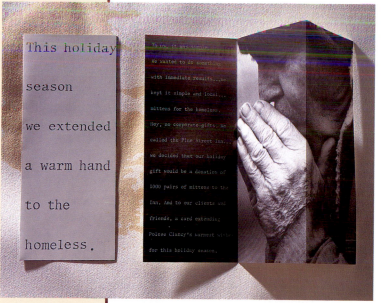

This holiday season we extended a warm hand to the homeless.

Design firm: Polese Clancy
Client: Polese Clancy
Art director: Ellen Clancy
Photographer: Steve Marsel

Materials: Westvaco Citation Cover
Printing method: Sheetfed offset
Quantity: 700

Postcard Announces Summer Hours

Closing shop early on Fridays to enjoy the summer weather gave Boston-based Polese Clancy the chance to send this postcard announcing the design firm's summer hours. In addition to posting its hours as a client courtesy, the firm saw the card as an opportunity to send a promotion.

The design firm used an illustration created in pen-and-ink showing a figure holding a clock under one arm and a flower in the other to convey its "enjoy life" message. To give the impression of a scratchboard rendering, the illustration was printed in reverse against a black background.

The card's background message, "enjoy life as much as you enjoy work" is set in Shelley—a script typeface that, at first glance, registers as a decorative motif rather than type. On the opposite side of the card, the firm's hours are listed, 8:30-5:00 every weekday except Friday, when hours change to 8:30-3:00.

The card was printed on an offset press with a screen tint of moss green and solid black on light green cover stock.

Design firm: Polese Clancy
Client: Polese Clancy
Art director: Ellen Clancy
Designer: Donna Altonian
Illustrator: Donna Altonian
Materials: Simpson Quest Cover
Printing method: Sheetfed offset
Quantity: 500

A Holiday Gift of Seasonally Themed Notecards

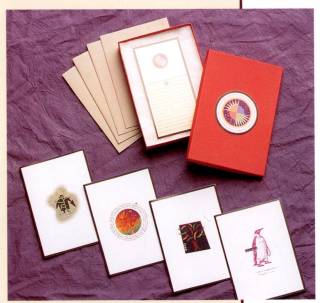

As a holiday gift to clients and studio suppliers, Dallas-based Brainstorm, Inc., sent this set of note cards. The collection consists of four different cards celebrating each of the four seasons of the year.

Each card features a seasonally-themed illustration on the front. The three designer/illustrators who collaborated on the project used computer illustrations to produce a rich variety of looks.

For optimal reproduction of color and detail, the cards are printed in four-color process on a glossy, coated stock. Brainstorm staff members collated the cards and used raffia to tie each set of four cards with four invitation-sized envelopes. The collection was mailed to its recipients in a red gift box.

Design firm: Brainstorm, Inc.
Client: Brainstorm, Inc.
Art directors: Chuck Johnson, Ken Koster
Designers: Chuck Johnson, Ken Koster, Lori Walls
Illustrators: Chuck Johnson, Ken Koster, Lori Walls
Materials: Coated, white stock; raffia; invitation envelopes; red gift boxes
Printing method: Sheetfed offset
Quantity: 1,000

Valentine's Card Serves Dual Purpose

This very special Valentine's Day card doubles as a celebration of the first birthday of a child, born on Valentine's Day, 1995. The card was designed by Mark Schwartz and Tina Katz, husband-and-wife design team of Cleveland-based Nesnadny + Schwartz. The fortunate child whose birthday falls on Valentine's Day is Sophie Schwartz, daughter of Mark and Tina.

The front of the card features a self-portrait of photographer Neil Winokur, who donated the image of himself reflected on the mylar surface of a heart-shaped balloon. Schwartz and Katz chose to run the photo against a solid red background, while the card's interior left panel is printed in purple, and the couple's Valentine's greeting is printed on the opposite panel in black, against the white of the card stock.

To obtain optimum detail and color reproduction, the card was printed in four-color process on a premium grade, cast-coated cover stock. The flap of a red Baronial envelope was printed with Sophie's name and address. The card was sent to friends, family and business associates.

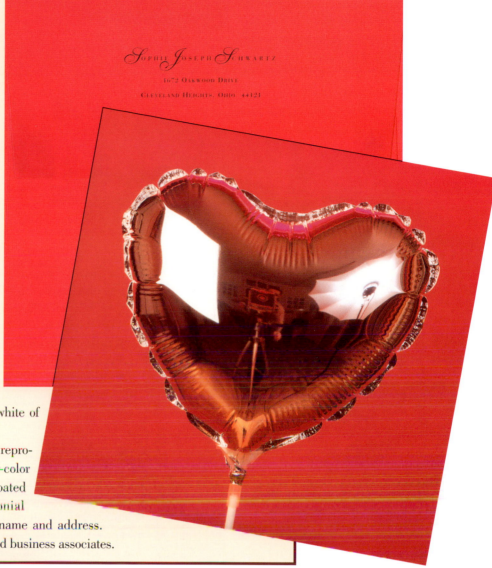

Happy Valentine's Day

SOPHIE, TINA AND MARK

Design firm: Nesnadny + Schwartz

Client: Sophie Schwartz

Art directors: Mark Schwartz, Tina Katz

Designers: Mark Schwartz, Tina Katz

Photographer: Neil Winokur

Materials: Consolidated Reflections Cover

Printing method: Sheetfed offset

Quantity: 500

Pop-Up Holiday Card Converts to Year-Round Greeting

Los Angeles-based Shimokochi/ Reeves designed this die-cut, pop- up card bearing its "marketing man" logo to be sent as a greeting to clients and vendors.

The marketing man motif first appeared on a T-shirt the firm sent during the 1990 holiday season. The motif drew such an enthusiastic response from those who received the shirts that the design firm was prompted to print these cards as a follow- up.

Printed in two colors on dull-coated cover stock, the cards were initially printed as a greeting card for the 1994 holiday sea- son. Since then, the firm has printed the same card without its "Season's Greetings" inscription to be used as a promotional mailer to keep in touch with cur- rent and prospective clients.

Design firm: Shimokochi/Reeves
Client: Shimokochi/Reeves
Art directors: Mamoru Shimokochi, Anne Reeves
Designers: Mamoru Shimokochi, Anne Reeves
Materials: Shasta Dull Cover
Printing method: Sheetfed offset
Quantity: 1,000

Festive Design Has a Way With Type

This holiday greeting, designed by Gahanna, Ohio-based Rickabaugh Graphics, shows that a Christmas card needn't be complicated to be effective. Firm principal and the card's designer, Eric Rickabaugh, relied on an accordion-folded format and playful typography to get across the card's merry message.

When the folded card is first viewed, the simplicity of its initial panel is a misleading introduction to the explosion of images and mixed fonts that spell out "Christmas" on the inte- rior panels. Rickabaugh used a variety of unusual fonts and a mixture of clip art images to produce the illustrated background. The card's last panel bal- ances the design by presenting the firm's closing wish for a Happy New Year with a graphic treatment that's as humble as the treatment of the card's first panel.

The card was printed in four match colors on cast-coated stock and mailed in an invita- tion-sized envelope to current and prospec- tive clients, studio suppliers and friends.

Design firm: Rickabaugh Graphics
Client: Rickabaugh Graphics
Art director: Eric Rickabaugh
Designer: Eric Rickabaugh
Materials: Champion Kromekote
Printing method: Sheetfed offset
Quantity: 150

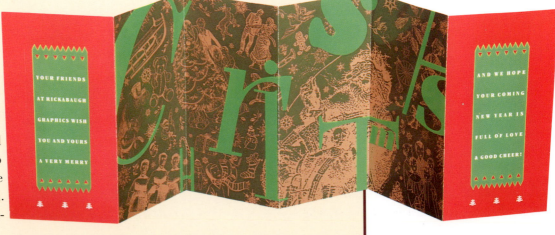

Star-Shaped Die Cuts Yield Starry Confetti

This holiday card makes use of negative space, the result of star-shaped die cuts, to carry across its message of holiday cheer.

Designed by Cincinnati-based Zender + Associates, the two-part card consists of a foldover card that is not printed, but is die cut in the configuration of a large star plus several smaller stars. The card's message is printed in red on an insert of translucent vellum, also die cut with the shape of the large star. For variety, the foldover card was cut from three different colors of a heavily textured, uncoated stock.

The card fits conveniently in a business-sized envelope. Before each envelope was sealed it was filled with "confetti"— tiny paper stars that were leftover trim from the star die cuts.

Design firm: Zender + Associates, Inc.
Client: Zender + Associates, Inc.
Art director: Nancy McIntosh
Designer: Nancy McIntosh

Materials: Strathmore Grandee, Gilbert Gilclear
Printing method: Sheetfed offset
Quantity: 500

Classic White Well-Suits Tidings of Peace

When it comes to communicating a holiday message of peace, few images are as universally recognized as a dove bearing an olive branch.

Stan Brod, of Wood-Brod Design, treated this classic image with elegance and simplicity in his decision to blind emboss it on cast-coated, white card stock. The multi-leveled emboss, with its layer of parallel curves on the wing and tail, makes an interesting visual statement, adding another level to an image which would have otherwise been too bland.

Brod chose an elegant script, Swallow, for the card's interior message. The card folds so that just the word "Peace," shows before the card is opened. Brod chose to have the dove's eye, the olive branch and the card's interior message printed in a deep green. The horizontal alignment of these three elements creates a strong sense of continuity in the card's overall design scheme.

The card was sent to patients and clients of The Ireland Cancer Center at University Hospitals in Cleveland.

Design firm: Wood-Brod Design
Client: The Ireland Cancer Center
Art director: Stan Brod
Designer/illustrator: Stan Brod
Materials: Champion Kromekote
Printing method: Sheetfed offset

East Meets West in Holiday Card

Asian Cinevision is a film production company based in New York City. As a fundraising venture, the company hired New York City-based Mike Quon Design Office to design a holiday card that could be sold both to Asian film-makers and to the general public. The card needed to appeal to both Asians and Westerners and somehow express unity between the two cultures.

Firm principal and designer Mike Quon came up with this card showing the oriental yin/yang symbol transforming into the image of Santa Claus. The sequence of nine illustrations was created by Quon using Adobe Illustrator. To give the card a festive look that wasn't too Christmasy, Quon chose to limit the card's palette to red, white and black.

Five thousand copies of the card were printed on recycled white coated cover stock and sold in boxes of twenty. Customers ordered the cards through ads placed in a variety of publications.

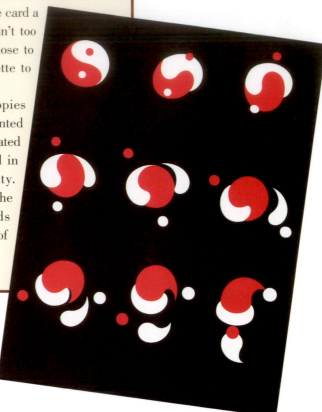

Design firm: Mike Quon Design Office
Client: Asian Cinevision
Art director: Mike Quon
Designer/illustrator: Mike Quon

Materials: Consolidated Centura Plus
Printing method: Sheetfed offset
Quantity: 5,000

A Holiday Card for the Nineties

Generation Xers can take heart knowing that at least one Christmas card out there focuses on some of their generation's cultural icons. Philadelphia-based Warkulwiz Design Associates designed this holiday card for the nineties as a satirical version of "The Twelve Days of Christmas."

When opened, each of the twelve windows on the front reveals a word associated with the holidays and a contemporary image that exemplifies it. Pictorial representations include a heart-shaped tattoo next to the word "love" and a picture of a condom to depict the word "faith." The images were pulled from photo clip files on CD-ROM and from Warkulwiz Design's archives.

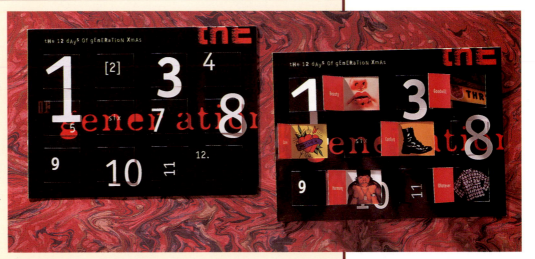

The card is actually one piece with die-cut windows on one side, folded over itself and glued that way to reveal another layer beneath the windows. It was printed in four-color process (and one match color) on a 100 lb. coated text stock. Varnish was applied on press in-line to give the card a high-gloss finish.

Design firm: Warkulwiz Design Associates, Inc.
Client: Warkulwiz Design Associates, Inc.
Art directors: Bob Warkulwiz, Mike Rogalski
Designers: Kirsten Engstrum, Carolyn Brown
Materials: Warren Lustro Gloss Text
Printing method: Sheetfed offset
Quantity: 1,000

Card Takes Holiday Greetings to Another Dimension

"Prepare yourself for the ultimate sensory experience," states this 3-D holiday card from Philadelphia-based Warkulwiz Design Associates. The card was sent along with a pair of 3-D viewing glasses to ensure the firm's clients and vendors would get the full effect of the collage on the card's interior.

The holiday icons that appear in the collage were created by illustrator Mike Rogalski in Adobe Dimensions. Vintage photos from the fifties, pulled from Warkulwiz's studio archives, enhance the card's retro theme.

Rogalski had enough of an understanding of how 3-D works to guess at how to register the red and green negatives to create the three-dimensional effect. He set up his QuarkXPress files with these two colors out-of-register, and asked the printer for a color key so he could make slight adjustments before the piece was on press.

The card was printed in four-color process and warm red on a dull-coated cover stock. An aqueous varnish was also applied in-line on press. The 3-D glasses were purchased from a marketing specialties mail order house and custom-printed with the "Virtyule Holidaze" logo that appears on the front of the card.

Design firm: Warkulwiz Design Associates, Inc.
Client: Warkulwiz Design Associates, Inc.
Art directors: Bob Warkulwiz, Mike Rogalski
Designer: Julie Colton
Illustrator: Mike Rogalski
Materials: Warren Lustro Dull Cover
Printing method: Sheetfed offset
Quantity: 1,000

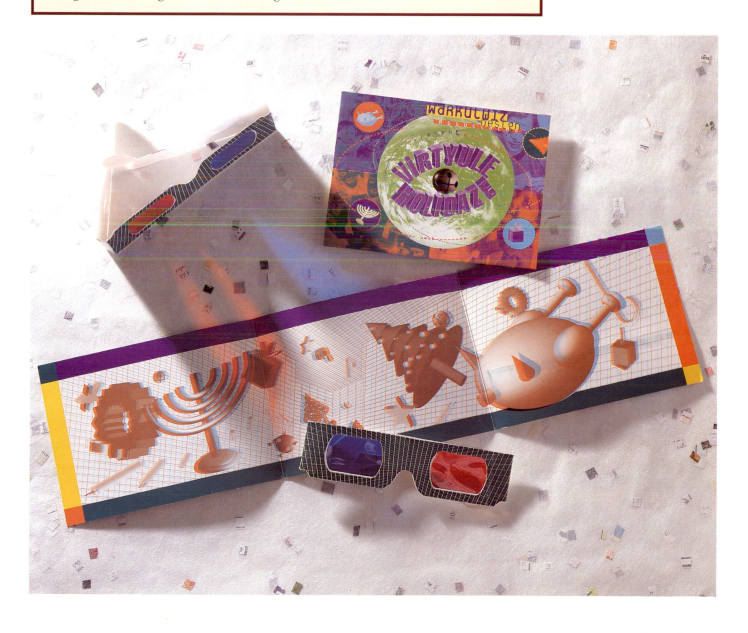

A Hebrew Wish for World Peace

This postcard celebrates the Jewish New Year with the Hebrew greeting, "Lashana Tovah," or "Happy New Year," printed in a circular format.

The card was designed by Stan Brod, of Wood-Brod Design, who sent it to family and friends. He started with a calligraphy rendering of the Jewish saying lettered in Hebrew. Scanning this and bringing it into Adobe Illustrator enabled Brod to step repeat and manipulate the saying into a spiral with a star in the middle. The card's inscription at the bottom, "Our Hope For Lasting Peace Around The World," gives meaning to the globe-shaped image.

The card was printed in dark blue on coated card stock with a pearlescent finish.

Design firm: Wood-Brod Design
Client: McCrystle Wood, Stan Brod
Art director: Stan Brod
Designer: Stan Brod
Materials: Pearlescent Currency
Printing method: Sheetfed offset
Quantity: 500

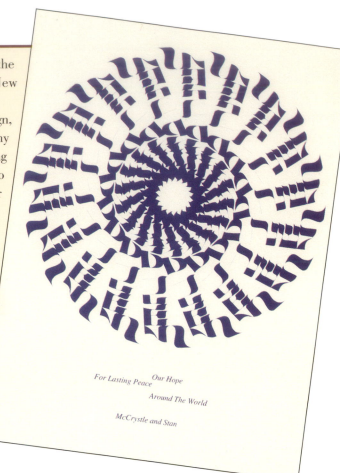

Our Hope
For Lasting Peace
Around The World

McCrystle and Stan

Three-Dimensional Christmas Tree Card

This three-dimensional card can be used as both a stand-up display and an ornament. New York City-based designer, Steff Geissbuhler, designed it as a packaged greeting card to be sold exclusively at New York City's Museum of Modern Art.

The museum came to Geissbuhler wanting a non-denominational card with a contemporary look. It was decided that the Christmas tree would be depicted for its universal appeal. "I utilized the shape of the tree to interpret the motif," says Geissbuhler, explaining his decision to render the tree's graphics in a series of geometrical patterns. All rendering was done on the computer. A digital mechanical and comp were supplied to the printer.

To keep costs to a minimum, the card was printed in one color. Die cuts were made to produce two flat tree-shaped cards, which were notched at top and bottom and assembled into the stand-up configuration.

The cards are packaged flat, so that twelve cards and their envelopes fit neatly in a greeting card box.

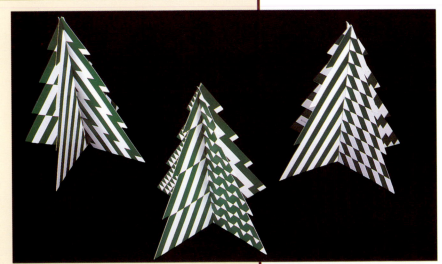

Designer: Steff Geissbuhler
Client: The Museum of Modern Art
Art director: Steff Geissbuhler
Illustrator: Steff Geissbuhler
Materials: Corolina Cover
Printing method: Offset, die cutting
Quantity: 7,500

Bold Colors and Simplicity Support Strong Concept

This holiday card's simple, graphic imagery of a star transforming into a dove is reinforced by its strong, pure colors. The constant graphic theme of a rainbow leads the recipient through its accordion-fold format revealing, a panel at a time, its message of a "Brilliant, Sparkling, Shining, Stellar Holiday" as well as a "Peaceful World for All." All type is set in Avant Garde, a classic and unpretentious san serif appropriate to the card's humble message.

Designer Stan Brod of Cincinnati-based Wood-Brod Design created the card for Berman Printing, a local printer. Like most printer's holiday greetings, Berman saw this card as an opportunity to promote the company's printing capabilities. The card achieves Berman's objective by using large areas of solid color, printed with flawless coverage, on a glossy, cast-coated card stock. Seven match colors were printed in all.

Design firm: Wood-Brod Design
Client: Berman Printing
Art director: Stan Brod
Designer/illustrator: Stan Brod
Materials: Champion Kromekote
Printing method: Sheetfed offset
Quantity: 1,000

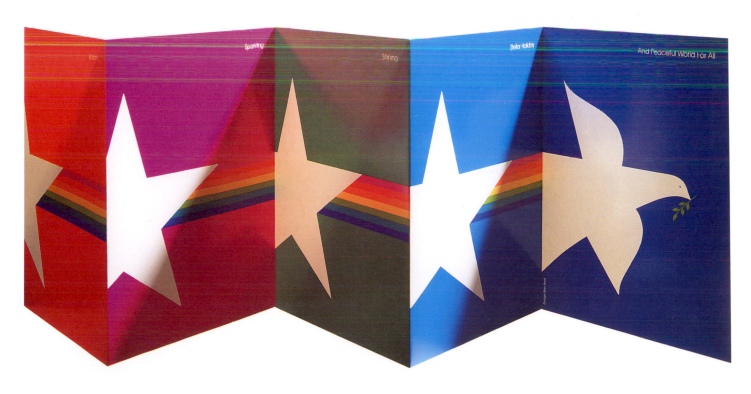

Card Depicts the Way They Were

Boston-based Polese Clancy used childhood photos of staff members to reinforce this holiday card's theme of children.

The card's tri-fold layout starts with a 5½" x 5½" square panel letting its recipient know that Polese Clancy has made a donation to Rosie's Place, a well-known Boston-based charity that takes in victims of child abuse. The card unfolds to reveal a nostalgic collection of images from the past—childhood photos of all of the design firm's staff members. The two large photos, which serve as background images, are those of firm principals Ellen Clancy and Marcia Polese.

The card was printed in three match colors on uncoated ivory stock and sent in a matching, baronial envelope.

Design firm: Polese Clancy
Client: Polese Clancy
Art director: Ellen Clancy
Designer: Tom Riddle

Photographers: Staff parents
Materials: Strathmore Pastelle
Printing method: Sheetfed offset
Quantity: 700

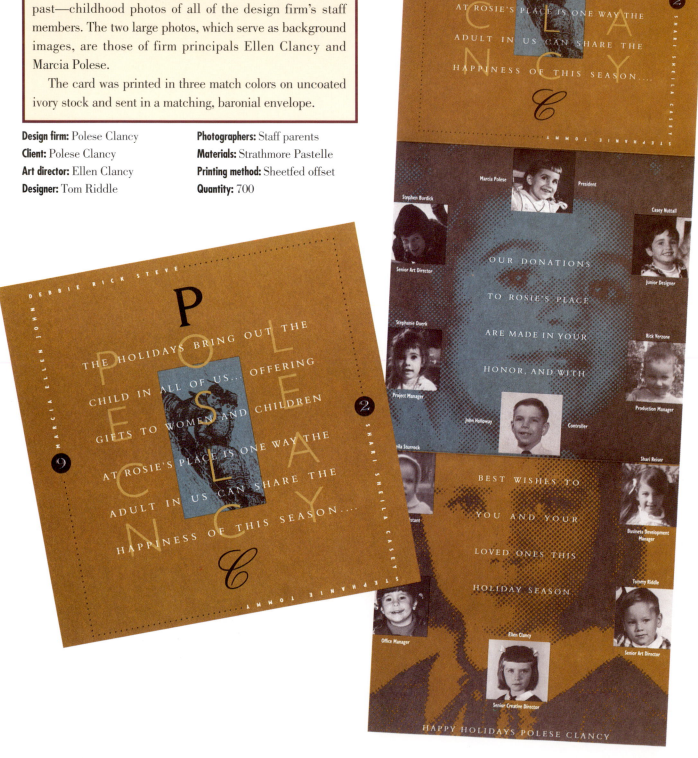

Card's Message of Giving is Reinforced by a Charitable Donation

For the 1994 holiday season, Boston-based design firm Polese Clancy chose to send a card that's a tribute to the spirit of giving. The card lets the design firm's clients and suppliers know that a donation has been made on their behalf to City Year, a national organization that helps inner city kids by getting them involved in community improvement projects.

The card's copy focuses on the personal benefits to be reaped from giving rather than receiving. This message is reinforced by the hand-drawn, personal look of the scripted copy, calligraphed by staff member Donna Altonian. Firm principal Ellen Clancy chose a backdrop of roses obtained from a photo clip file on CD-ROM for the front of the card. The image was vignetted in Photoshop and printed as a duotone.

Clancy decided to print the card in moss green and black on an off-white cover stock so that it would coordinate with existing envelopes used for the firm's business correspondence. Because the cards were sent in business envelopes, the studio saved money that would have otherwise been spent on custom envelopes.

Design firm: Polese Clancy
Client: Polese Clancy
Art director: Ellen Clancy
Designers: Ellen Clancy, Donna Altonian
Calligraphy: Donna Altonian
Copywriter: Marcia Polese
Materials: Hopper Kiana Cover
Printing method: Sheetfed offset
Quantity: 1,000

Inspirational Message Gets to the Heart

Faith, hope and wonder are sensitively expressed in this holiday card designed by Cincinnati-based Zender + Associates.

The card's designer, Nancy McIntosh, purposely limited the card's format to a size that would fit neatly within a standard, business-size envelope. She chose a horizontal orientation that focuses on three overlapping words: faith, hope and wonder, set in Stemple Garamond, a classic typeface appropriate to the card's reverent wish.

McIntosh chose three match colors for the card, and specified each as a tint. In addition, she treated the three photographs that appear on the front of the card as gradients for a delicate look that complements the pastel treatment of the card's message. The cards were printed on a premium grade, dull-coated cover stock and mailed in a gray envelope.

McIntosh says the card inspired joy in many of its recipients who kept it on their desks where they could view it often.

Design firm: Zender + Associates, Inc.
Client: Zender + Associates, Inc.
Art director: Nancy McIntosh
Designer: Nancy McIntosh
Photographer: Nancy McIntosh
Materials: Potlatch Eloquence Silk
Printing method: Sheetfed offset
Quantity: 500

Die Cuts and Folds Give Card Multi-Dimensional Appeal

This unusual card uses die cuts and a double-sided approach to achieve a stand-up configuration of holiday icons. Designer Steff Geissbuhler created the card for Anchor Engraving, a New York City-based printer, as a means of showcasing its printing, engraving and die cutting capabilities.

One side of the card is printed and die cut with Roman numerals for the New Year, 1995. The opposite side is die cut with the shapes of holiday icons—one for each of four panels. Messages engraved on the oppo-site side of the sheet behind the icons appear within each die-cut icon.

The card was run in four match colors as well as engraved in three colors. It was printed on two pieces of 20" x 5" cover stock, which were glued together at each end before being accordion-folded into a four-panel configuration.

The card was sent to friends and relatives of Geissbuhler and Anchor president, Gerry Schneiderman, as well as to clients and suppliers of Anchor Engraving.

Designer: Steff Geissbuhler
Clients: Anchor Engraving, Schneiderman family, Geissbuhler family
Art director: Steff Geissbuhler
Materials: Simpson Starwhite Vicksburg
Printing method: Offset, engraving, die cutting
Quantity: 750

Creative Typography Makes a Strong Statement

Classic in its simplicity, this holiday promotion relies primarily on expressive typography and an elegant presentation to communicate its message.

The card's holiday message stresses the importance of family ties and lets clients of Boston-based design firm, Polese Clancy, know that a donation has been made on their behalf to Habitat for Humanity, a non-profit group that helps families by building and refurbishing low-cost houses.

By contrasting various weights of a serif typeface, American Garamond, with Ribbon, a bold sans serif, the card achieves visual interest and strong typographical texture. Its message is emphasized by boldfacing key words and phrases.

The card relies almost totally on typography to create visual impact—its sole visual, an illustration of two figures, is strategically placed and sized so that it won't overpower the type.

Art director Ellen Clancy chose a tri-fold format consisting of three 5" x 4½" panels. The third panel is a mini-folder that contains a separate 5" x 4¼" card and same-sized sheet of translucent vellum. She chose a cover stock with a texture similar to an art paper for the folder to enhance the elegant simplicity of the card's graphics.

Design firm: Polese Clancy
Client: Polese Clancy
Art director: Ellen Clancy
Designer: Ellen Clancy
Illustrator: Debbie Dreschler
Materials: Strathmore Pastelle, Gilbert Gilclear
Printing method: Sheetfed offset
Quantity: 700

Die Cuts Yield a Variety of Images

Clever use of die cuts make this holiday card for Aspen Traders an especially noteworthy one. The clothing manufacturer commissioned the card design from Greteman Group, a design firm based in Wichita, Kansas.

The accordion-folded card consists of five panels. The first two panels are die cut with intricate shapes followed by a third panel with a star-shaped motif. The next two panels repeat the pattern with a third die cut panel framing a star motif. The effect is similar to viewing a kaleidoscope—when graphic elements are viewed through different shaped die cuts, they yield a motif quite different from what is actually printed. The final panel is printed with Aspen Traders' greeting where Greteman Group set Aspen employees' names in the shape of a Christmas tree.

The Greteman Group design team created visual interest on each panel by using a scanned pattern or texture to serve as a background. The variety of graphic approaches used on each panel is unified by a consistent palette of four match colors: gold, black, dark red and gray. The card's subtle palette and sophisticated concept yields an image well-suited to this manufacturer of natural clothing.

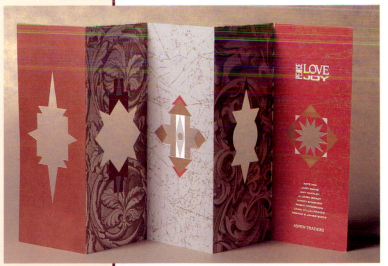

Design firm: Greteman Group
Client: Aspen Traders
Art director: Sonia Greteman
Designers: Sonia Greteman, Bill Gardner
Illustrator: Sonia Greteman
Materials: Champion Benefit Cover
Printing method: Sheetfed offset
Quantity: 6,000

Cards' Modern Flair Suits Museum of Contemporary Art

Los Angeles-based Shimokochi/Reeves originally conceived and designed these two three-dimensional cards for their own studio's holiday greeting. The two designs were printed in five colors on dull-coated cover stock and ganged on the same print run. Because each card was printed in three different color combinations, six different cards were produced from the run.

The cards were so successful, Los Angeles's MOCA—Museum of Contemporary Art—asked Shimokochi/Reeves to design similar cards to sell in the museum's gift shop. The design firm obliged by letting them reproduce both card designs with different colors.

Design firm: Shimokochi/Reeves
Client: Shimokochi/Reeves
Art directors: Mamoru Shimokochi, Anne Reeves
Designers: Mamoru Shimokochi, Anne Reeves
Materials: Potlatch Quintessence Dull Cover
Printing method: Offset
Quantity: 2,500 (each card)

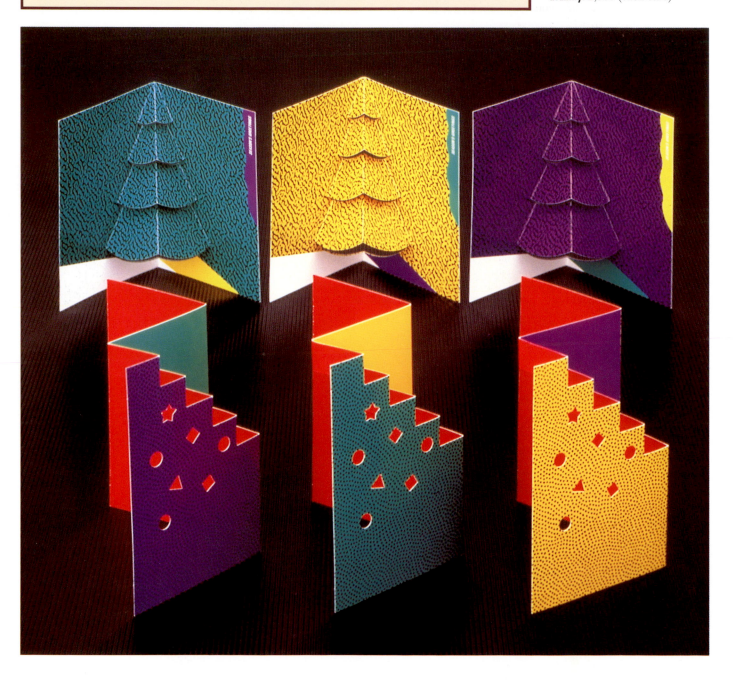

Putting on the Glitz

The sheen of iridescent foil gives this card a glittery, tinseley look in keeping with the holiday spirit, yet its unusual palette of purple and celadon set it apart from conventional holiday cards of red and green.

Stewart Monderer Design produced the card for Massachusetts Mutual Life Insurance. The insurance company wanted an eye-catching card based on a non-religious theme that was different from the traditional cards typically sent by insurance companies.

Monderer's card projects the modern, upbeat image that his client sought to achieve. The high-gloss finish of the card's cast-coated stock gives the inks a shiny finish comparable to that of a sports car. In fact, there's so much sheen, the numerals "1994" are reflected on the purple panels opposite each green panel.

Massachusetts Mutual was also pleased with the "expandable" aspect of Monderer's accordion-folded card. The card arrives folded in its narrow envelope, but when removed fans out into a much larger card. The accordion-folded format also allows the card to stand alone on a shelf, offering additional exposure as an eye-catching display.

Design firm: Stewart Monderer Design, Inc.
Client: Massachusetts Mutual Life Insurance
Art director: Stewart Monderer
Designer: Robert Davison
Materials: Champion Kromekote
Printing method: Sheetfed offset, foil stamping
Quantity: 500

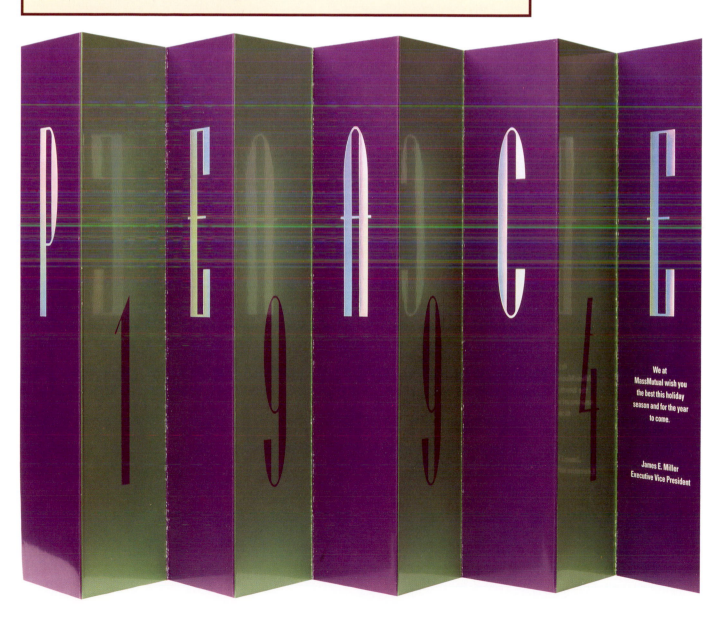

Permissions

p. 8 © David Carter Design Associates
p. 9 © Osborn & DeLong
p. 10 © Rickabaugh Graphics
p. 11 © Modern Dog
p. 12 (top) © DBD International, Ltd.
p. 12 (bottom) © Mark Oldach Design
p. 14 © Dyer Mutchnick Group, Inc.
p. 15 © David Carter Design Associates
p. 16 © Pressley Jacobs Design, Inc.
p. 17 © Powell Design Office
p. 18 © David Carter Design Associates
p. 19 (top) © Shapiro Design Associates
p. 19 (bottom) © Design Horizons Intl.
p. 20 © Powell Design Office
p. 21 © Mark Oldach Design
p. 22 © Ultimo, Inc.
p. 23 (top) © Brainstorm, Inc.
p. 23 (bottom) © Mark Oldach Design
pp. 24-25 © Modern Dog
p. 26 © Powell Design Office
p. 27 © David Carter Design Associates
p. 28 © Osborn & DeLong
p. 29 © Pressley Jacobs Design
p. 30 © David Carter Design Associates
p. 31 © Powell Design Office
p. 32 © Mark Oldach Design
p. 34 © PandaMonium Designs
p. 35 © Powell Design Office
p. 36 © Courtney & Company
p. 37 © The Atlantic Group
p. 38 (top) © Aartvark Communications
p. 38 (bottom) © Paprika
p. 39 © Phoenix Creative
p. 40 © Real Art Design Group, Inc.
p. 41 © Vaughn Wedeen Creative
p. 42 © Warkulwiz Design Associates, Inc.
p. 43 © Pressley Jacobs Design, Inc.
p. 44 © Connie Helgeson-Moen/
 Batik Illustration
p. 45 © Pisarkiewicz & Company
p. 46 © Vaughn Wedeen Creative
p. 47 (top) © Ultimo, Inc.
p. 47 (bottom) © Aartvark Communications
p. 48 © Diversified Graphics
p. 49 © David Carter Design Associates
p. 50 (top) © The Pushpin Group, Inc.
p. 50 (bottom) © Paprika
p. 51 © Pisarkiewicz & Company
p. 52 © PandaMonium Designs
p. 53 © Vrontikis Design Office
p. 54 © Warkulwiz Design Associates, Inc.
p. 55 © K² Design
p. 56 (top) © Shimokochi/Reeves
p. 56 (bottom) © Warkulwiz Design
 Associates, Inc.
p. 57 © Rickabaugh Graphics
p. 58 © Paprika

p. 59 © Phoenix Creative
pp. 60-61 © Supon Design Group
p. 62 © Vrontikis Design Office
p. 63 © Hard Drive Design
p. 64 (top) © Shimokochi/Reeves
p. 64 (bottom) © Warkulwiz Design
 Associates, Inc.
p. 65 © Ultimo, Inc.
p. 66 © Diversified Graphics
p. 67 © Connie Helgeson-Moen/
 Batik Illustration
p. 68 © Aartvark Communications
p. 69 © Supon Design Group
p. 70 (top) © Rickabaugh Graphics
p. 70 (bottom) © Shapiro Design Associates
p. 71 © William & House
p. 72 © Ultimo, Inc.
p. 73 © Warkulwiz Design Associates, Inc.
p. 74 © Shimokochi/Reeves
p. 75 © Phoenix Creative
p. 76 (top) © Vrontikis Design Office
p. 76 (bottom) © Warkulwiz Design
 Associates, Inc.
p. 77 © Paprika
p. 78 © Supon Design Group
p. 80 © Nesnadny + Schwartz
p. 81 © Paprika
p. 82 (top) © Powell Design Office
p. 82 (bottom) © Viva Dolan
 Communication & Design
p. 83 © Brainstorm, Inc.
p. 84 © Copeland Hirthler Design +
 Communications
p. 85 © Hornall Anderson Design Works,
 Inc.
pp. 86-87 © DBD International, Ltd.
p. 88 (top) © Supon Design Group
p. 88 (bottom) © Sayles Graphic Design
p. 89 © Paul Shaw/Letter Design
p. 90 © Concrete Design Communications,
 Inc.
p. 91 (top) © Concrete Design
 Communications, Inc.
p. 91 (bottom) © Sayles Graphic Design
pp. 92-93 © Louey/Rubino Design Group,
 Inc.
p. 94 © Hornall Anderson Design Works,
 Inc.
p. 96 © Pisarkiewicz & Company
p. 97 © Vrontikis Design Office
p. 98 © K² Design
p. 99 © I & Company
p. 100 © Mike Quon Design Office
p. 101 (top) © Richardson or Richardson
p. 101 (bottom) © Platinum Design, Inc.
p. 102 © I & Company
p. 103 © SHR Perceptual Management

p. 104 © Group C Design
p. 106 © Brainstorm, Inc.
p. 107 © Stewart Monderer Design, Inc.
p. 108 (top) © Steff Geissbuhler
p. 108 (bottom) © The Dunlavey Studio
p. 109 © Rickabaugh Graphics
p. 110 © Margo Chase Design
p. 111 (top) © Little & Company
p. 111 (bottom) © Polese Clancy
p. 112 (top) © Polese Clancy
p. 112 (bottom) © Smullen Design
p. 113 © Diversified Graphics
p. 114 (top) © Chermayeff & Geismar, Inc.
p. 114 (bottom) © Hornall Anderson Design
 Works
p. 115 © Warkulwiz Design Associates, Inc.
p. 116 © Wood-Brod Design
p. 117 © Zender + Associates, Inc.
p. 118 © Vrontikis Design Office
pp. 118-119 © [Metal] Studio, Inc.
p. 120 © Grafik Communications, Ltd.
p. 121 © Stewart Monderer Design, Inc.
p. 122 (top) © Powell Design Office
p. 122 (bottom) © Warkulwiz Design
 Associates, Inc.
p. 123 © Rickabaugh Graphics
p. 124 © Diversified Graphics
p. 125 © Copeland Hirthler Design +
 Communications
p. 126 © Margo Chase Design
p. 127 (top) © Little & Company
p. 127 (bottom) © Polese Clancy
p. 128 (top) © Polese Clancy
p. 128 (bottom) © Brainstorm, Inc.
p. 129 © Nesnadny + Schwartz
p. 130 (top) © Shimokochi/Reeves
p. 130 (bottom) © Rickabaugh Graphics
p. 131 (top) © Zender + Associates, Inc.
p. 131 (bottom) © Wood-Brod Design
p. 132 (top) © Mike Quon Design Office
p. 132 (bottom) © Warkulwiz Design
 Associates, Inc.
p. 133 © Warkulwiz Design Associates, Inc.
p. 134 (top) © Wood-Brod Design
p. 134 (bottom) © Steff Geissbuhler
p. 135 © Wood-Brod Design
p. 136 © Polese Clancy
p. 137 (top) © Polese Clancy
p. 137 (bottom) © Zender + Associates, Inc.
p. 138 © Steff Geissbuhler
p. 139 (top) © Polese Clancy
p. 139 (bottom) © Greteman Group
p. 140 (top) © Shimokochi/Reeves
p. 141 (bottom) © Stewart Monderer Design,
 Inc.

Index